Preface

by Cathy Larqué, 2006

At the beginning there was nothing; at least there was no one. Then, by the laws of evolution, or of clay, Man was born. Parachuted into an environment that one could hardly describe as hostile, he interpreted his providential survival with the intellectual means available to him. Nature, this enigmatic power, both nourishing and quick-tempered, became divine. Until the Middle Ages she was linked with a transcendent power outside Man: everything is an expression of a higher will, nothing is dictated by chance.

Later, the 18th century, emancipating itself from religious faith, conceptualised nature. Very soon it was opposed to Culture: thus the myth of the "natural savage" was born. "Nature made man happy and good, but society corrupted him and made him miserable." To put it another way, ideas, touched by the exotic and primitivism, centred on an imagined benevolent nature that ensured peace and happiness.

That was yesterday; what about today?
What has happened to the gentle Utopia of the return to nature? The very expression speaks of both paradise and loss. Could nature be no more than a mirage? If it is considered to be an element not susceptible to any intervention that can change it, how can we claim that we were ever part of it?

Let's keep calm, take a deep breath. I'm sorry to tell you that nature unfortunately disappeared.

And when it comes to life again, it exaggerates.
Society, dedicated to immediate information, tends to give nature a spectacular character by emphasising its most exponential manifestations. Typhoons, tsunamis and other movements of the earth are always on our screens.
Nature now has a media-staged image. It is like the celebrity, whose least escapades and wildest behaviour are reported.

Always on the look-out for sensationalism, paparazzi hunters of tornadoes and amateur video makers track them ceaselessly. The anecdotal visions of natural phenomena, filmed in New Orleans or Phuket, are beyond decency and comment.

Faced with such visual violence, we have to give ourselves a moment for reflection. I hesitate in front of two CDs bought for 15 euros each in Nature and Discoveries: "Nature after Rain" or "A Day in the Life of a Mosquito"?
Happiness is on the shelves of the mass distributors, which harbour a nature made-to-measure.
Having said which, this nature proves to be an unstoppable promotional medium, a powerful marketing tool. Nature helps to sell and sells well. In the present environment, in which the artifice of production reigns, nature is seen as a healthy alternative. Everyone is on to this little gold mine, which is exploited with all the resources of language.
"Quality of life", "public health", ",100% pure' labelling", "ecology": in the unfathomable magma of the "politically correct", the representation of nature is worked at in order to be deliberately used.

My dear, bold reader, if a breath of the desire for freedom invites you to leave the beaten track, the means of escape are within reach at the steering wheel. Super-powerful, super-equipped, super-sized, vehicles are tailored to break through all the most insurmountable barriers of nature. Compared to your Range rover Sport, the Ford Mustang Falcon Hardtop V8 Turbo 5.71 of Mad Max will look like a pushchair. On board an aerodynamic monster you will become an eagle of the highway.
I cannot avoid being fascinated by the language of advertisements. They alone have the hilarious ability to use the word "hostile" and "refinement" in the same sentence. Dear consumer, rejoice: comfortable nature has been invented.

You want to sleep under the stars in the Gobi desert, set off to conquer the Andes or plough across the ice-fields of the Antarctic? BUT you find the local food difficult to digest, the thought of long journeys on the back of a camel unattractive? Don't despair: plenty of travel agents offer "à la carte" packages, "adventure" holidays, "discovery" trips. This is also how canned nature was invented.

Although it is evident that the need for nature increases in proportion to the progress of urbanisation, nature can, in fact, be easily packaged. Can be got hold of quickly, satisfactorily, efficiently. Time is short, we are in a hurry. We opt for a weekend in one of the sixteen Center Parks to enjoy all the attractions of a canned nature and "the year-round tropical climate of Aqua Mundo, to experience intense moments on the lagoons, jacuzzis, waterfalls and waves, or simply relax amidst exotic vegetation."

On reading this argument in favour of plastic nature, the answer to my question seems quite clear. Nature is a myth. While making a mockery of technological arrogance, it has assimilated virtual reality so as better to feed fantasies and untruths. I am full of admiration: its ingenuity is only equalled by its power. Nature does not exist, and that is its strength. Only its mental representation, the idea one has of it, is real. In this case, let us enjoy the irony and begin by writing the word in the manner of any self-respecting ideal: with a capital N.

Contemporary art and the imitation of nature

by Katharina Klara Jung, 2006

If when thinking about the connection between art and nature you see a belling stag in an Alpine landscape in your mind's eye you can safely forget about it - the art world (with the exception of a few neo-Romantics who have just dragged themselves out of the academies and into the galleries), is in complete agreement that the age of belling stags is over. But does the end of the stag also mean the death of nature, whatever that may be exactly, in art?

What does "nature" mean Gernot Böhme[1] defines nature as something "that is there in its own right, is what it is in terms of itself and reproduces itself as such". But this definition is based on one of the two different kinds of nature within nature philosophy. According to Aristotle they are creative, incomprehensible nature, natura naturans, and created, real nature, natura naturata. The change in meaning that the concept of "nature" has undergone in the course of time can be demonstrated very clearly by interpreting this distinction and the way it is weighted in various contexts: Aristotle saw the two kinds of nature as two sides of the same coin, while Spinoza divided the concepts into categories it was easier for his contemporaries to grasp, "God" and "nature": nature is reduced to its reality and subordinated to a higher power previously thought to be inherent in it.

If one thinks of "nature" in the largely secularized world of today, the creative principle disappears almost completely and the tangible idyll of the marketable quality and leisure value of purity and unspoiltness shifts into the foreground. As there is no longer a clear counter-concept to the world of things, nature is defined only by demarcating it from a large number of other concepts, and blurs into a semantically imprecise terms with a wealth of very different connotations.

Mimesis as a reflection criterion The forms imitating nature in contemporary art are as numerous as these connotations. Imitating nature for nature's sake has been passé for a long time now - little more has remained in the highly intellectualized contemporary art discourse of the Baroque attempt to surpass nature herself in copying her, down to purely decorative and edifying landscape painting continuing into the late 19th century, than a recognition of craft skills and a mildly understanding smile about the simple naïveté of such representations.

But imitating nature is always a form of reflection, and while merely illustrating nature certainly does not have to mean mimesis, mimesis can appear even in the most widely differing forms of illustration by doubling, or in sensual visualization expressions, down to substitution or even actual representations, according to the conceptual lens through which nature is seen. So what exactly is the concept of nature that can show something in common between Olafur Eliasson's brilliantly atmospheric installation of a gigantic, orange-glowing sun ("The Weather Project", 2003), Damien Hirst's four-metre-long shark in formaldehyde ("The Physical Impossibility of Death in the Mind of Someone Living", 1991) or Christian Löhr's fragile architectures made up of dried seeds and stalks - and what makes it possible to distinguish between these different views?

Olafur Eliasson - The Weather Project "I am interested in the process of seeing within the discrepancy between conveyed knowledge and knowledge as actually experienced,"[2] explained Olafur Eliasson in an interview. Although of course a sunset does not consists of a large stationary disc of monochrome orange light, Eliasson's project invokes precisely this association. Reduced to its most succinct characteristic, it isolates a single aspect of nature experience and puts the viewer centre stage by using artificial mist and the specific light situation.

In this way the public, rather than the imitated natural phenomenon, becomes the object of the artistic exploration: the installation is intended as a quasi-scientific experiment, as a kind of test lab for (self-) reflection about perception forms and the role of key associative stimuli.

Damien Hirst - The Physical Impossibility of Death in the Mind of Someone Living Like Eliasson, Damien Hirst also addresses a part of nature, albeit much more directly, also making it a subject of heated discussion within this directness: the object is immediately accessible - everyone has seen at least one picture of a shark - but also alien, a direct confrontation with the idea of death in the double sense of a threat to life and the actual dead, preserved creature. Once again it is not about nature itself, but about an example of a universal aspect of life itself made visible: the incompatibility of the will to live with transience, something implied in the title and accessible within the overall context of Damien Hirst's work.

Christiane Löhr Christiane Löhr offers an approach relating to nature itself. Her fragile geometrical sculptures using ivy seeds, tree blossom or plant stems take up the architectural rules prescribed in the growth of the plants themselves, thus creating gentle, poetic structures combining the natural and the artificial world by continuing the contrasting but related principles of "growth" and "building": thinking back to simplicity and the great effect of small gestures.

Nature as a signifier The three chosen examples show some of the tendencies towards functionality projected on to mimesis in contemporary art: as well as the memorability provided by the mere use of a familiar phenomenon, object or material, and the access to the particular work associated with this, the works share a form of thinking back to something more fundamental

and original than high-sounding intellectuality in their handling of nature. The "nature" element still seems to me to form an alliance with the human element in demarcating technology and progress: placed before the choice of an expressive medium, metaphysical and philosophical themes are translated into action - even if indirectly, and without making one part of nature stand out concretely against another -, by using the comprehensible qualities of mimesis.

So: no. It is not the end of nature - the belling stag still exists. But it is neither the stag nor its roaring that determines the mimesis content of contemporary art, but what it is able to represent in the overall semantic and pictorial context, and to invoke or indeed not invoke in the viewer.

© Katharina Klara Jung, 2006

[1] Gernot Böhme: Die Natur im Zeitalter ihrer technischen Reproduzierbarkeit, Kunstforum volume 114, 1991
[2] Olafur Eliasson in conversation with Dieter Buchhart, Kunstforum volume 167, 2003

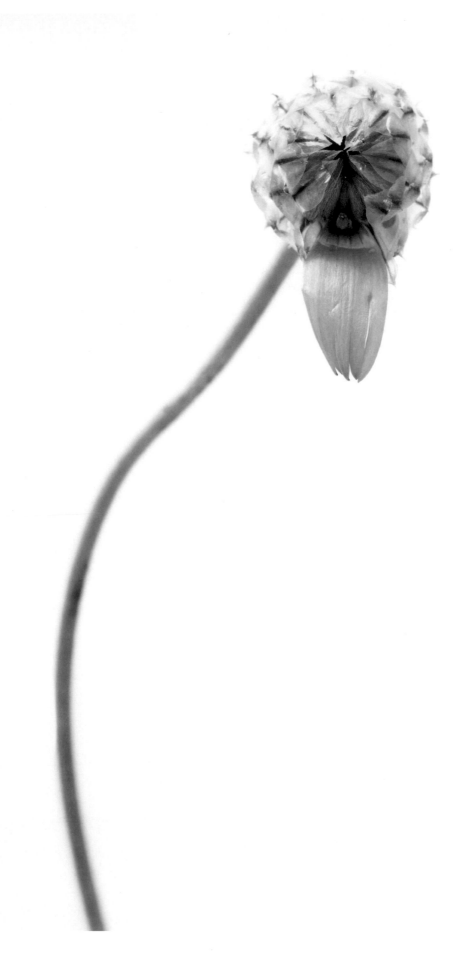

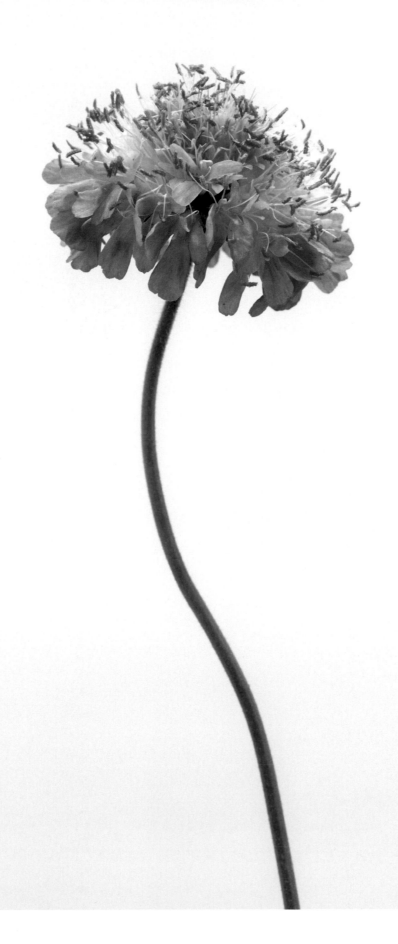

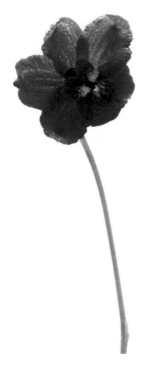

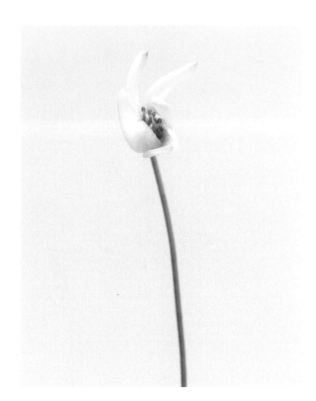

Naturalistic Collecting, listing, describing, classifying, making collections.
Putting under glass, in a herbarium, stuffing. I go to the Natural History
Museum, the zoo, the Winter Garden, I go to the vivarium, the aquarium,
the reptile house.
Getting in touch with Nature can sometimes take place within a limited
framework and a system based on control. In this protected area every
possible chance event has been considered – in order to prevent it happe-
ning. Safety reigns.
Moreover, the physical barriers multiply and at the same time attempt
to melt into the landscape. The infrastructure makes great use of the
transparency of a window or the frailness of a barrier rope. The desire to
reconstruct the 'natural milieu' is a sort of obsessive game. Its primary
aim is to create the illusion of an open and living environment.
It's the road to appreciating the grandeur of nature and is taken to ex-
tremes. We work away at reconstituting mammoths, we organise excur-
sions to feed sharks, we explore safari parks from inside our own cars.
Who is the captive, who the laboratory rat? Who is being studied?
Deceiving barriers, you are both transparent and all-powerful. Danger is
your trump card, the human mind your chosen territory.

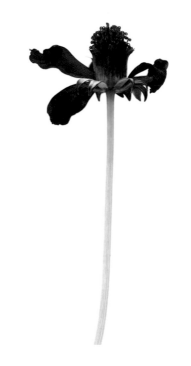

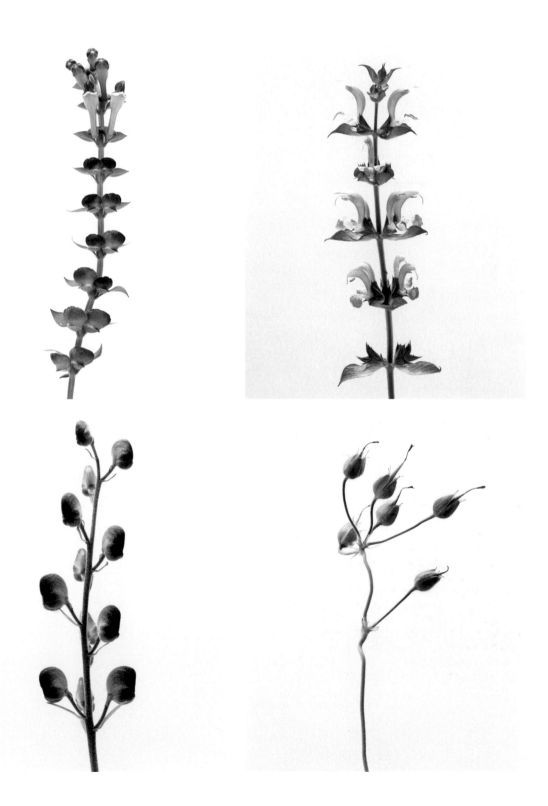

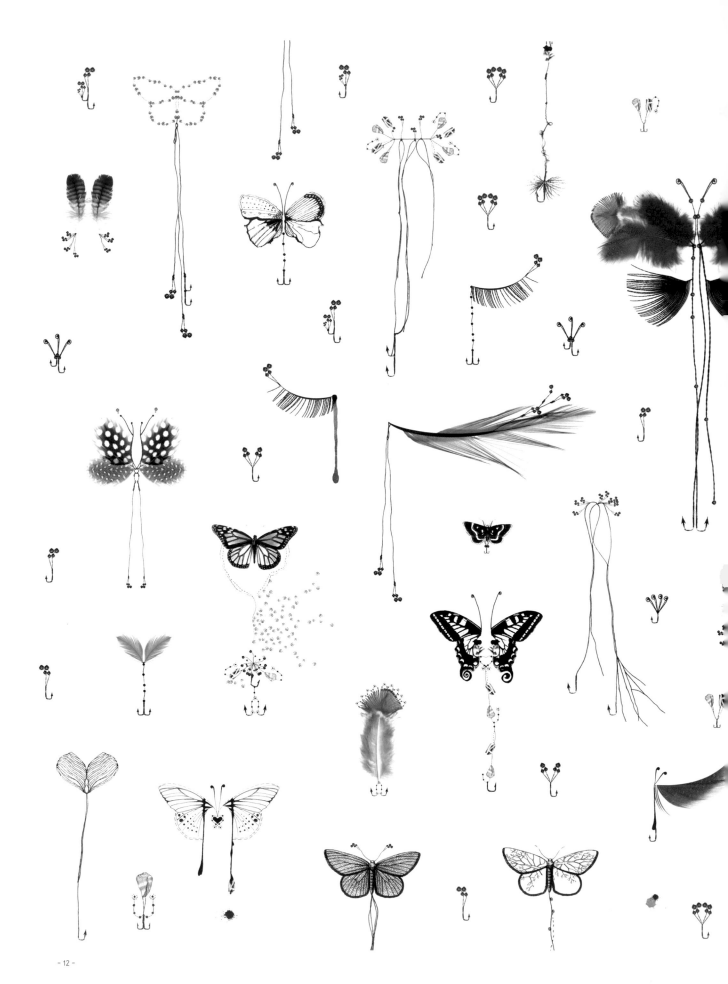

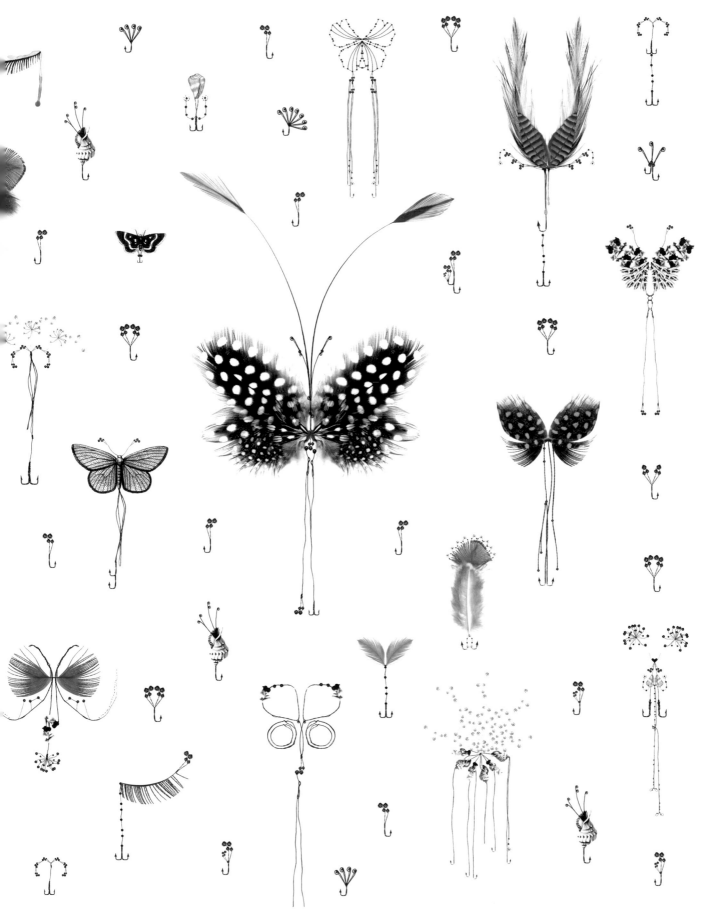

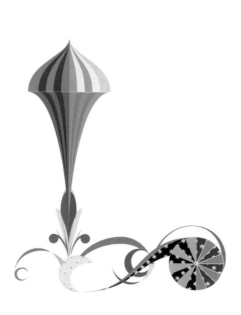
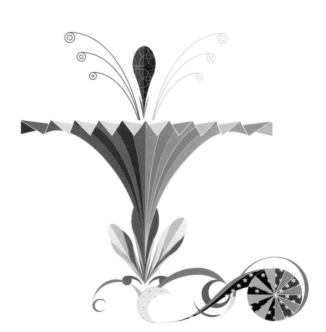

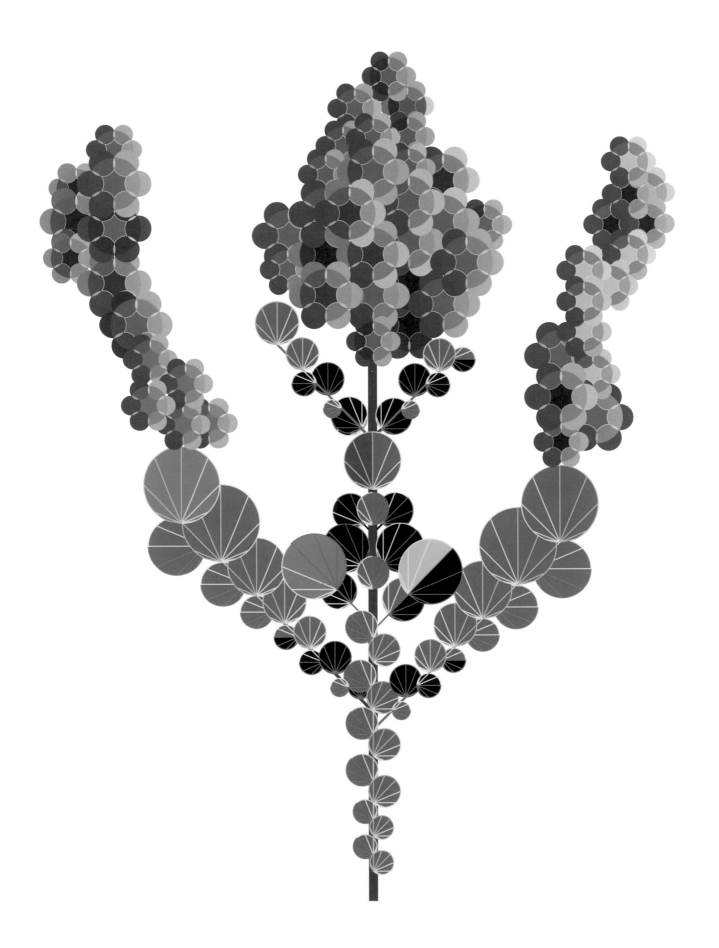

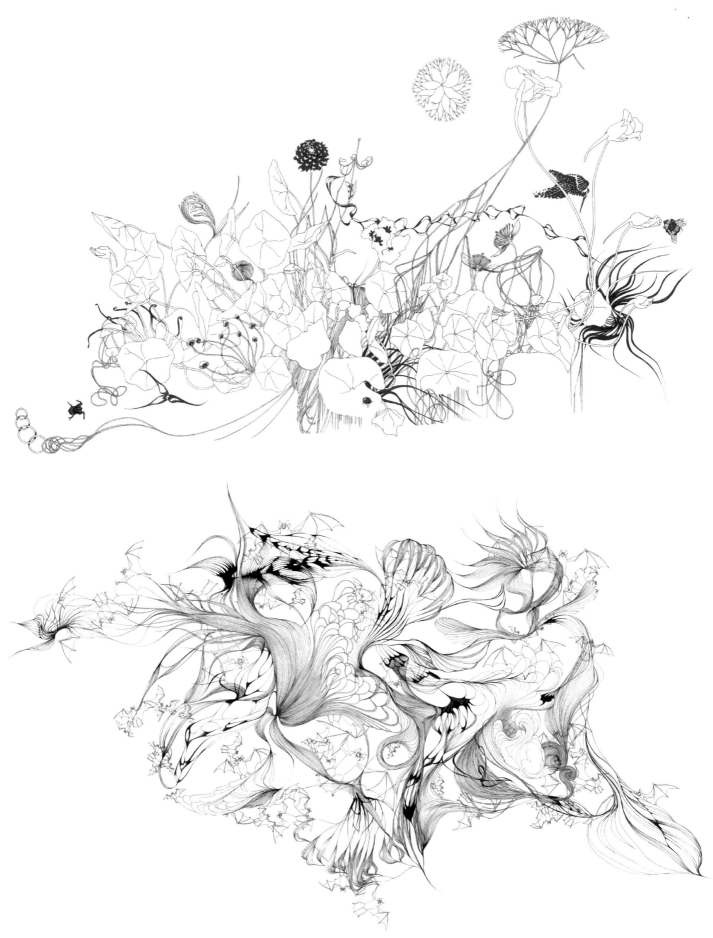

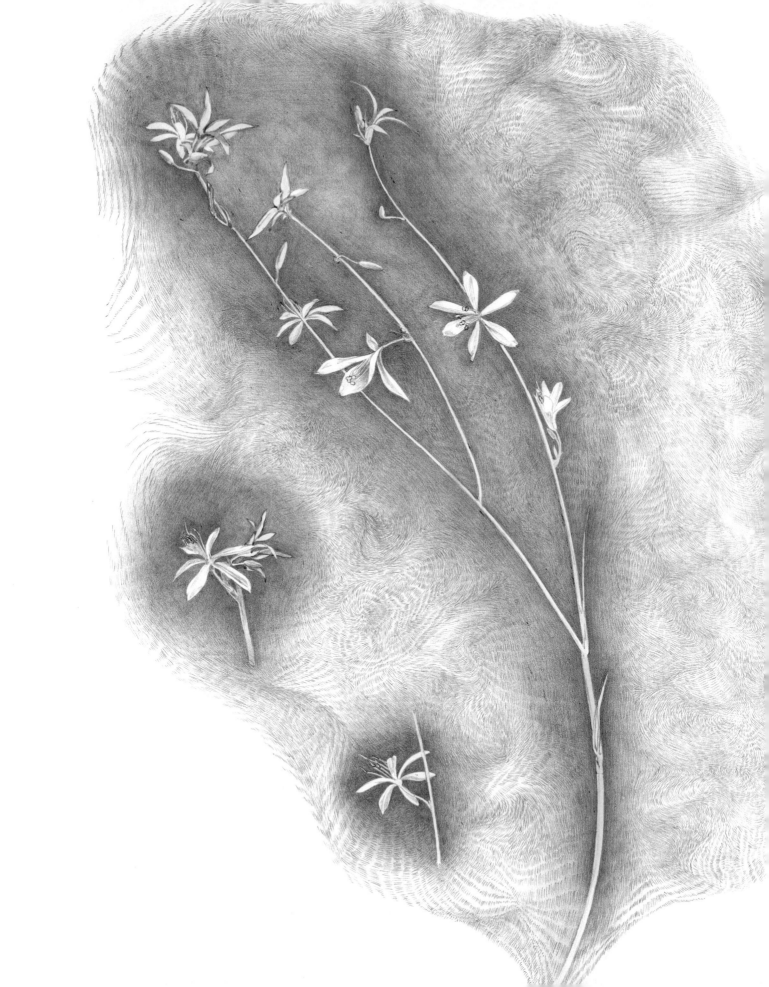

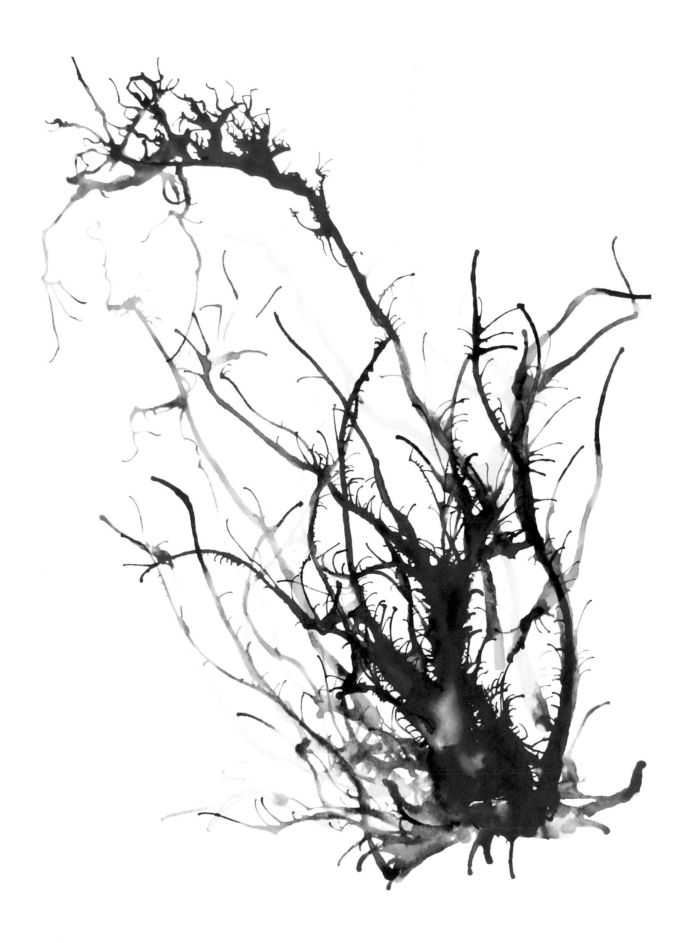

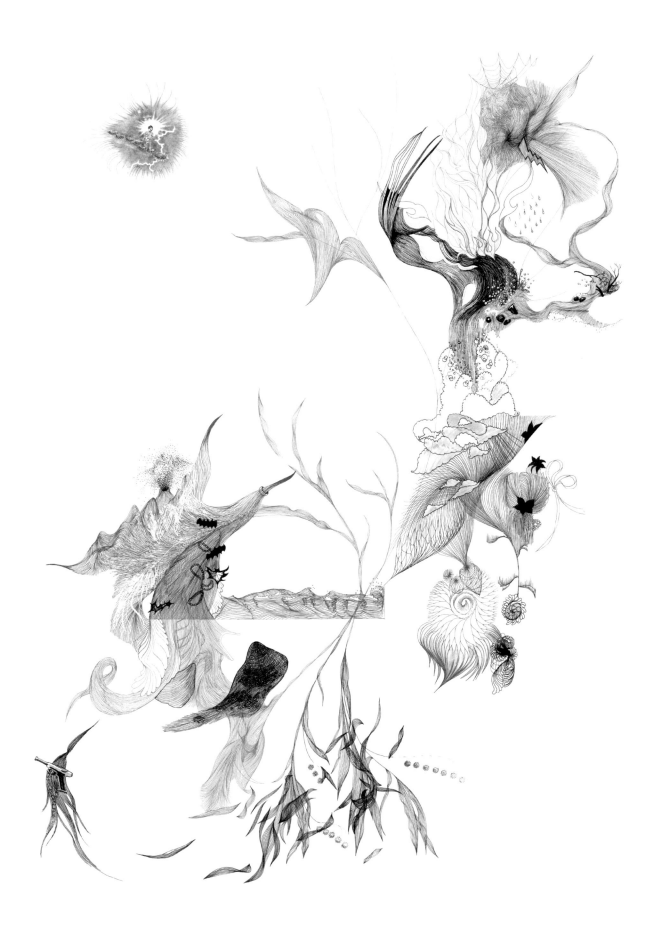

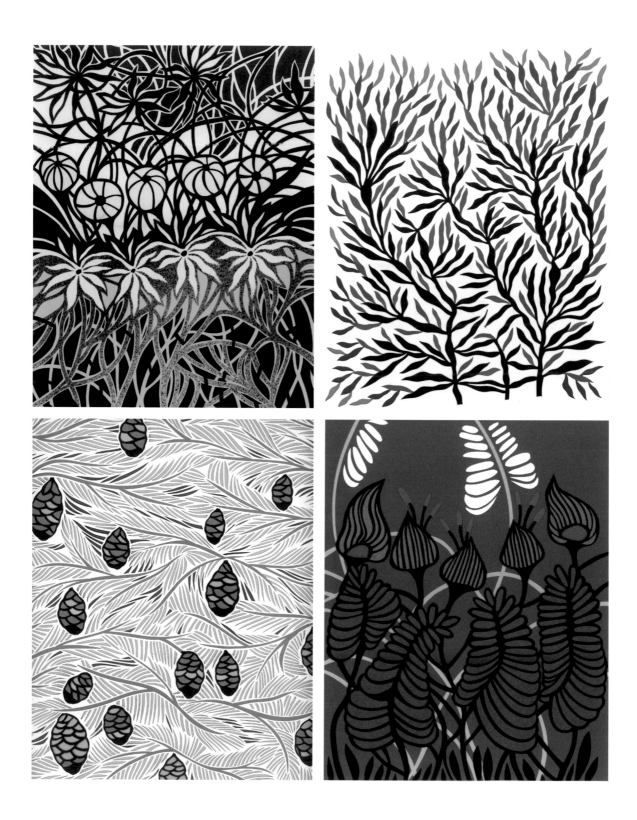

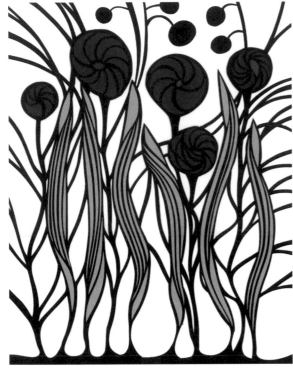

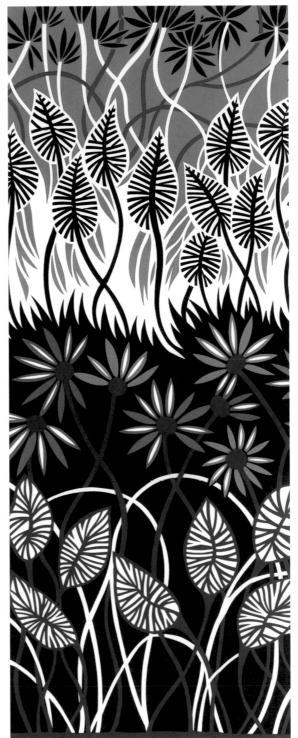

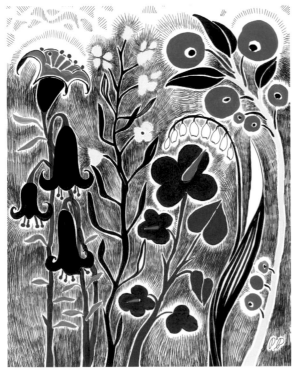

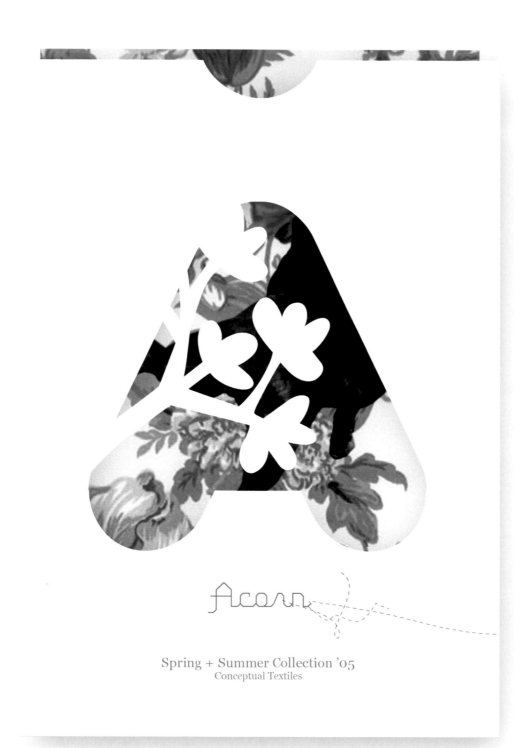

Acorn

Spring + Summer Collection '05
Conceptual Textiles

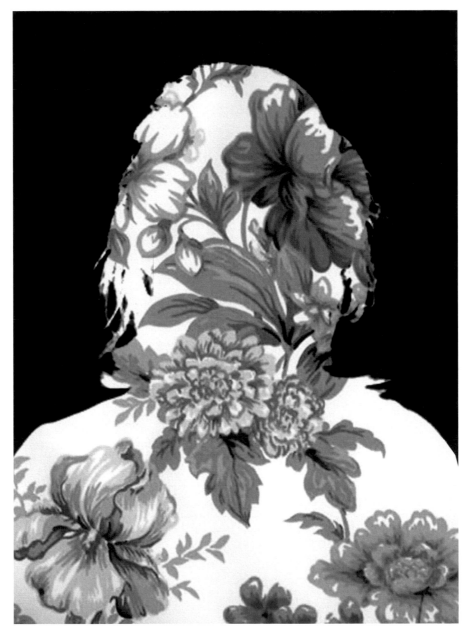

ROMANTIQUE
A transitional large scale floral and leaf tapestry

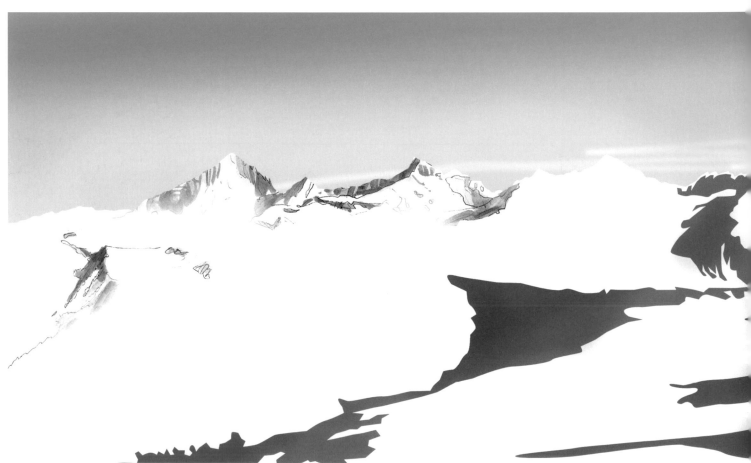

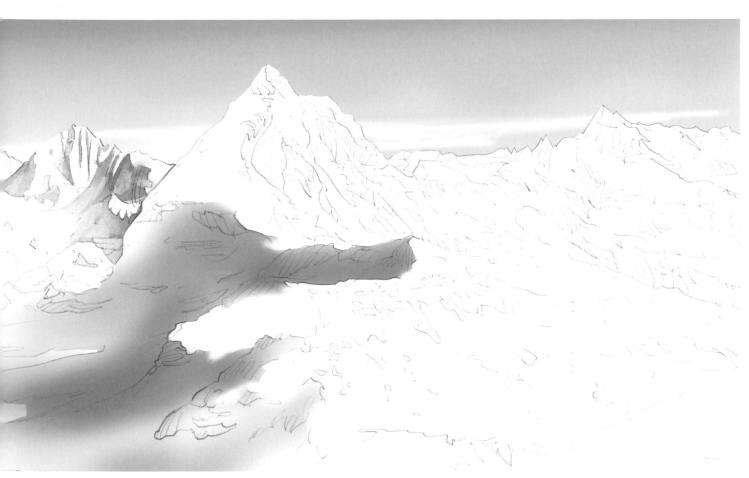

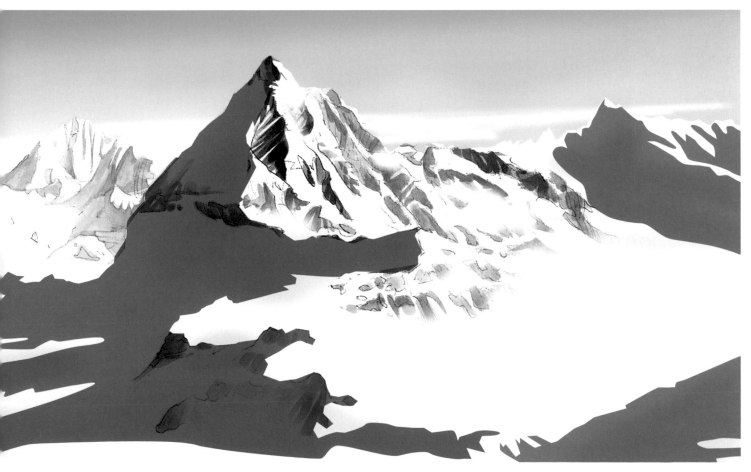

A NEW FOREST

MIGHTY OAK

OCEAN FRESH

SUMMER BREEZE

SUN FRESH

FOREST WITH CLOUDS

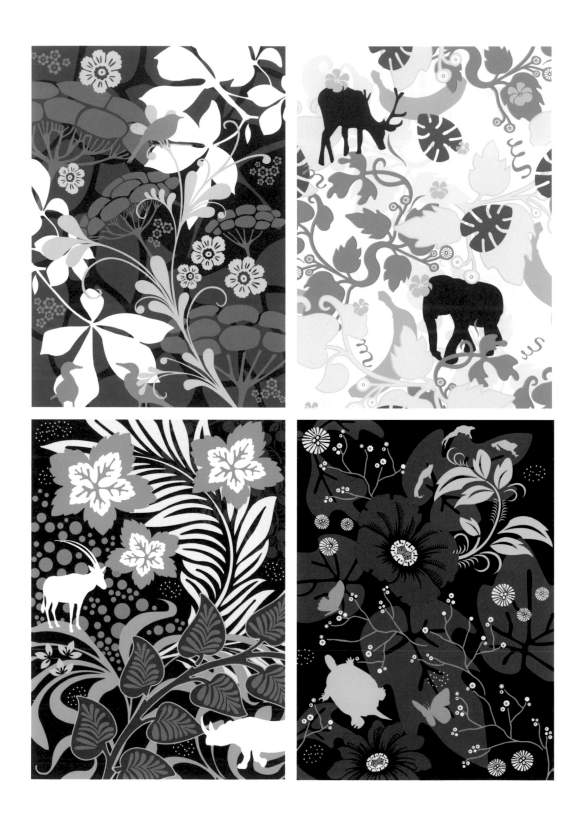

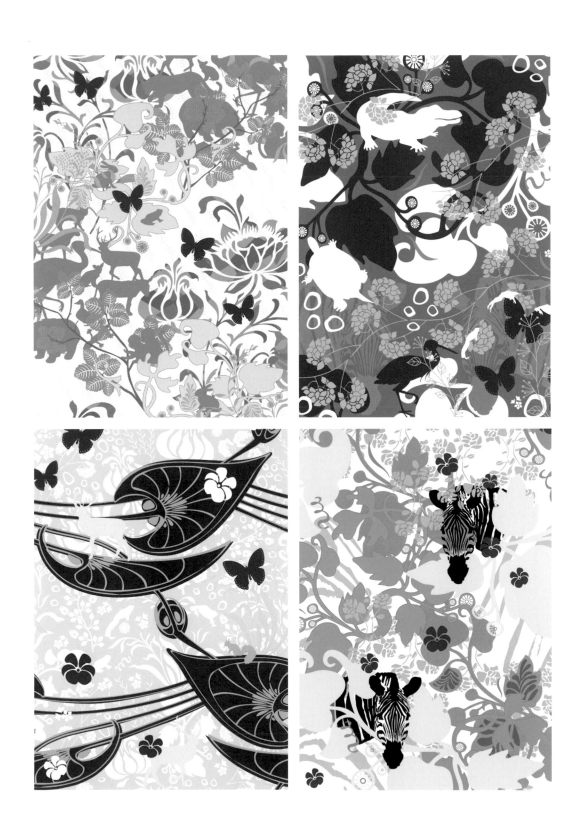

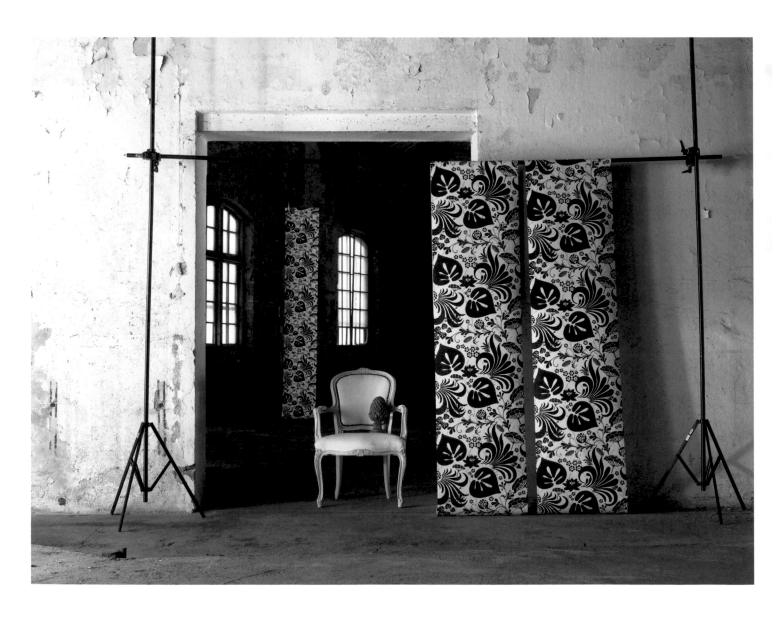

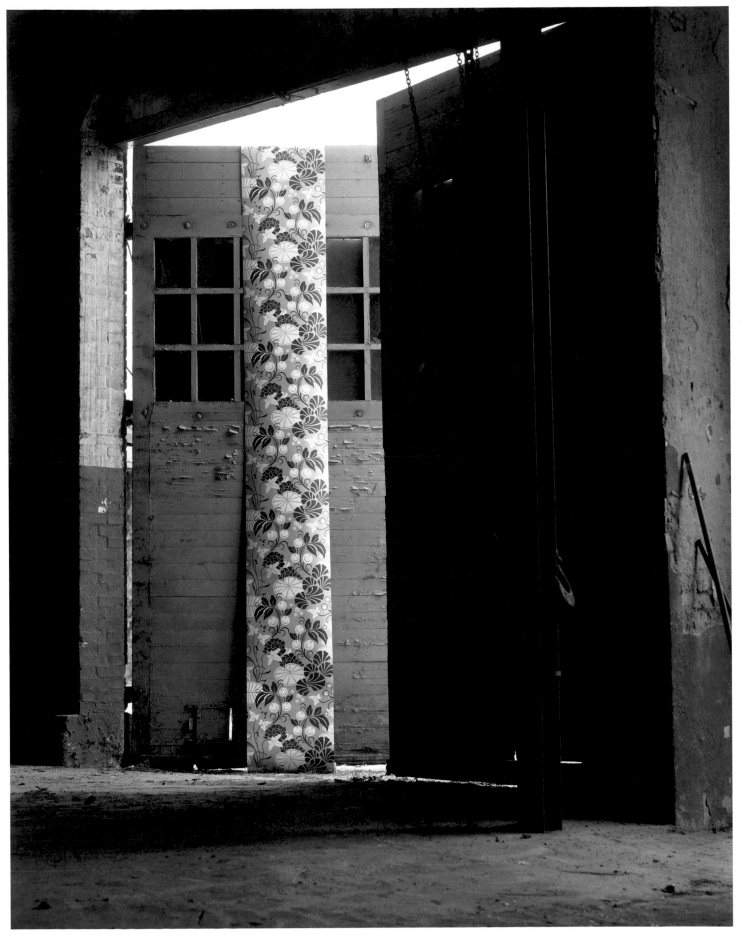

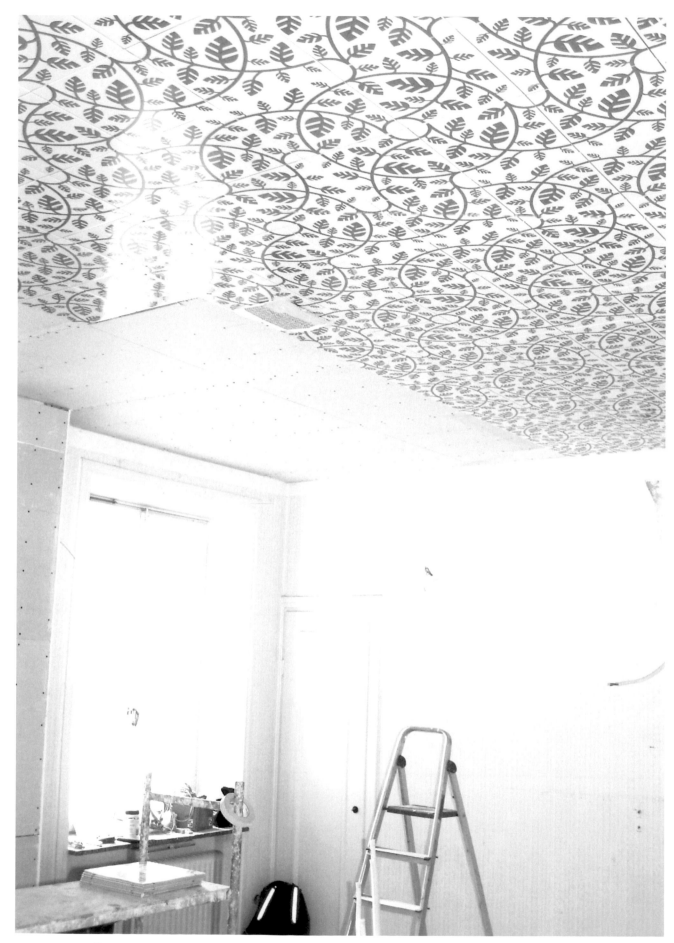

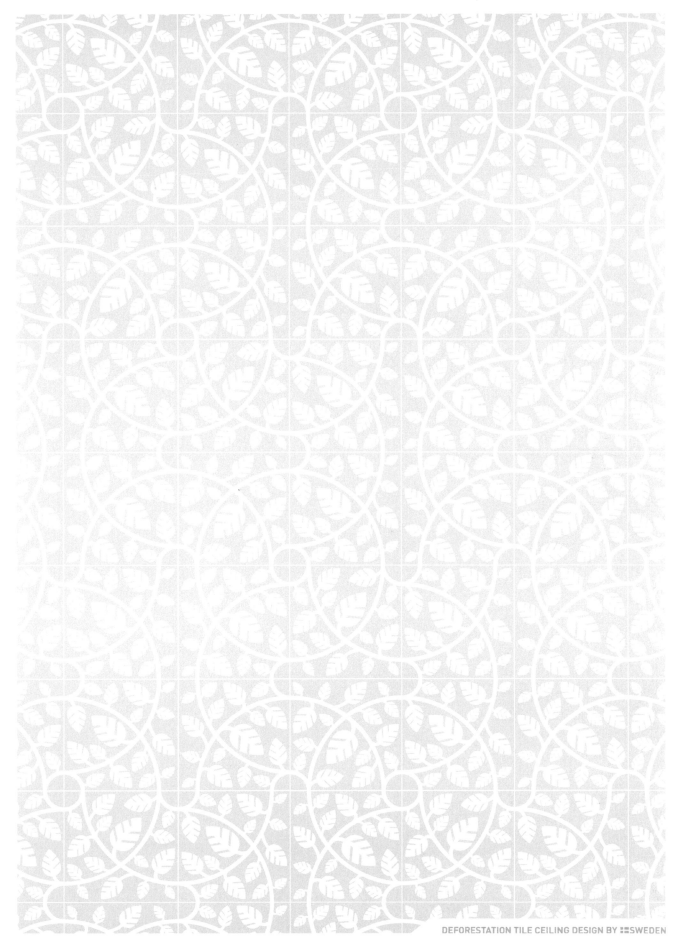

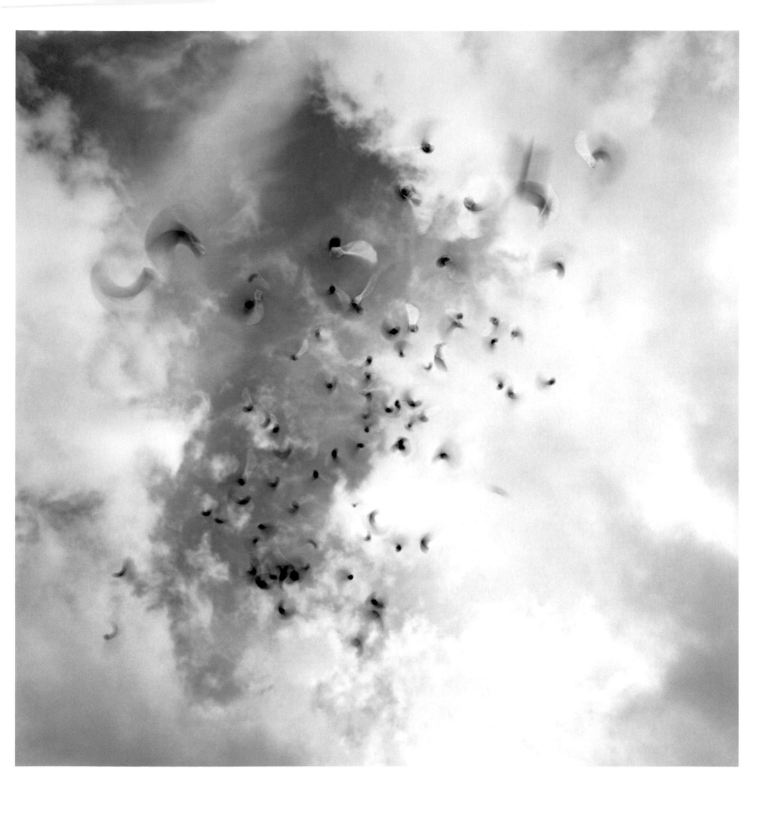

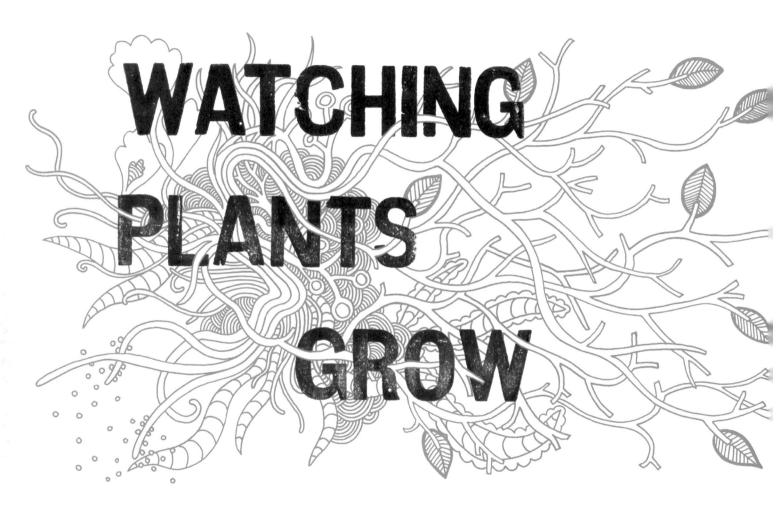

WATCHING PLANTS GROW

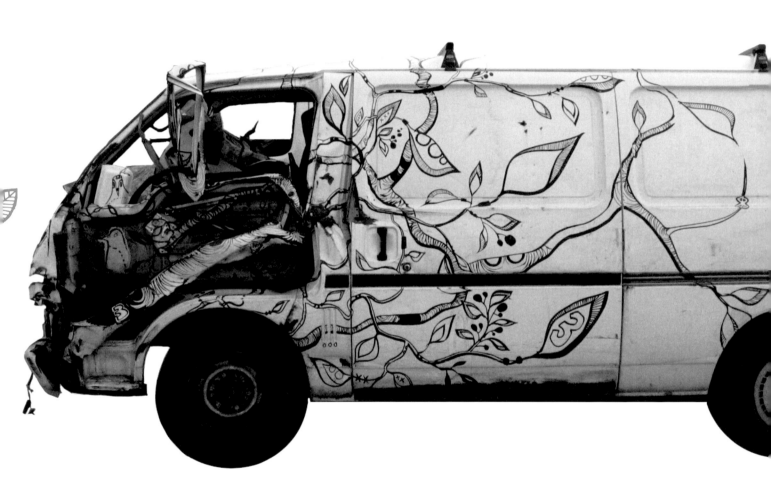

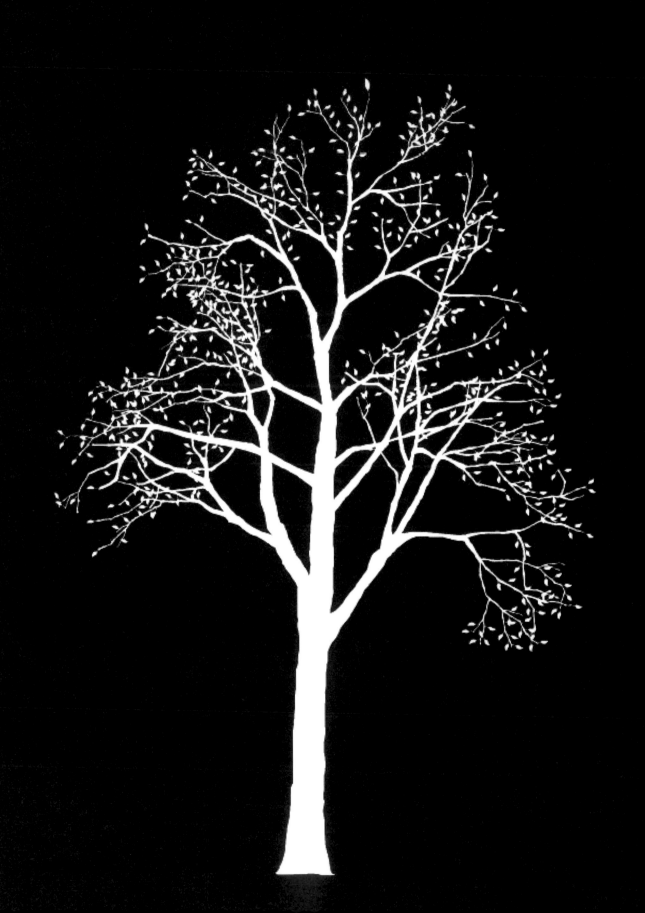

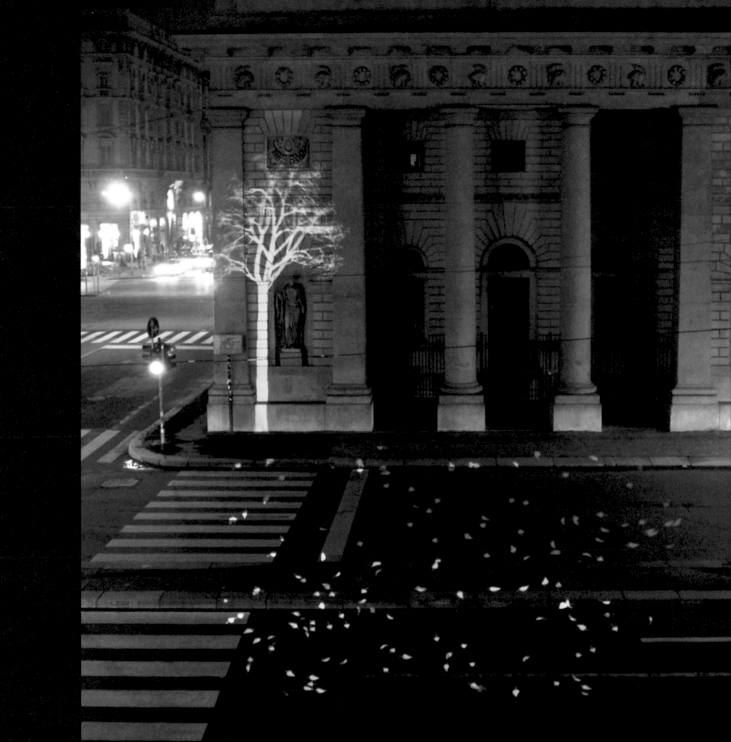

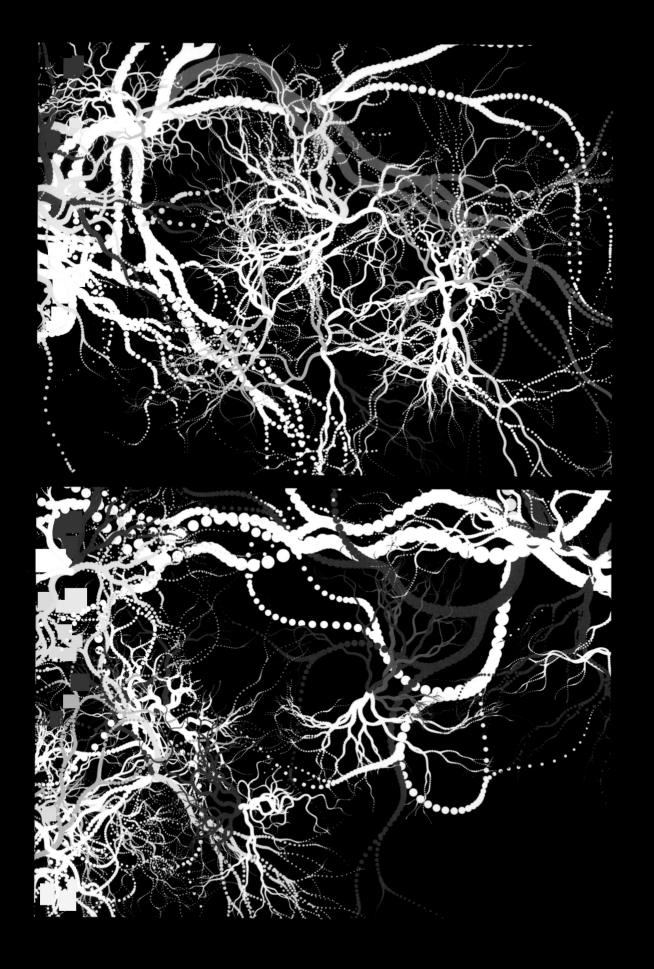

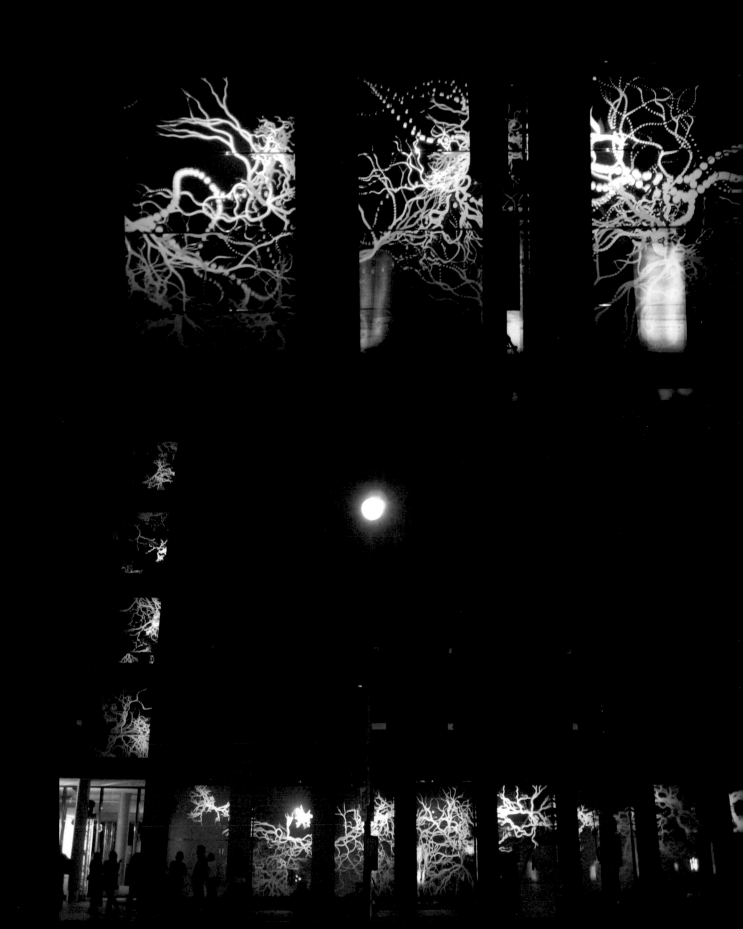

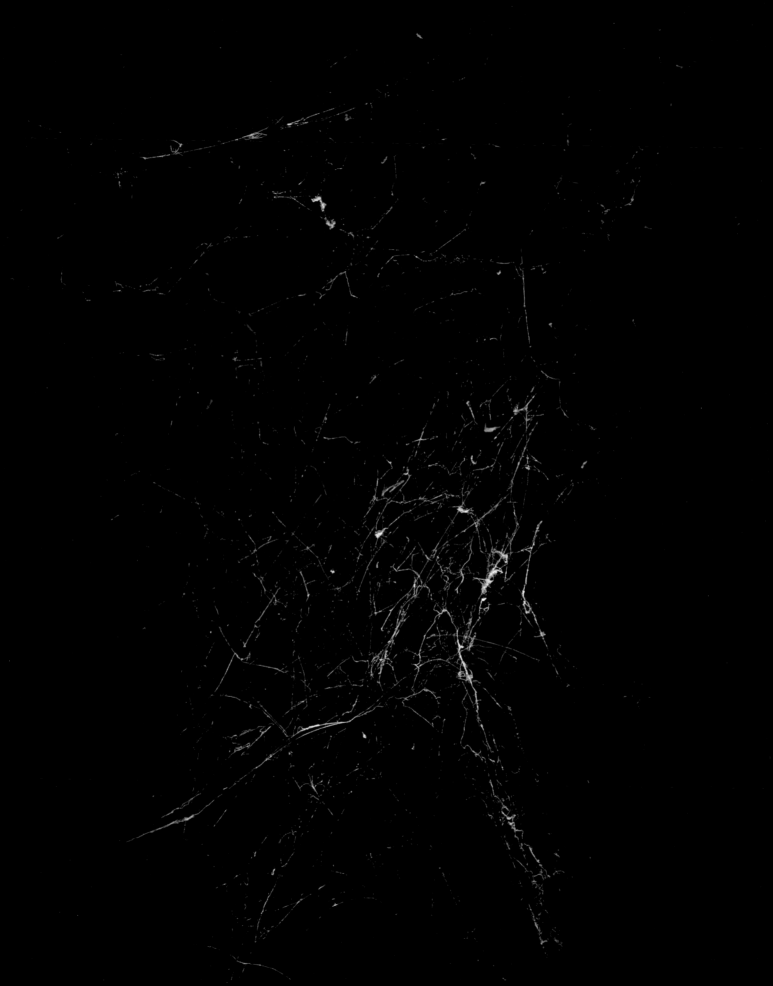

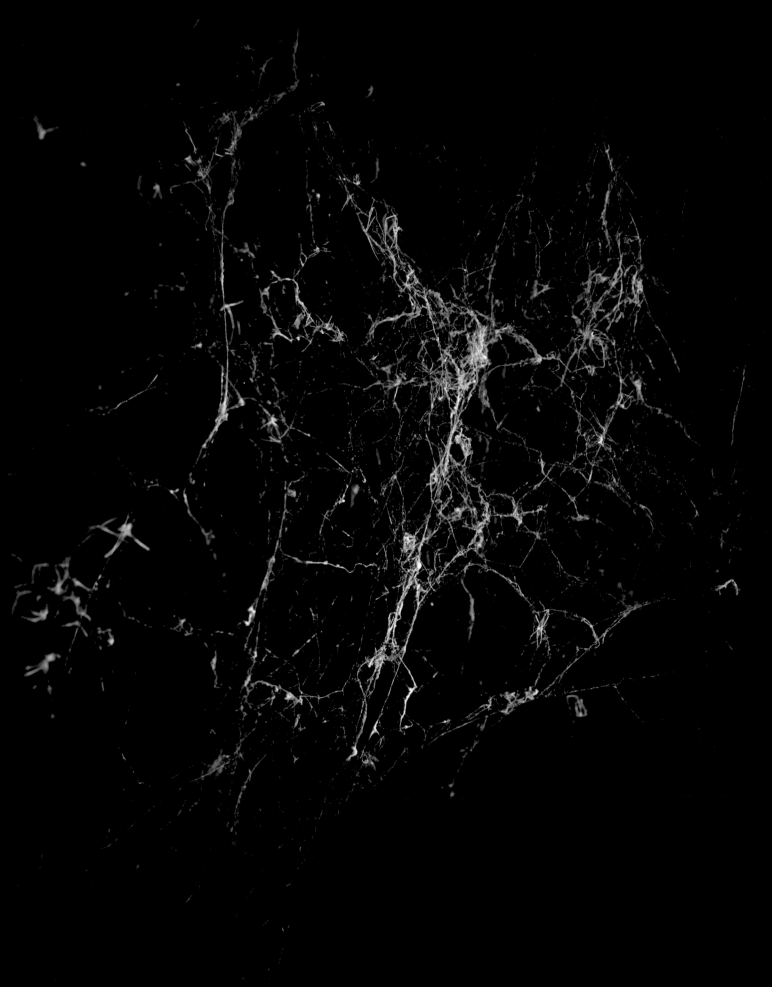

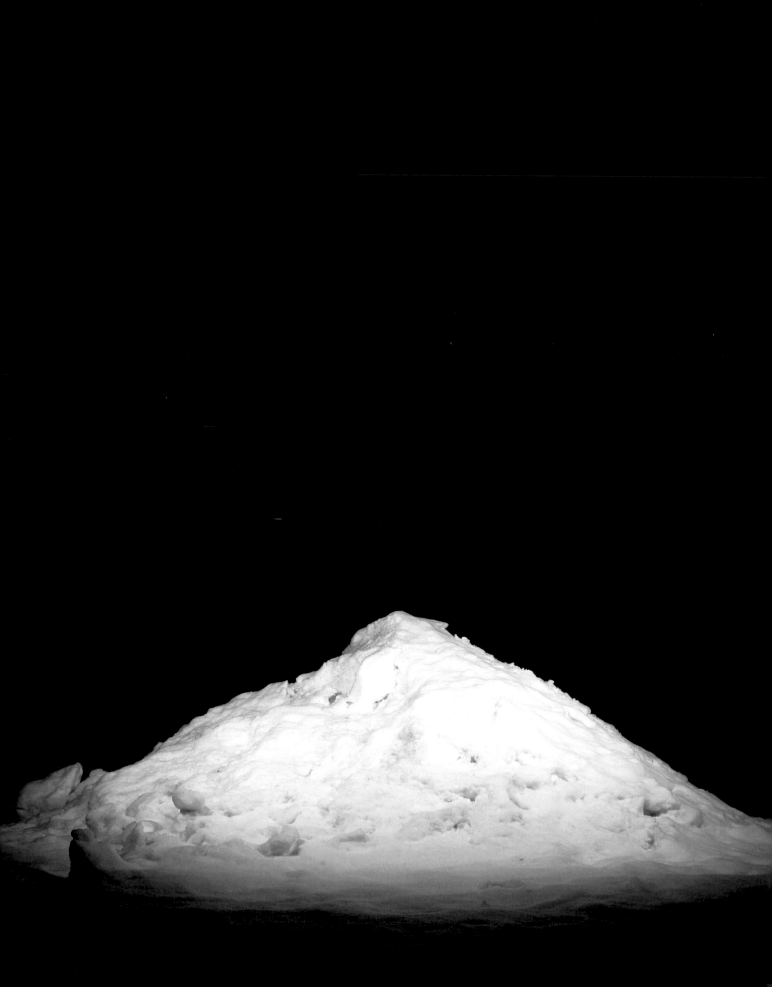

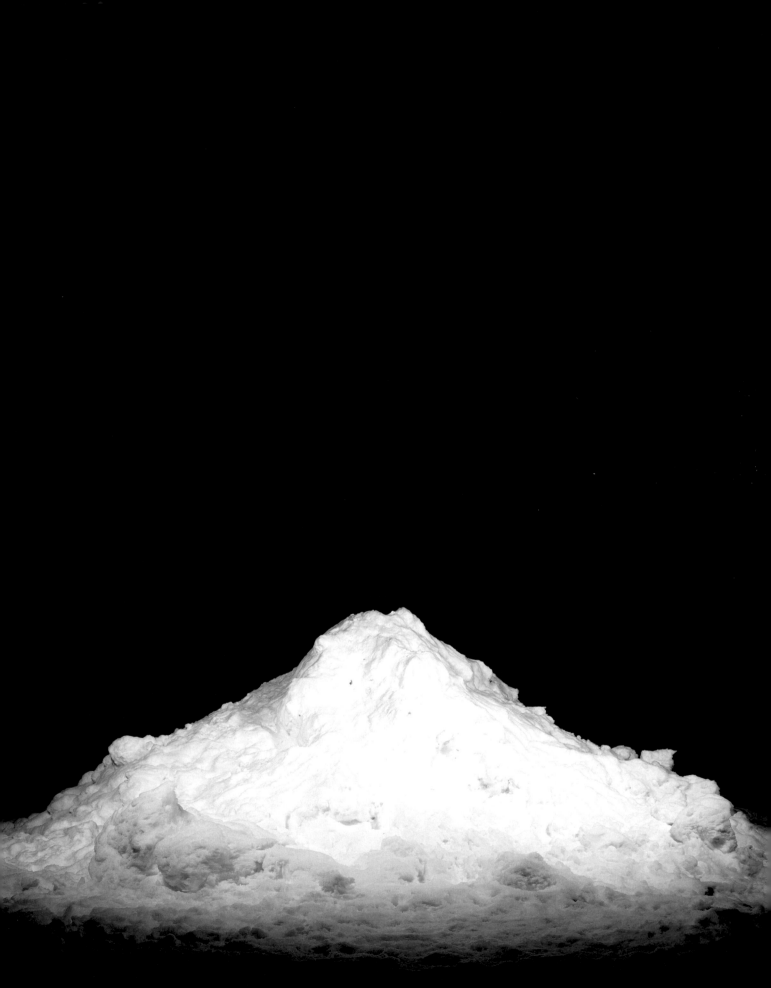

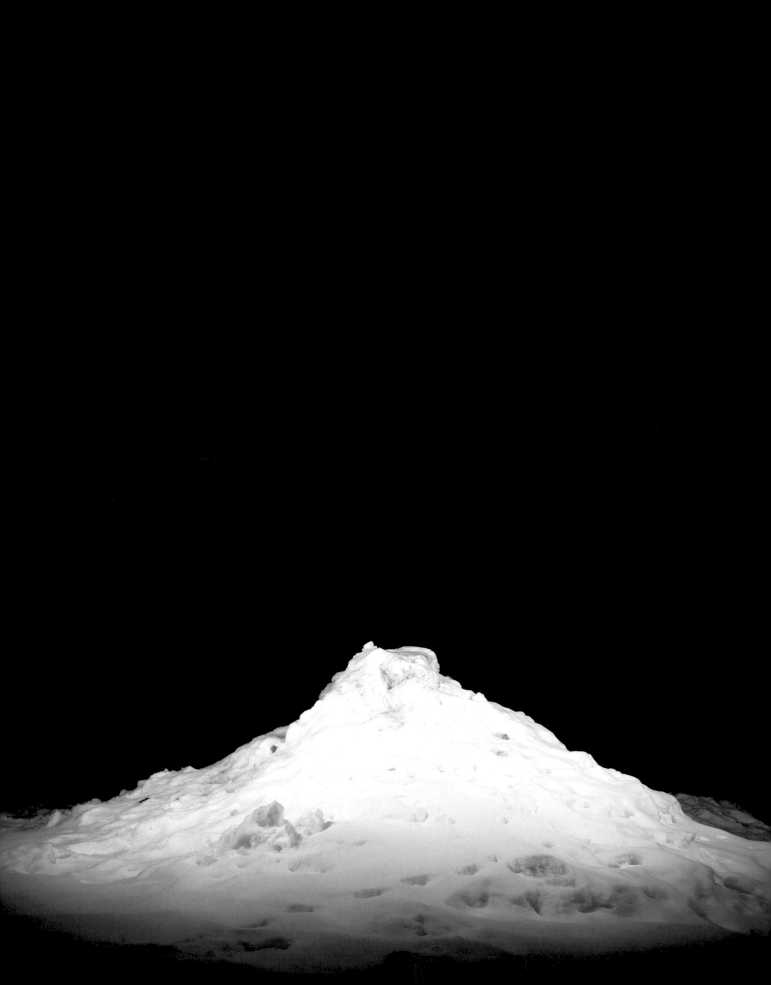

Civilisation Hayao Miyazaki's Castle in the Sky is a reflection of the contemporary fantasy of an ideal city. Stamped by nostalgia and poetically futuristic, his vision depicts a Nature that generates civilisation and protects it.

Detached from its terrestrial chains, the city, nestling in the hollow of the tree of life, floats in the skies among thick clouds.

"To live happily, we live hidden."

For a while at least: beyond a certain point the human presence becomes persona non grata. Of the inhabitants of Laputa only a tomb remains; their rare descendants were exiled to Earth a long time ago.

A Nature that has reasserted it rights is evidence of a fall, a collapse. It recalls the idleness of the Roman Empire, the lust of Sodom and Gomorrah, a tactical error, reinforced sometimes by divine punishment. Eve bites the apple and it's Atlantis that sinks beneath the waves.

One day ambitious and bright, some societies are then swallowed up, taken over by the animal world. Elsewhere, artificial islands are constructed to satisfy the insatiable needs of fast-growing populations. The puppet show goes on. Caught in a vicious circle, the puppet and the puppeteer change roles in a scenario that involves renewal and extravagance.

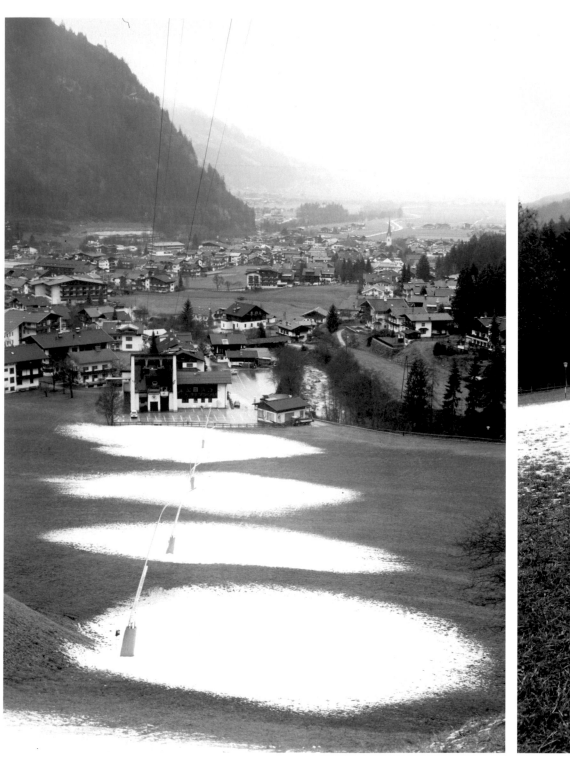

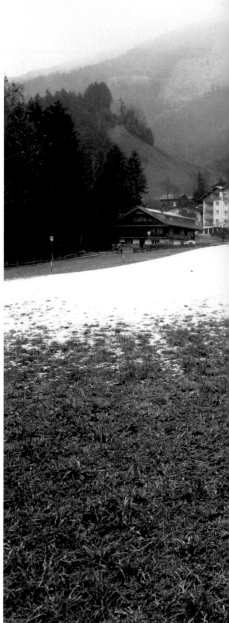

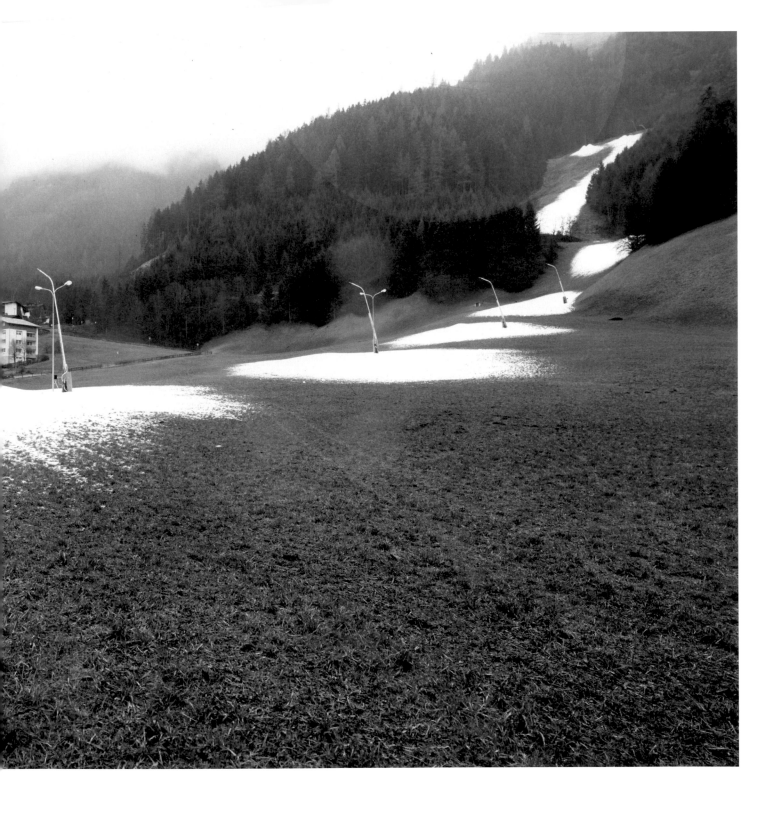

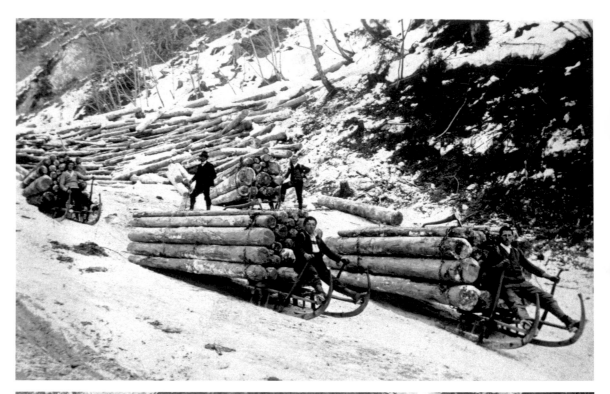

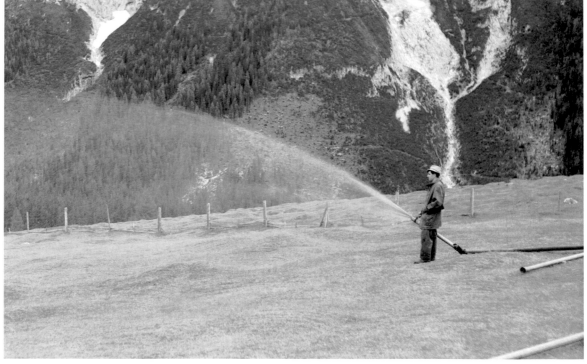

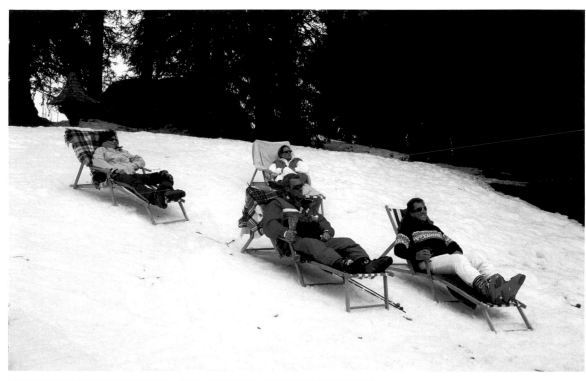

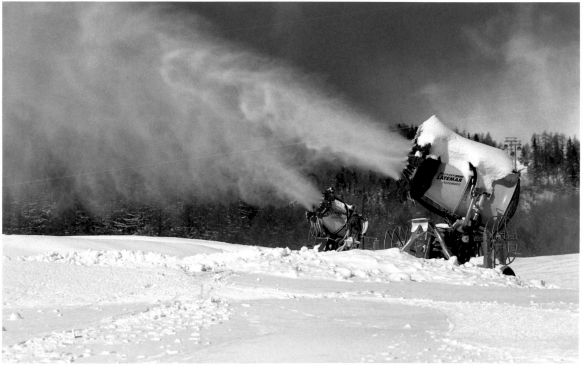

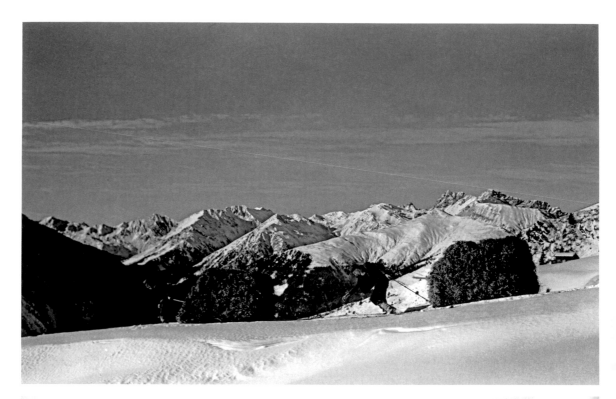

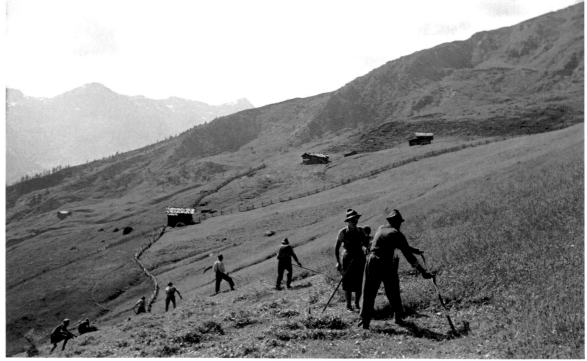

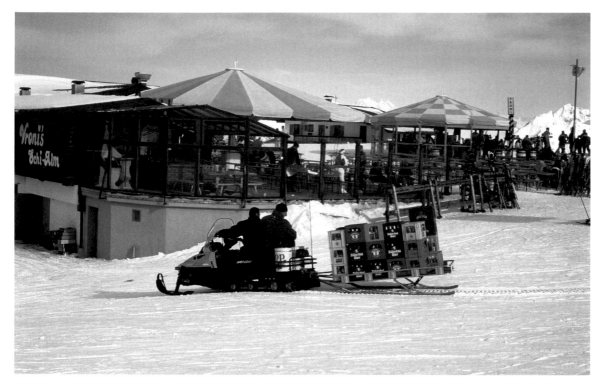

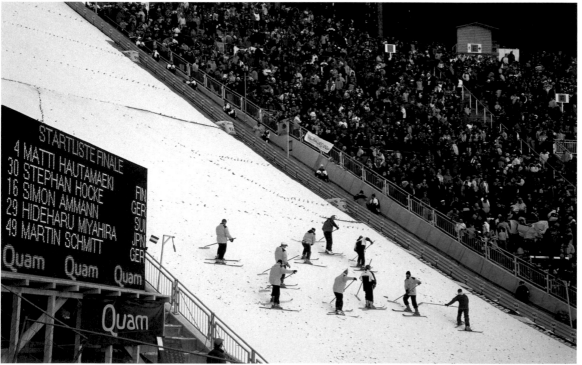

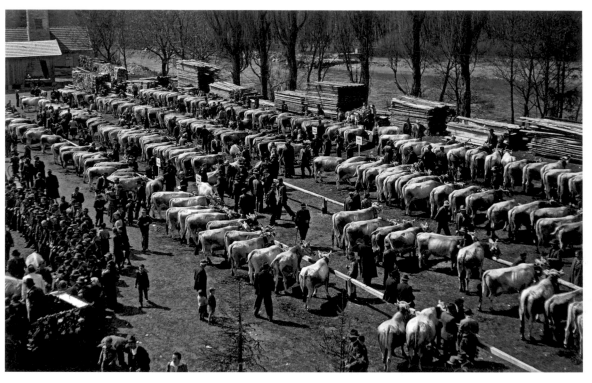

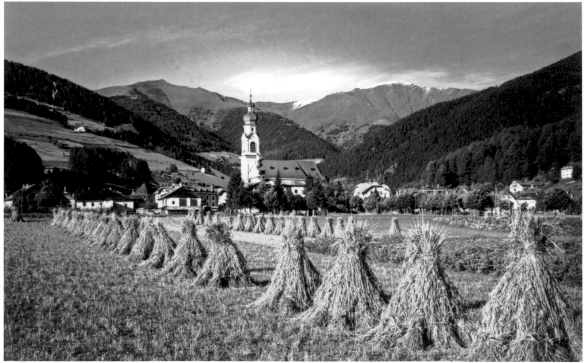

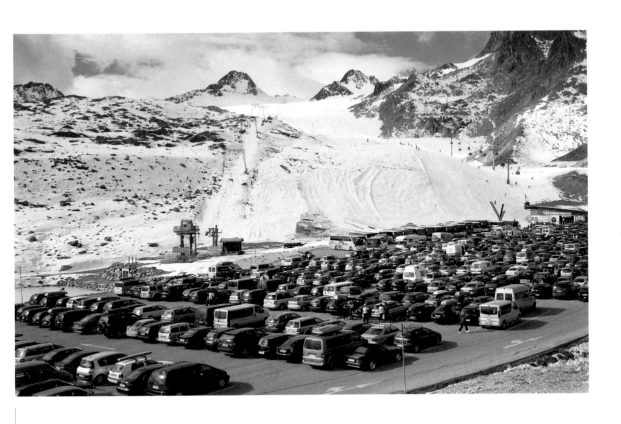

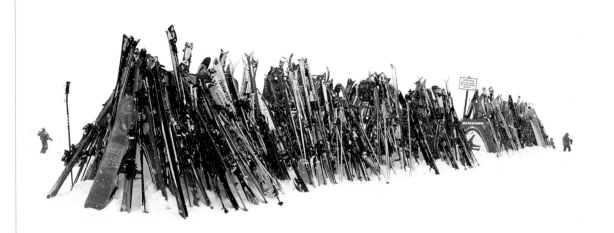

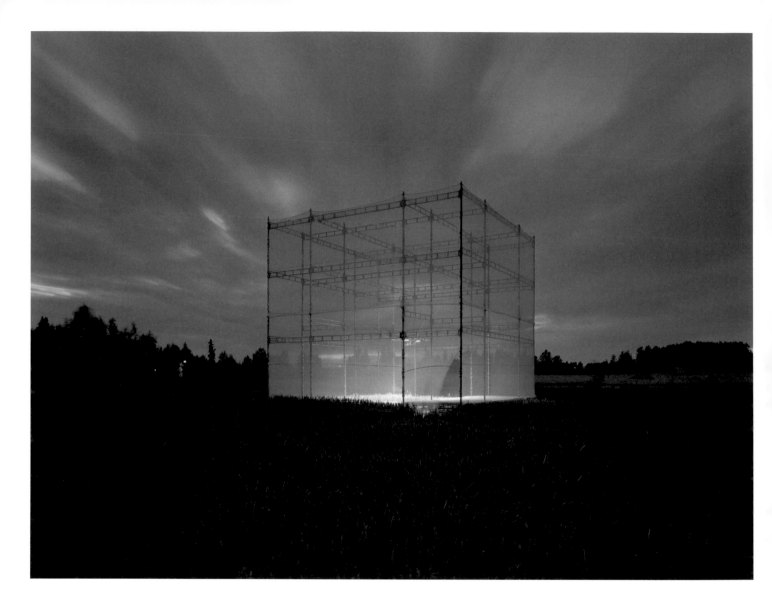

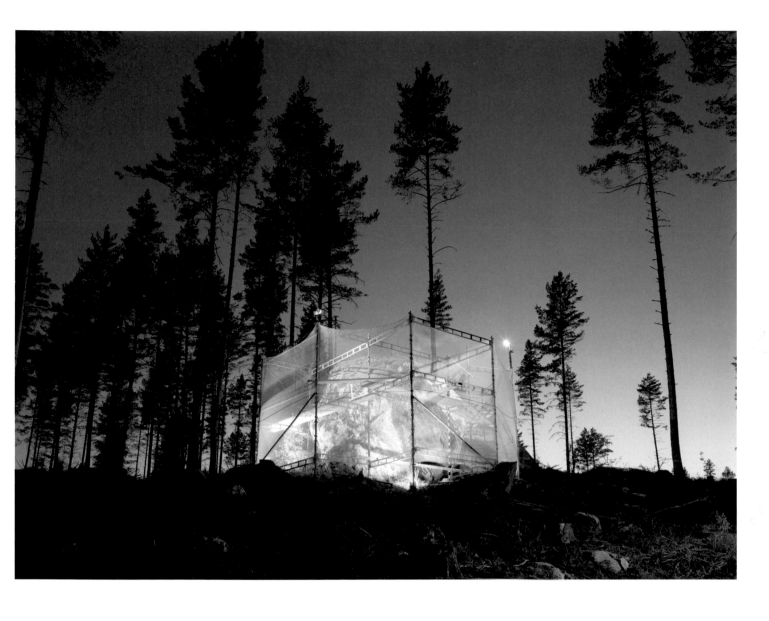

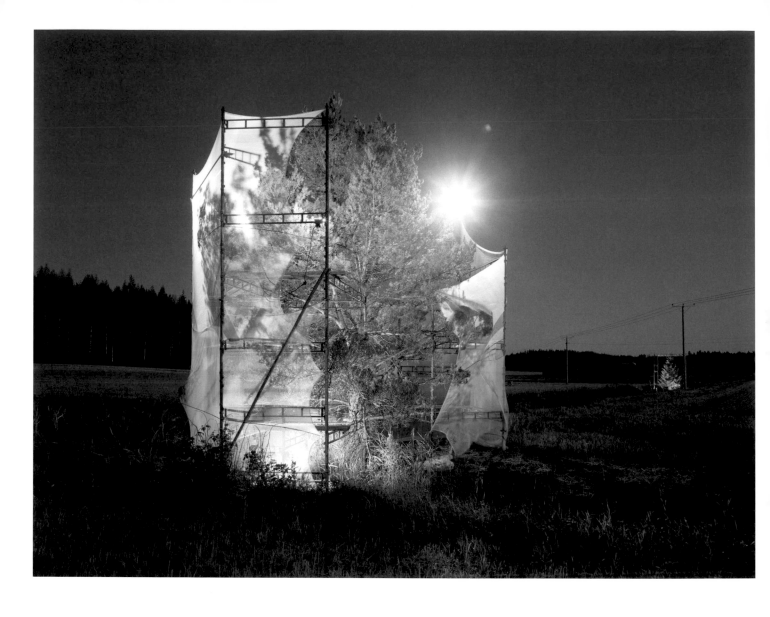

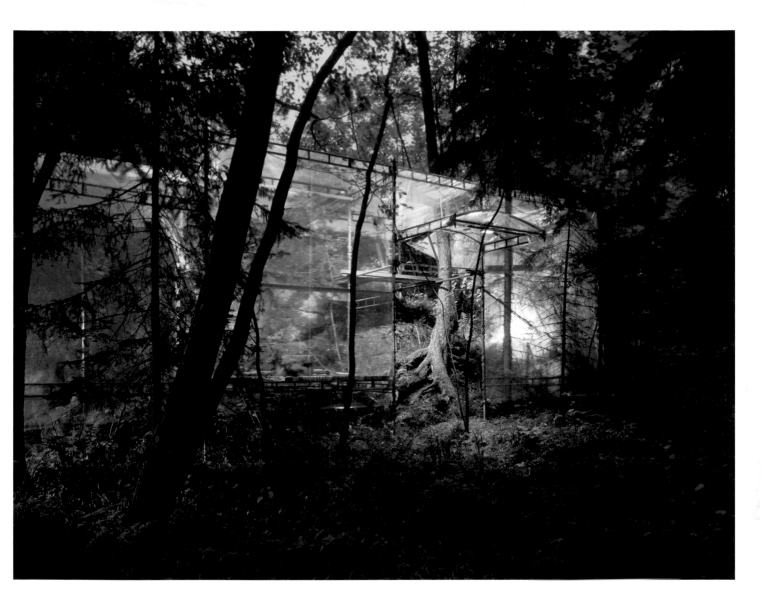

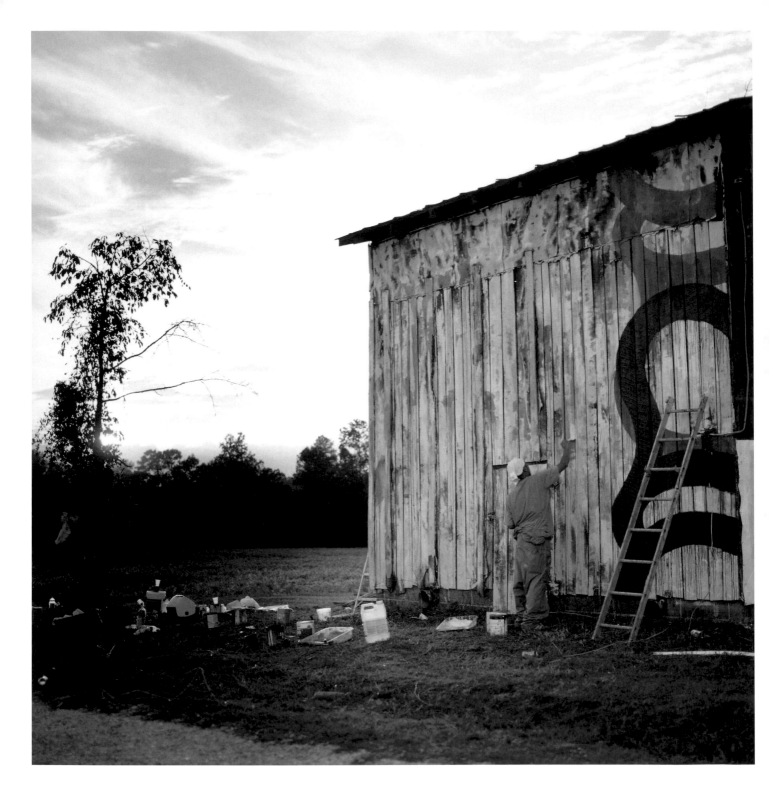

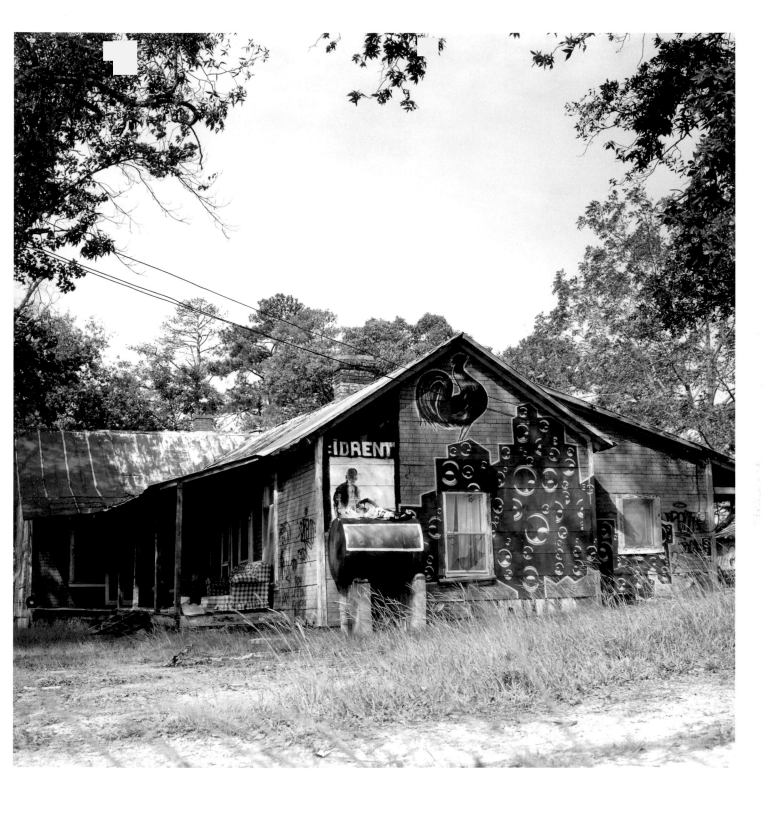

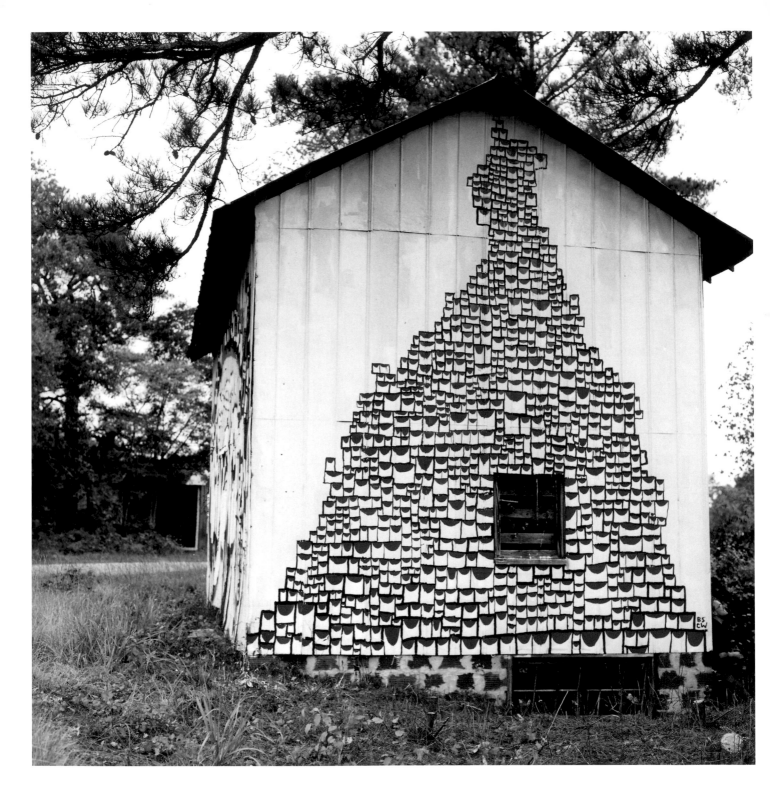

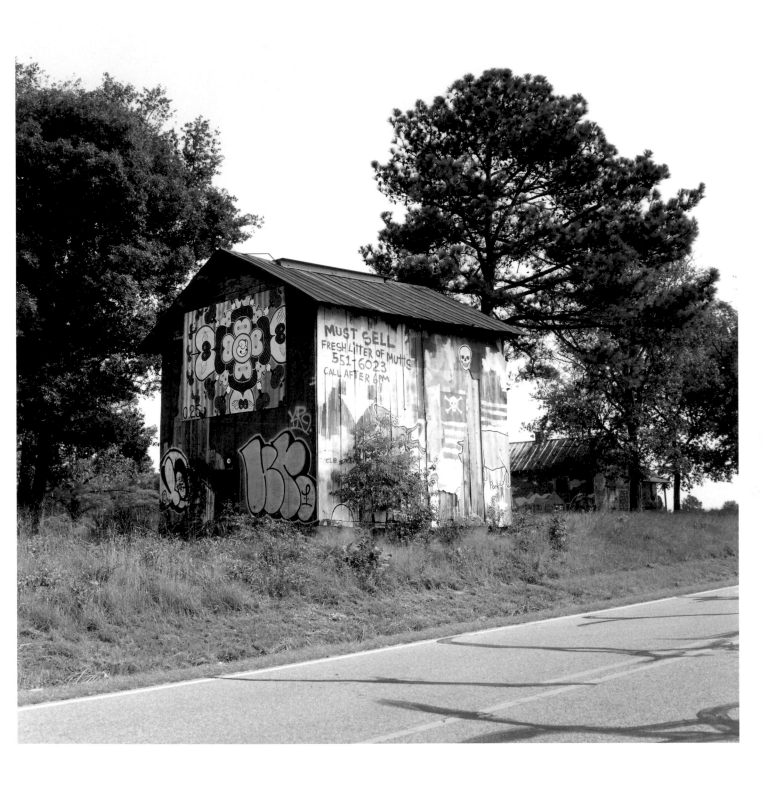

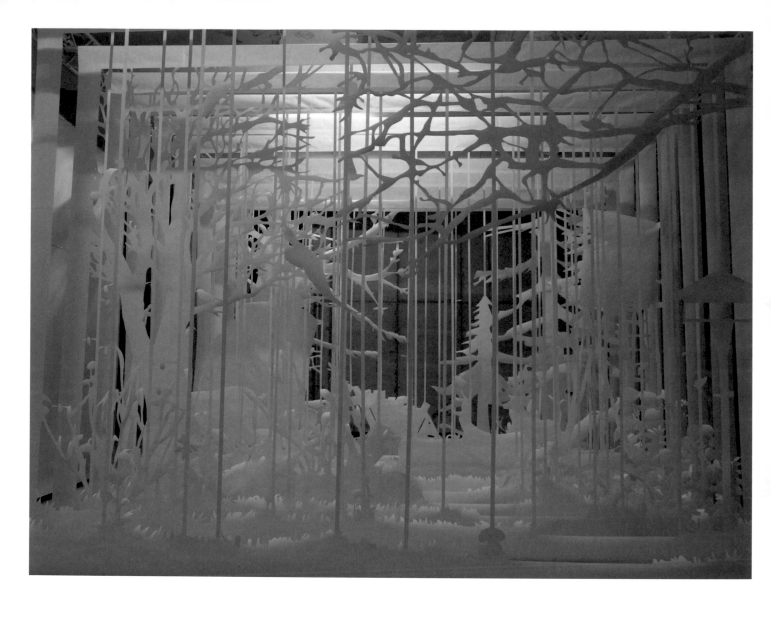

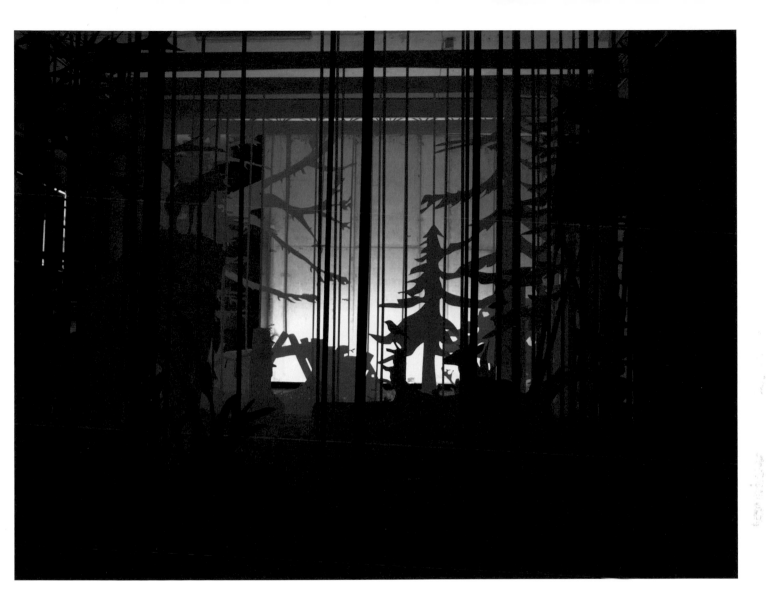

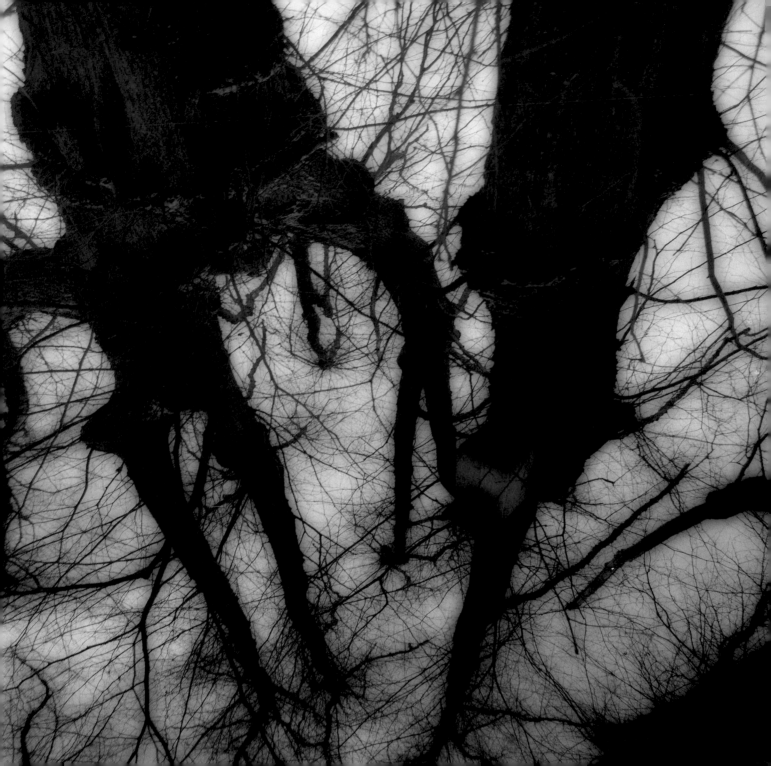

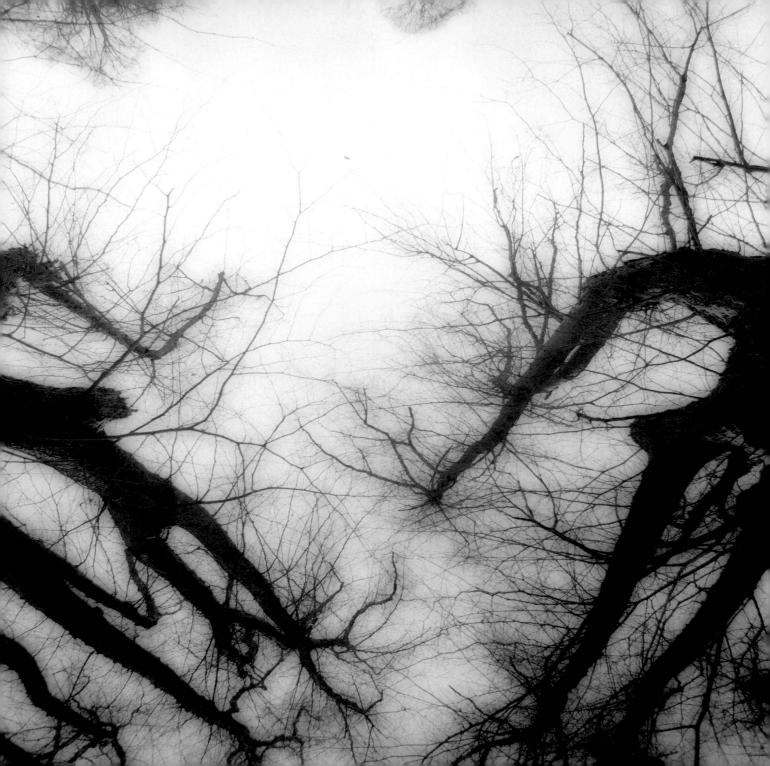

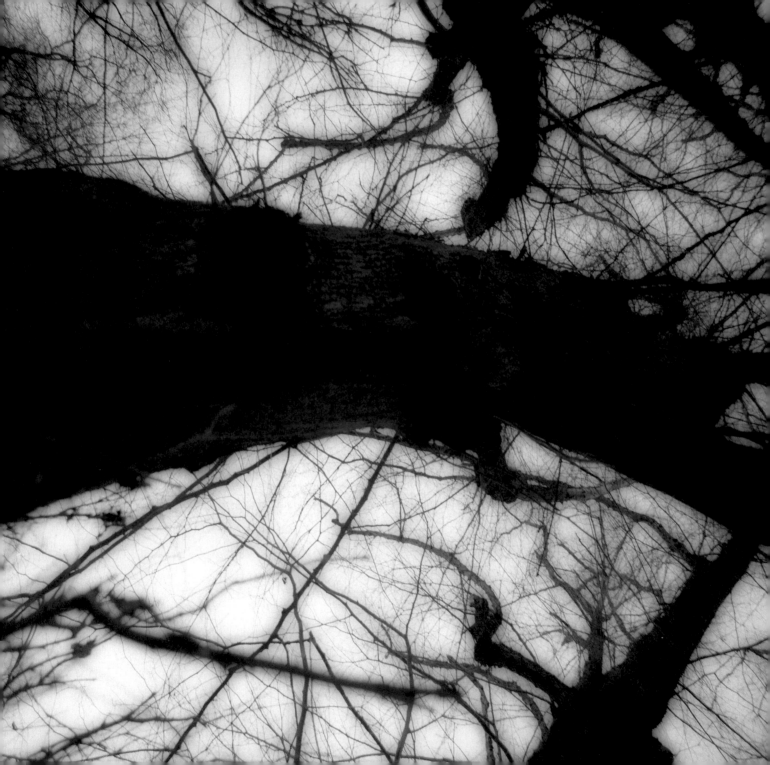

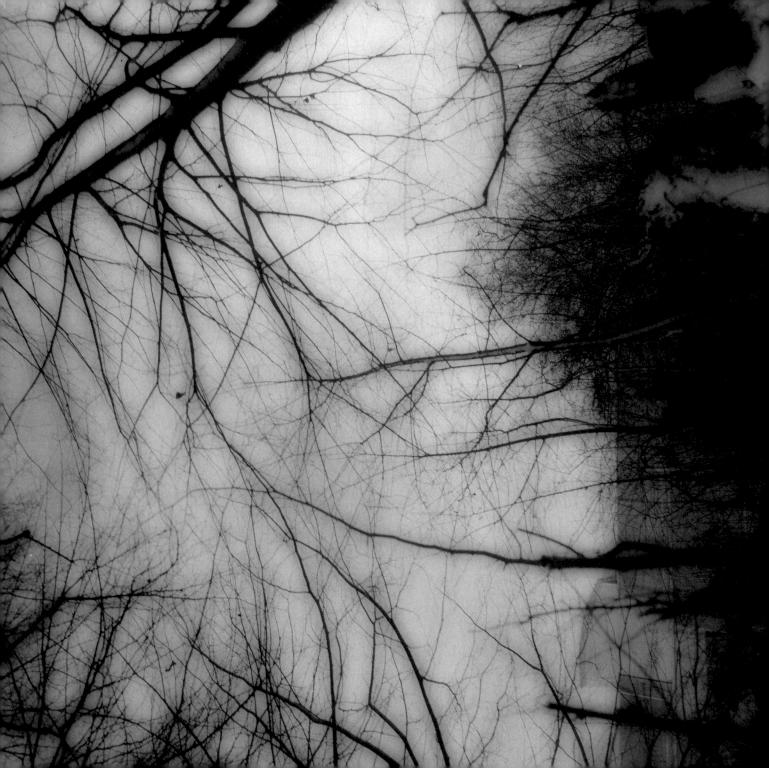

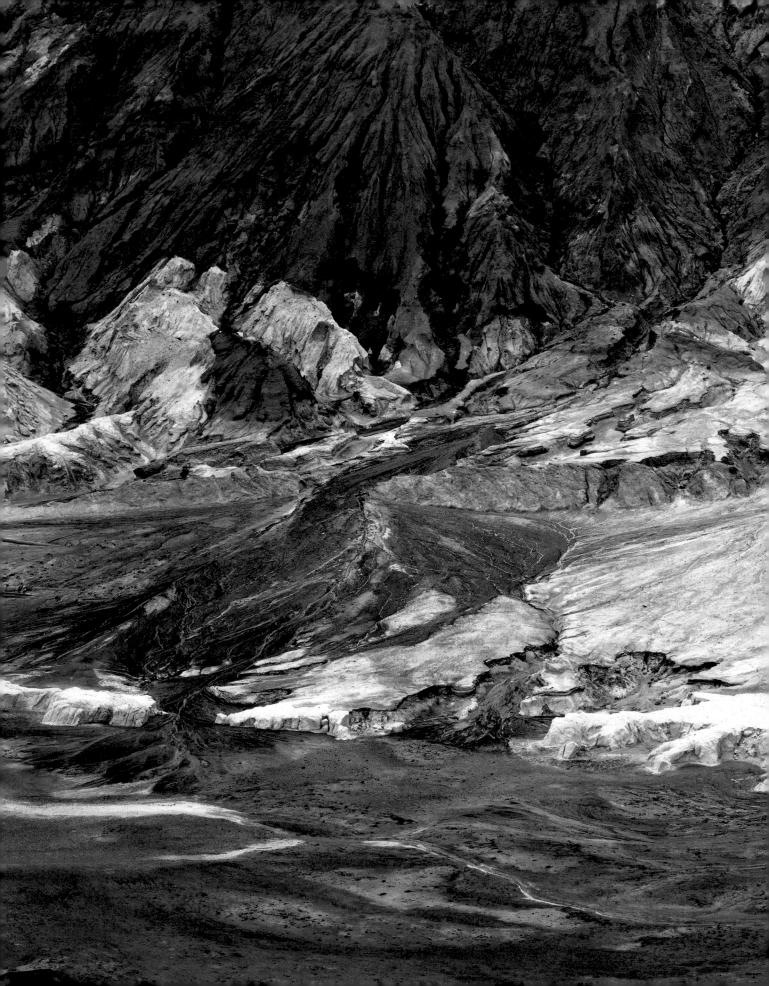

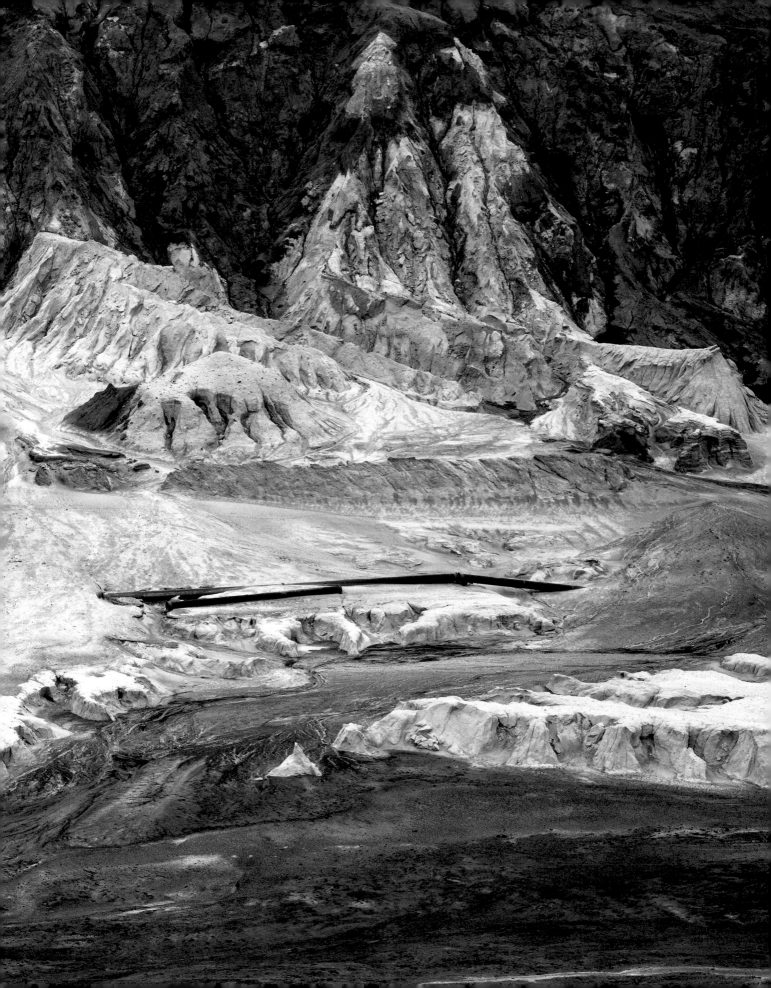

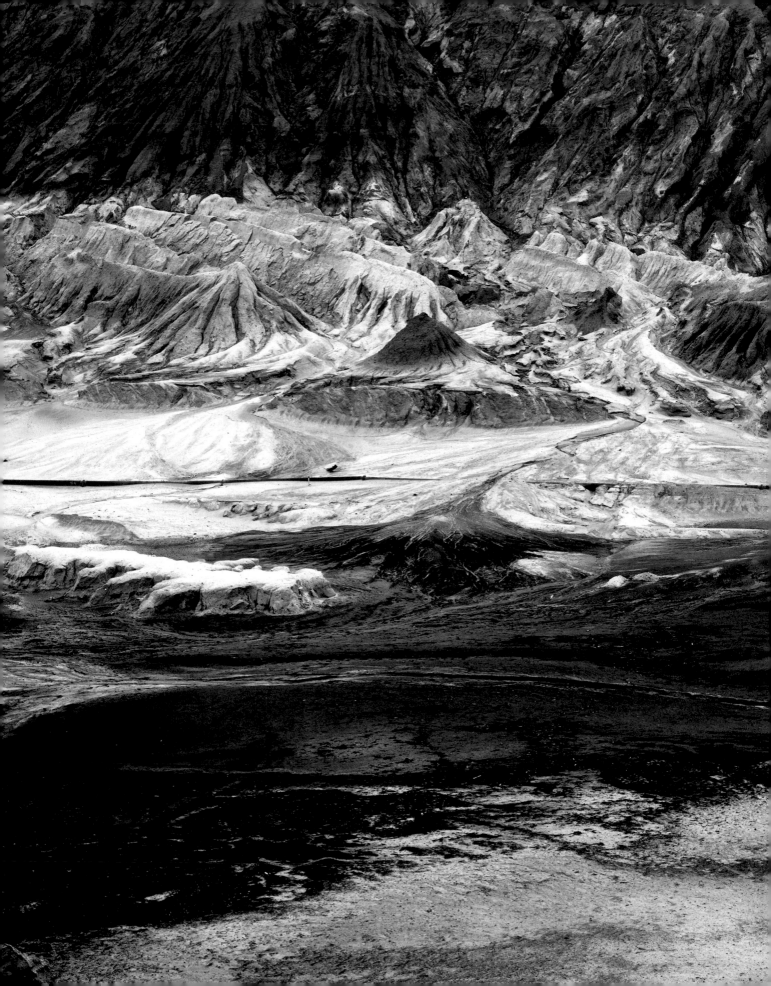

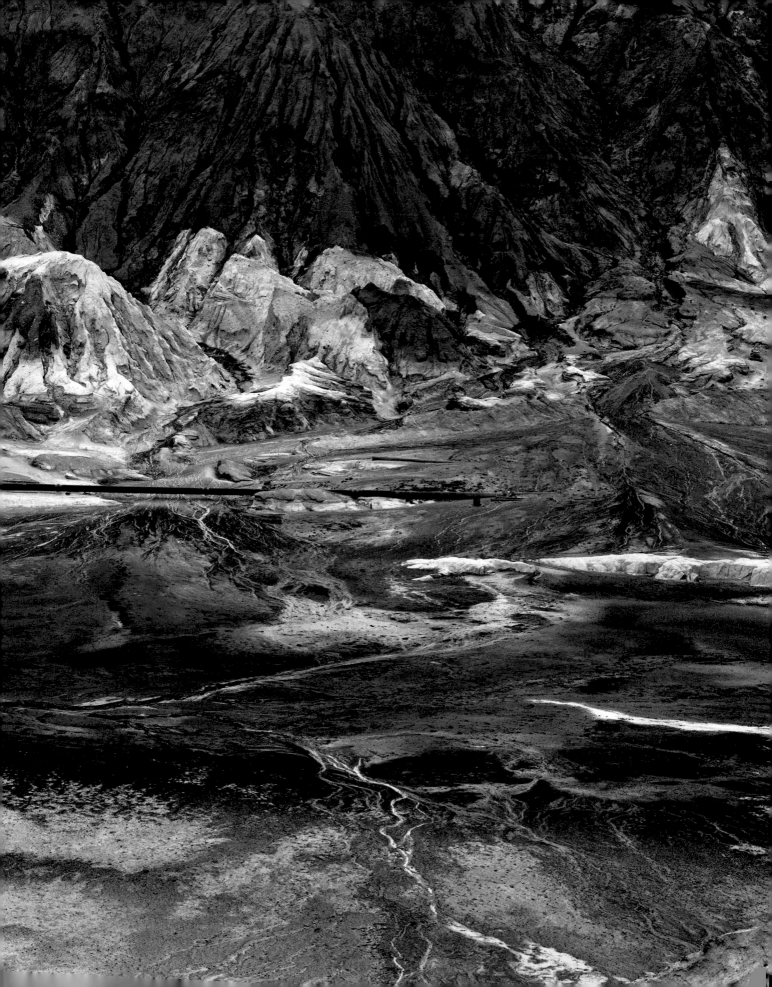

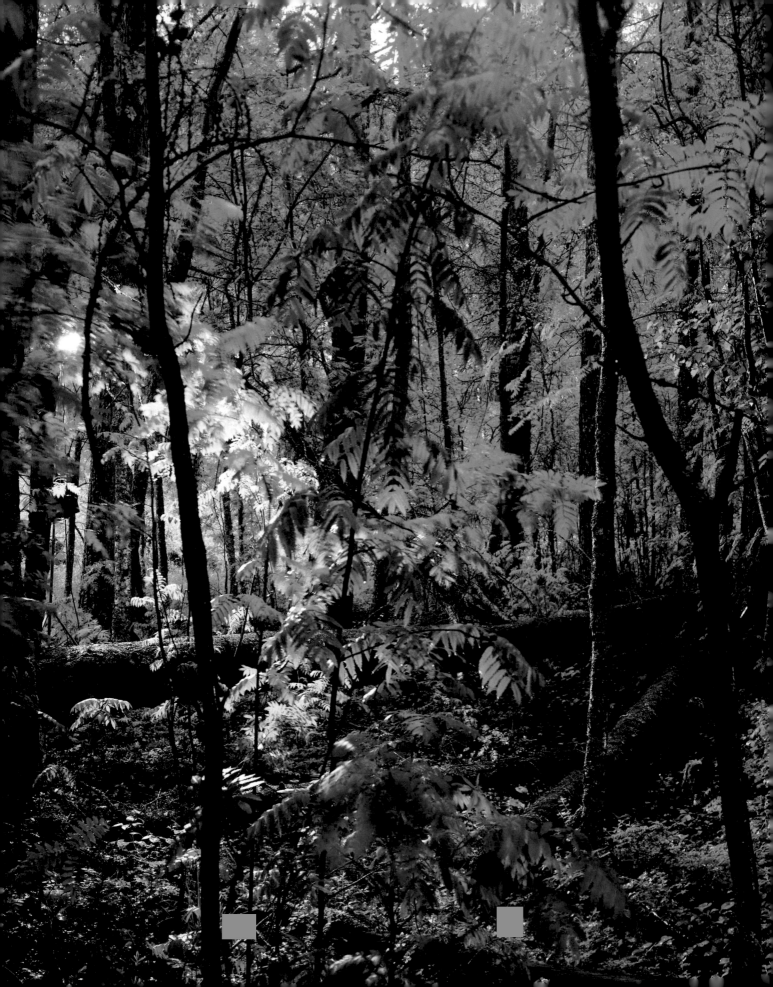

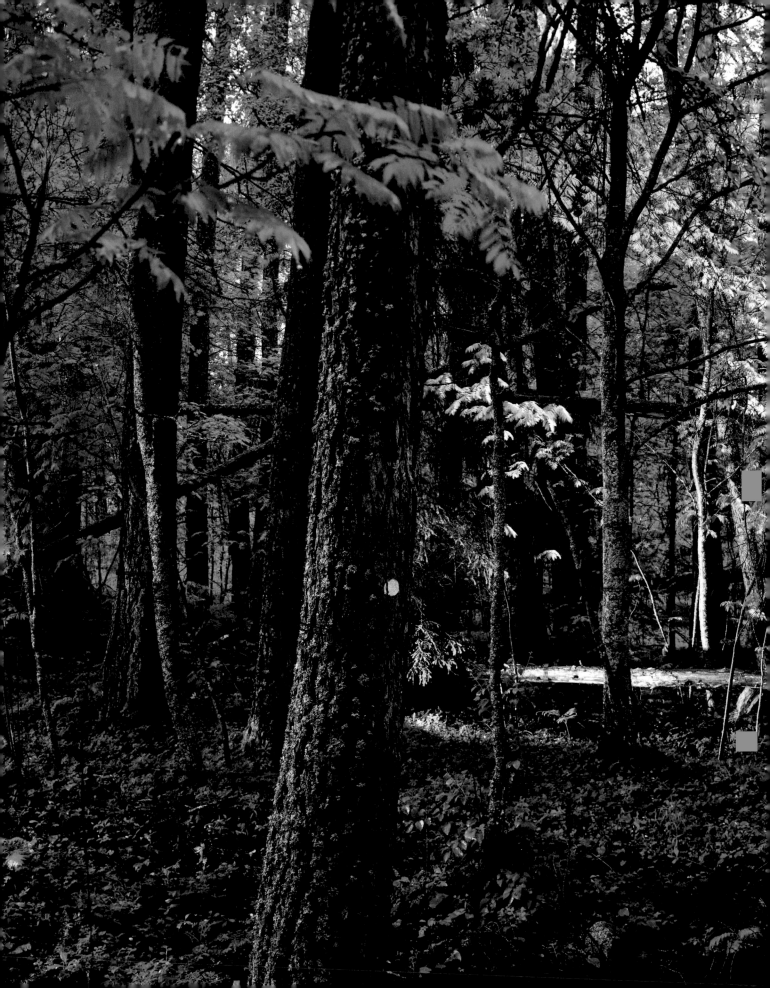

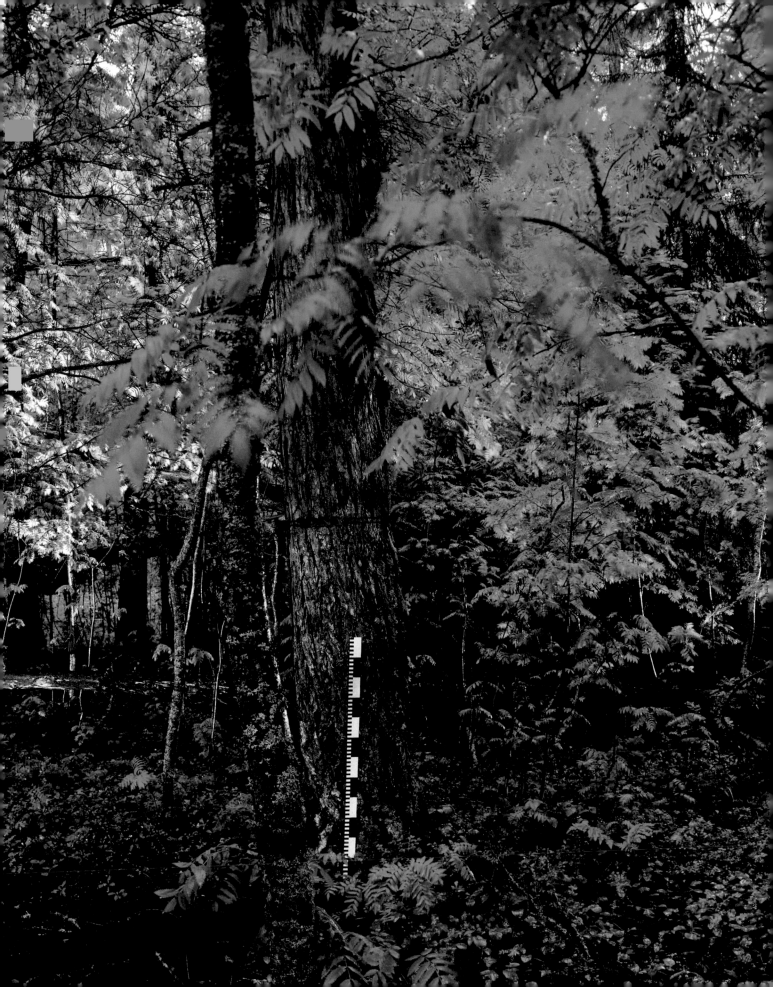

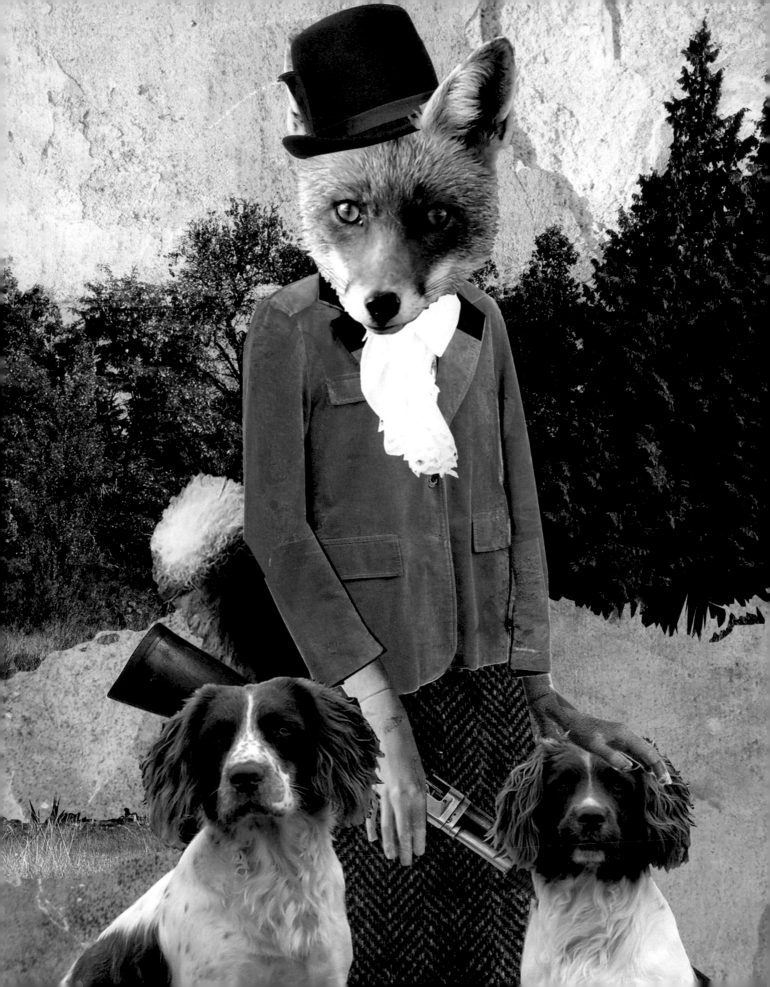

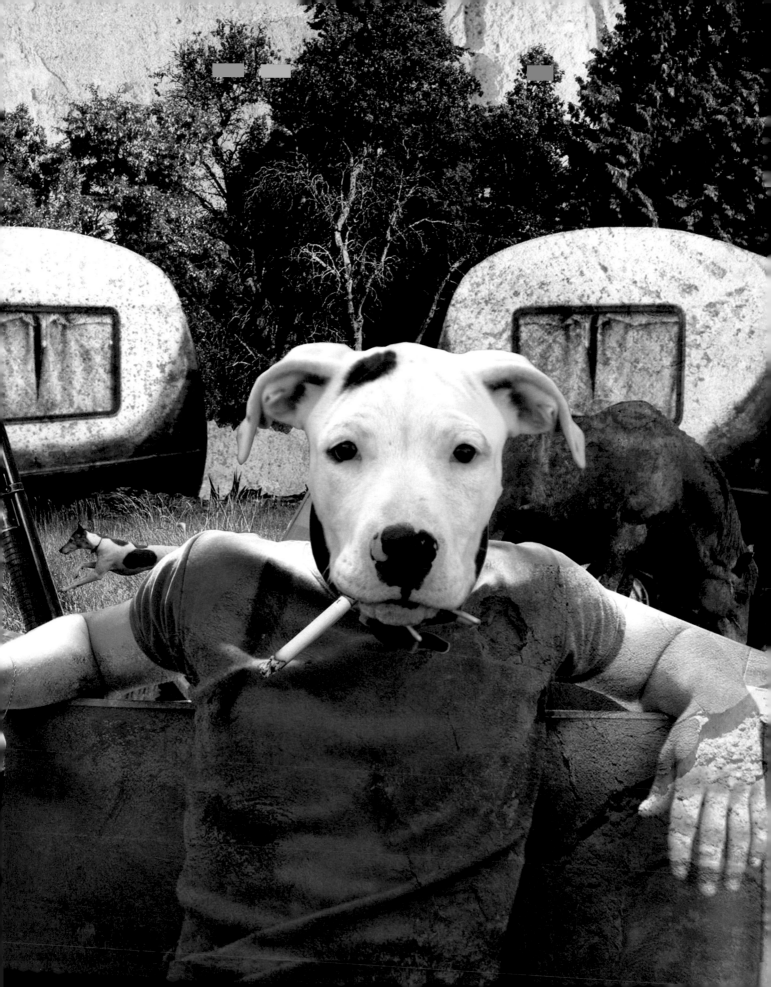

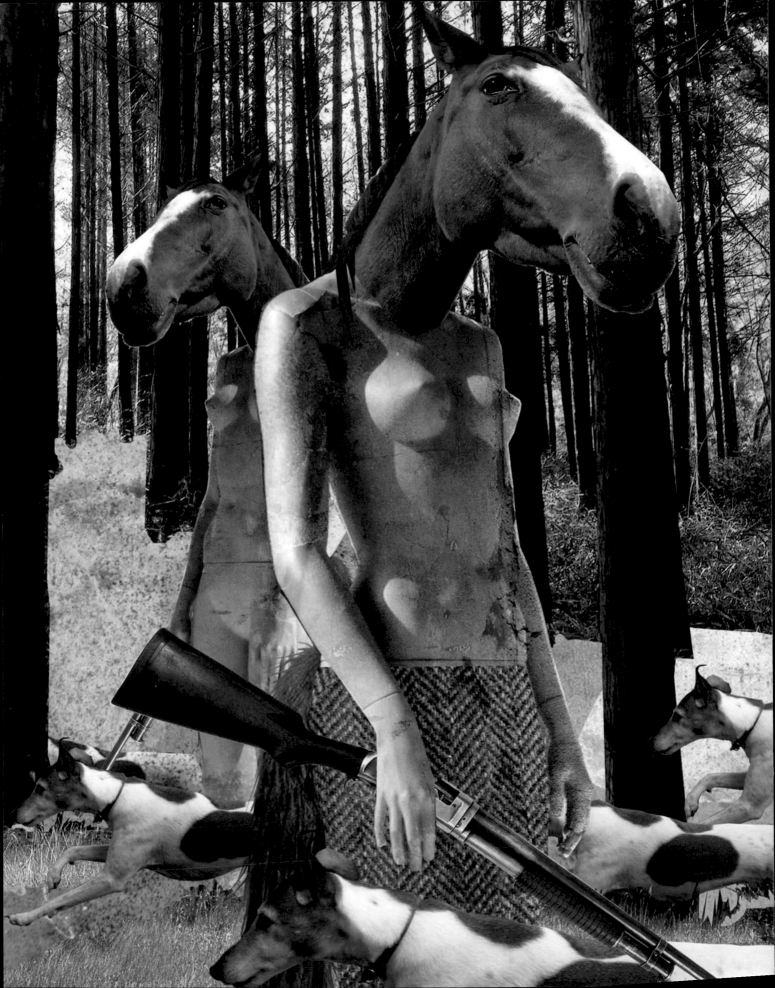

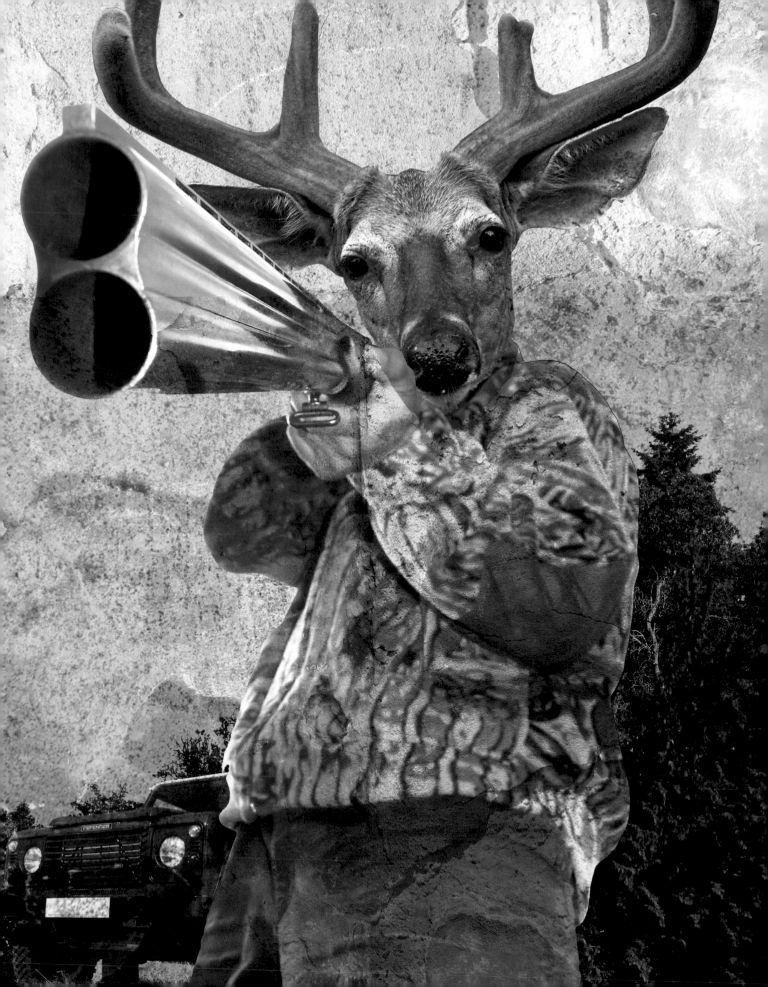

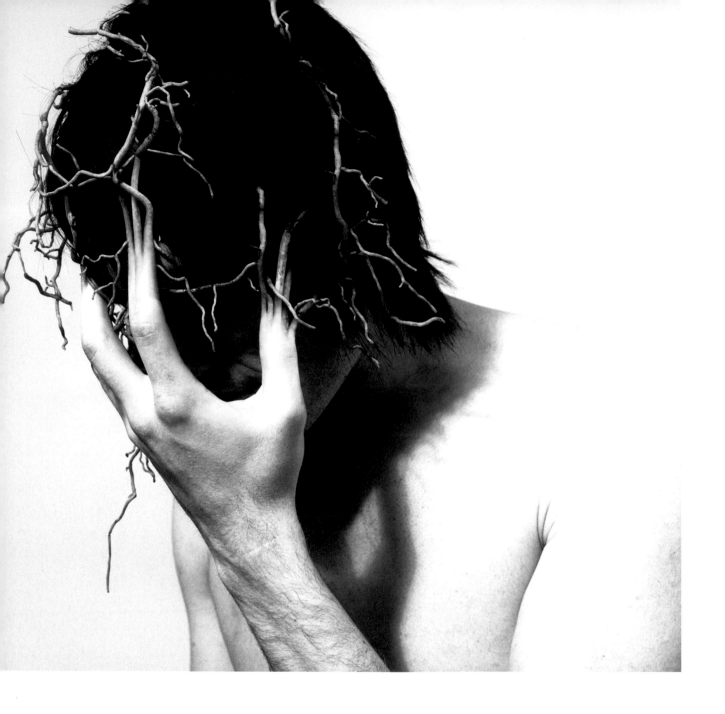

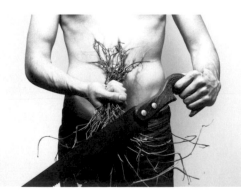

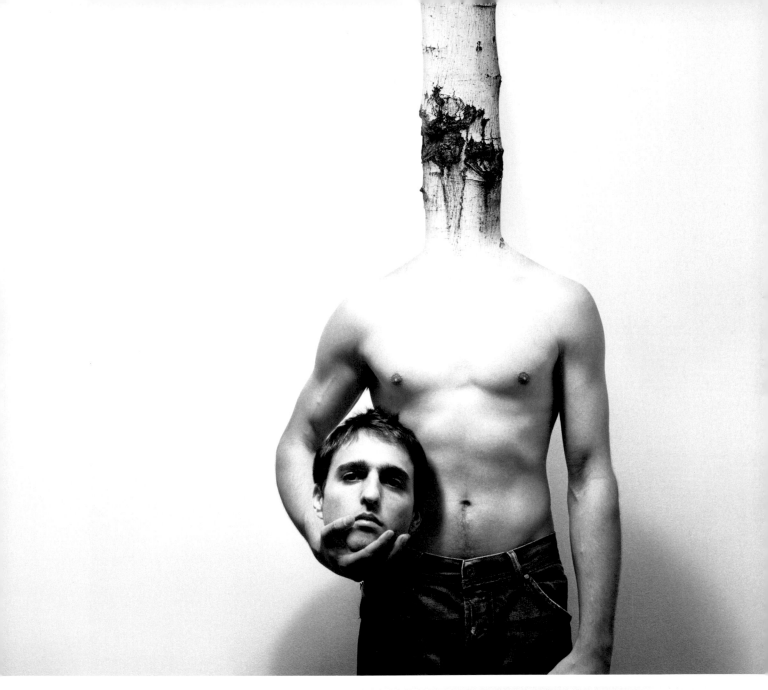

Manipulated January 2006. A BBC Hong Kong news headline: Scientists Announce the Birth of Three Phosphorescent Pigs. Inseminated with jellyfish DNA at the embryo stage, three piglets shine with extraordinary luminosity after dark. The researchers point out that these 'guinea-pigs' are not the first examples of creating fluorescence by means of genetic engineering, but they are the most successful so far.

It is certainly sometimes frightening to read of the achievements of genetic engineering, but we have to admit to smiling sometimes as well. Nature is a vast field for experimentation and conquests, a veritable inspiration. Today we are prey to frenetic functionalism, and Nature is no exception to the rule. Fashion victims, rejoice. Up to now refractory pythons have had to be cut up to make a handbag; but soon it will be possible to breed snakes and crocodiles in the shape of a bag or a pair of court shoes.

The human capacity for endless invention is fascinating. Given full rein, and rejecting the demands of the ecologists, it is leading to a parallel and mutant Nature. Here comes the X-Nature.

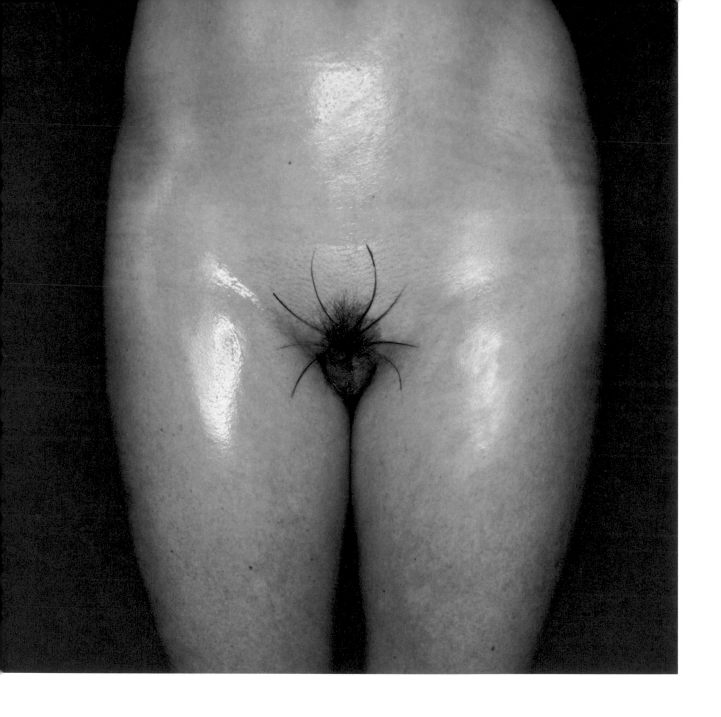

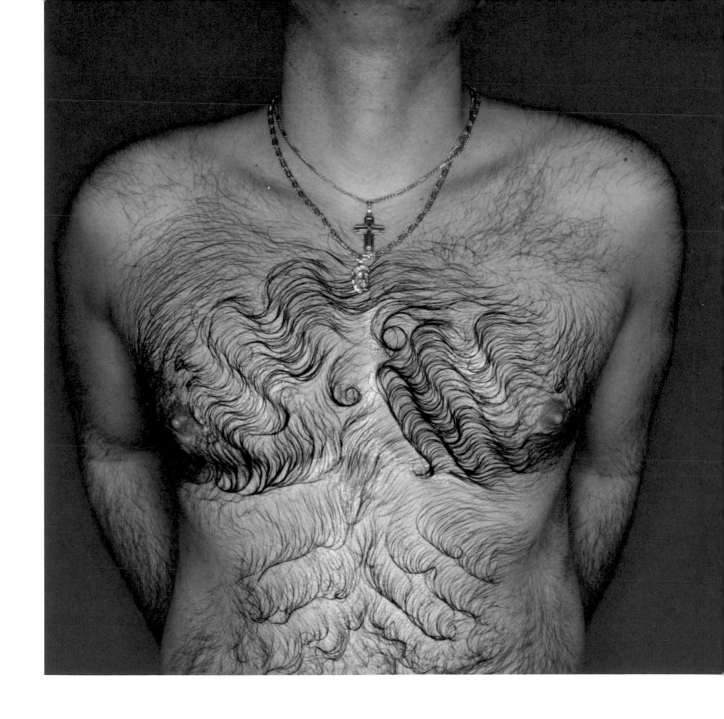

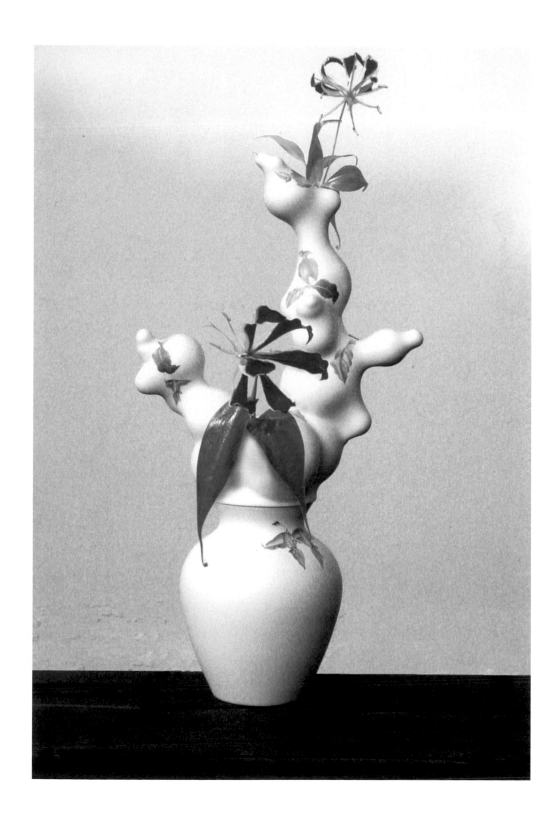

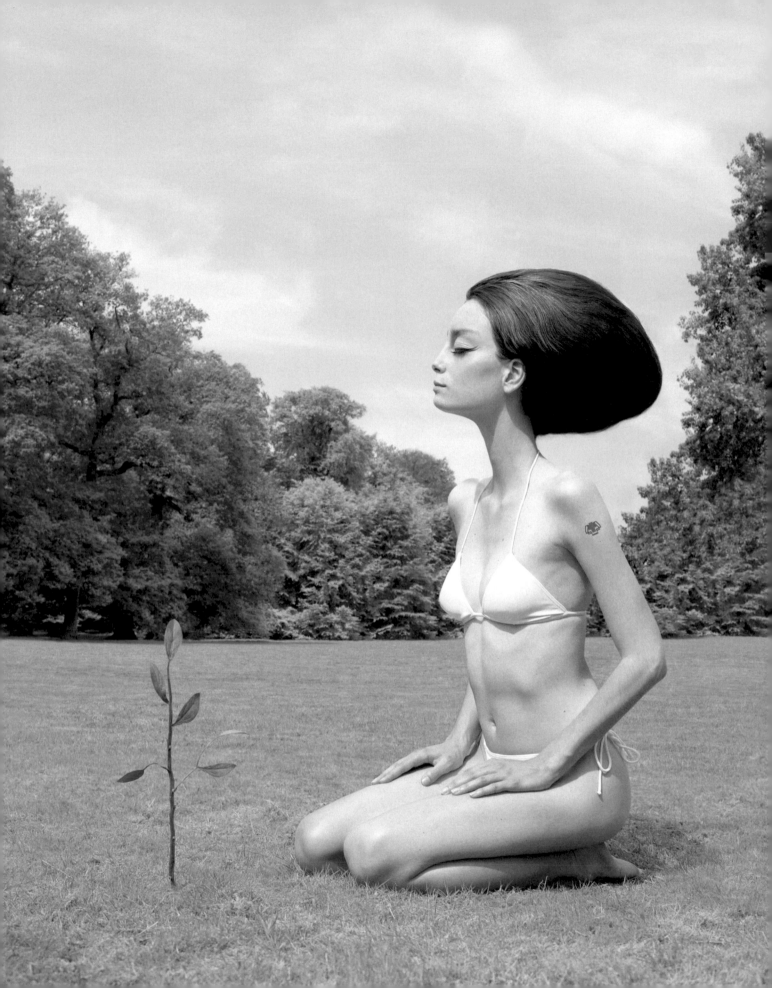

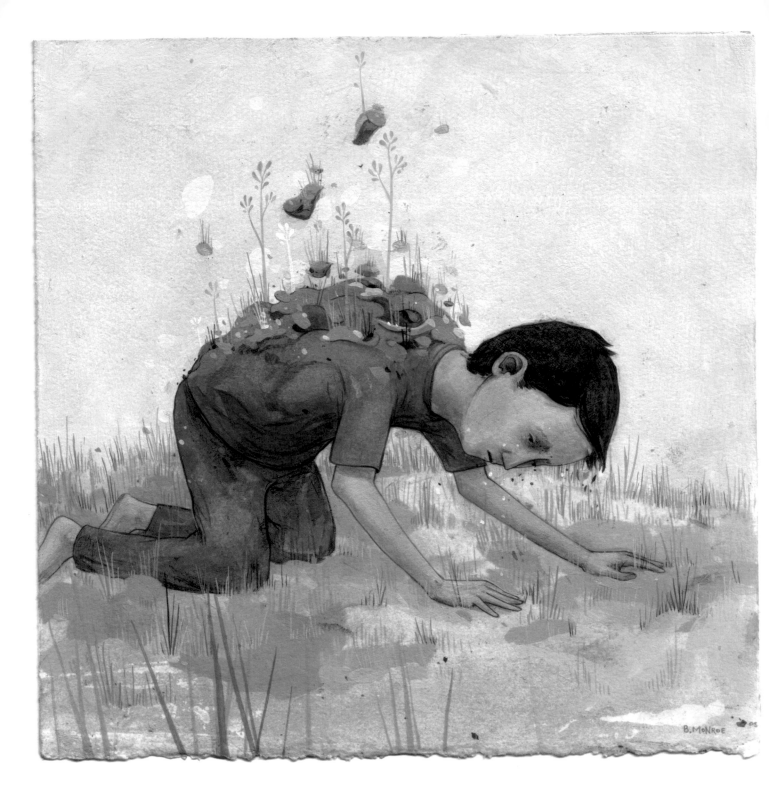

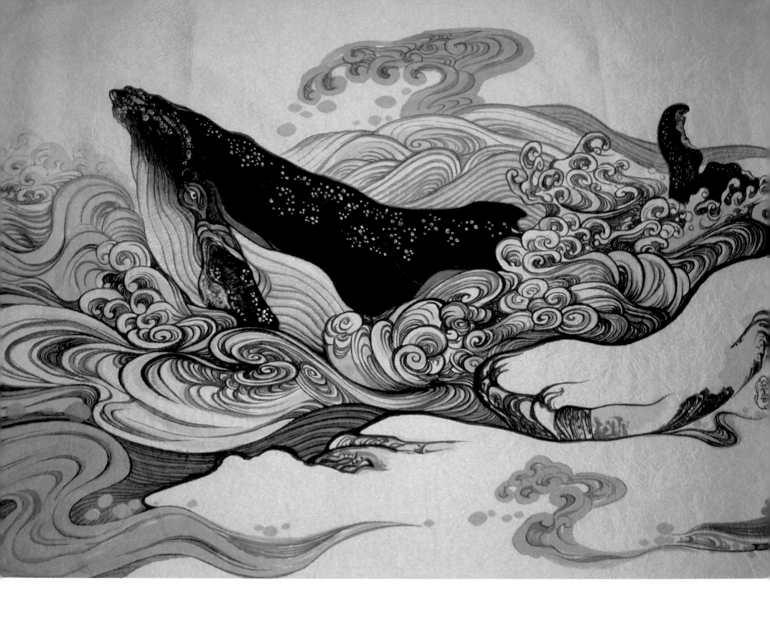

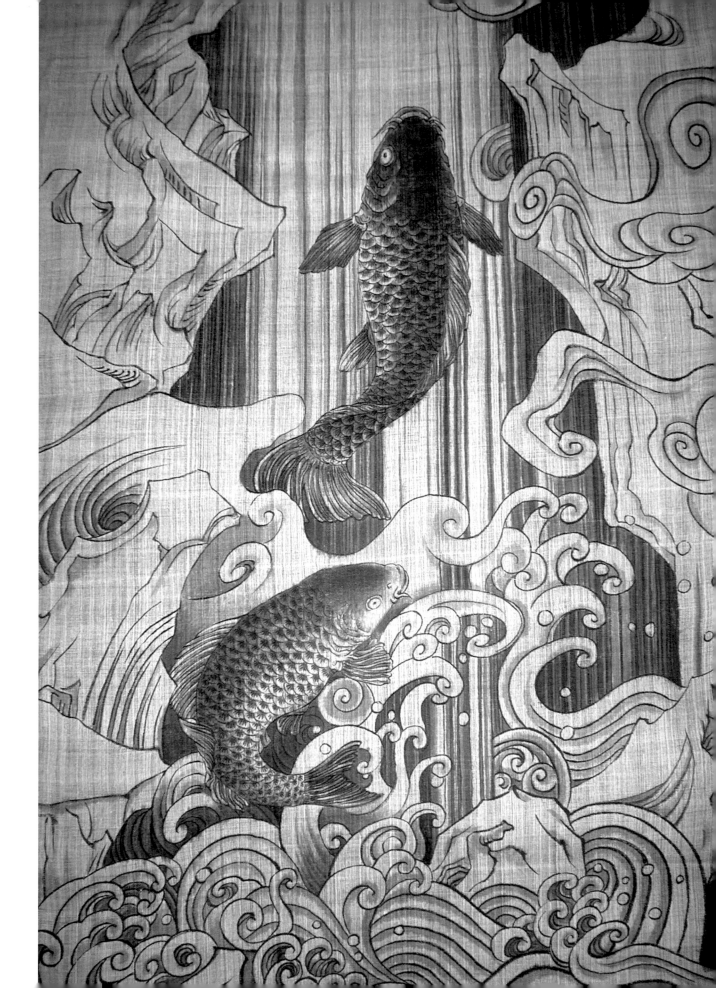

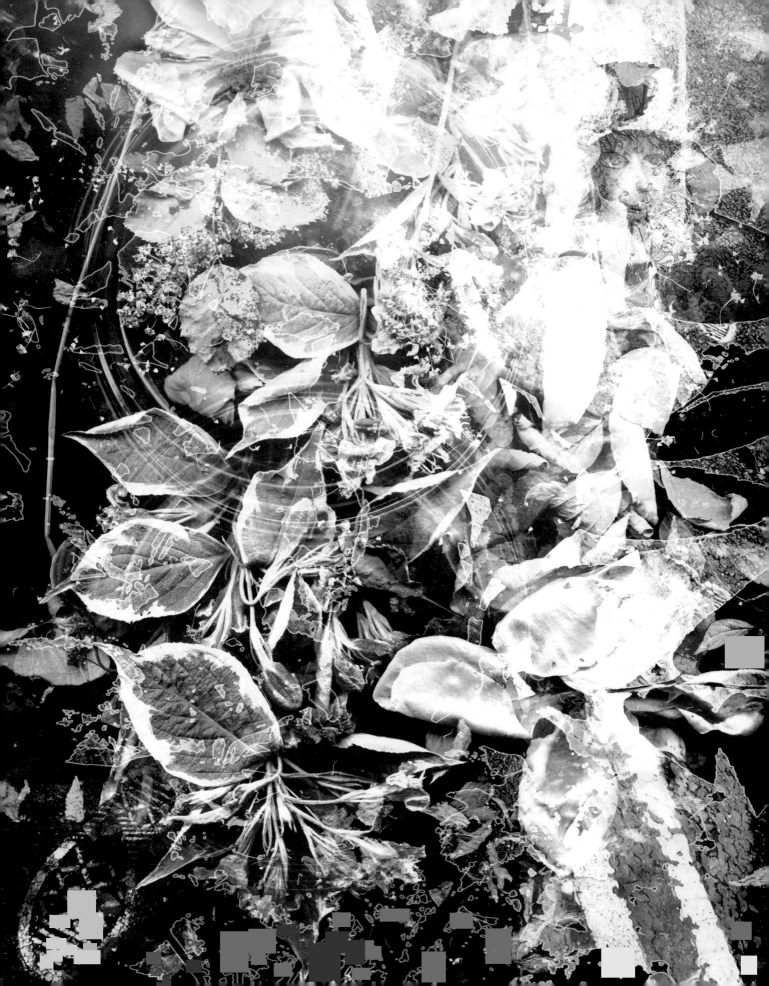

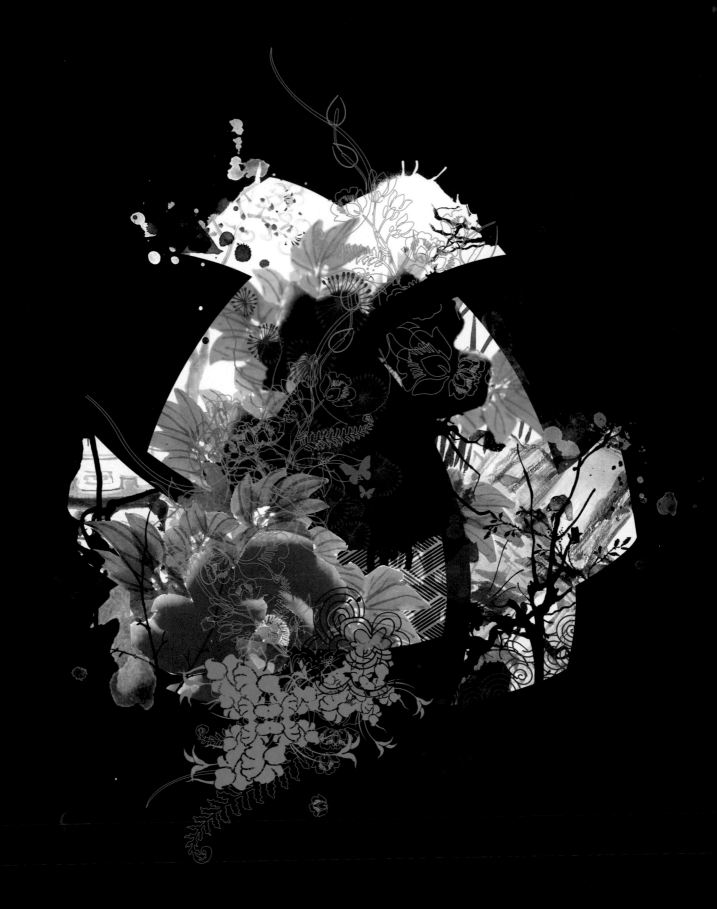

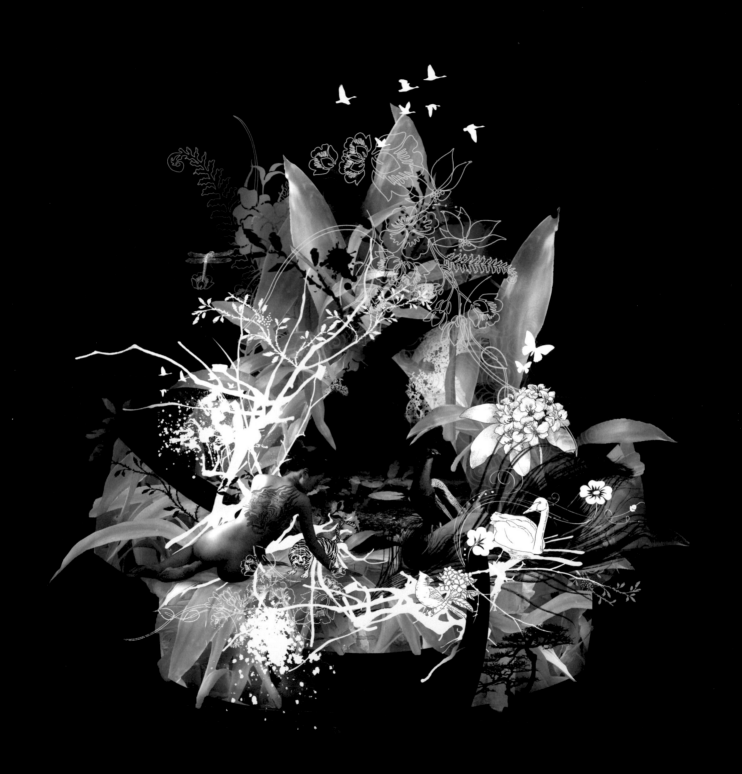

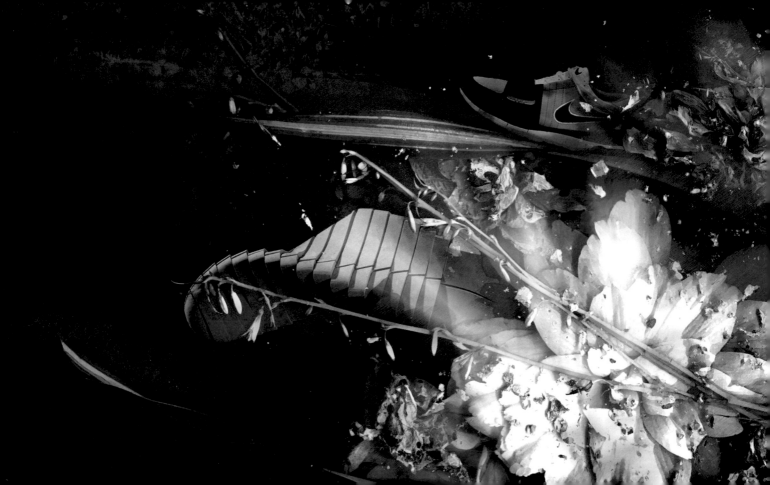

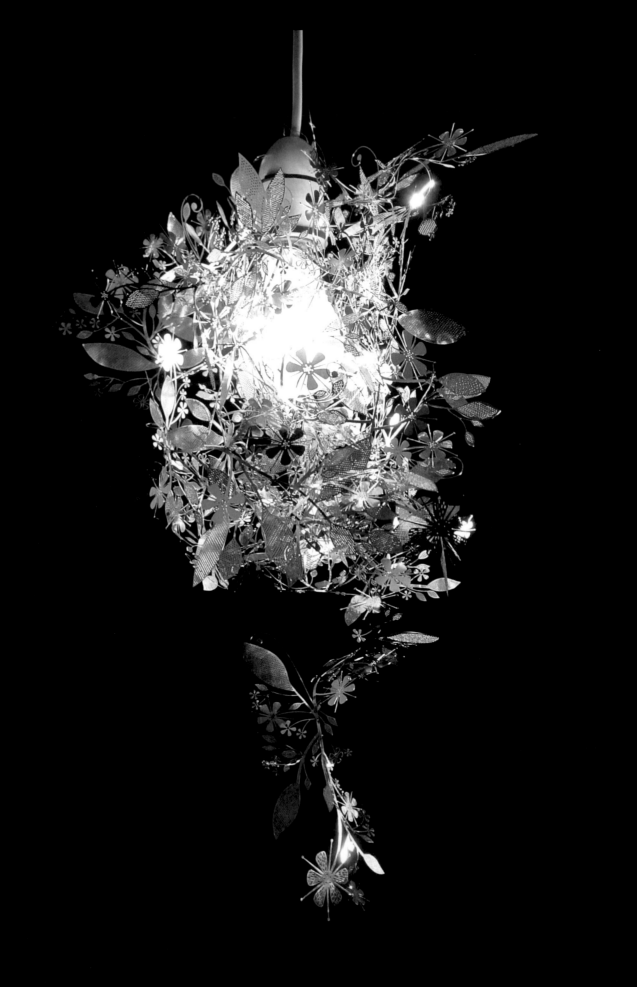

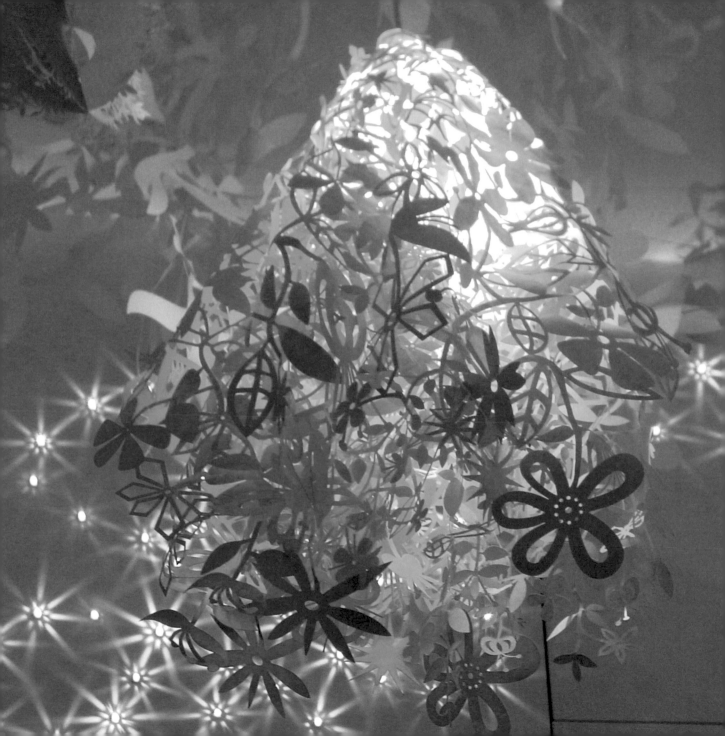

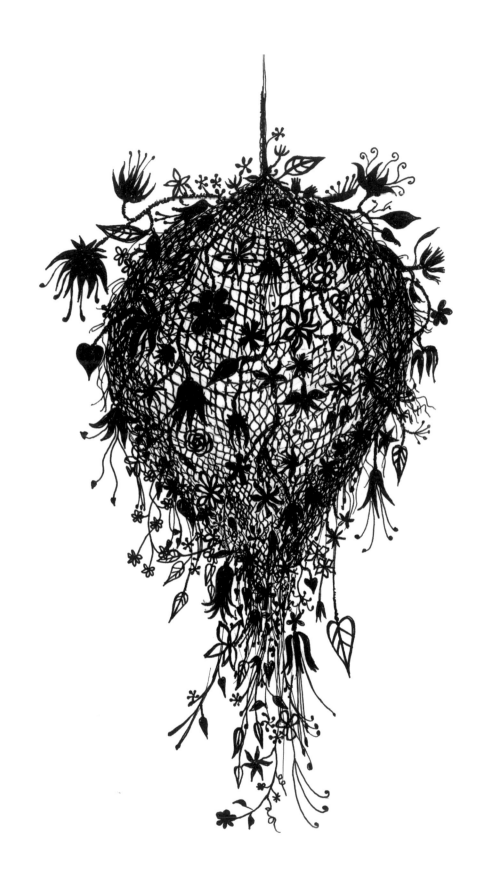

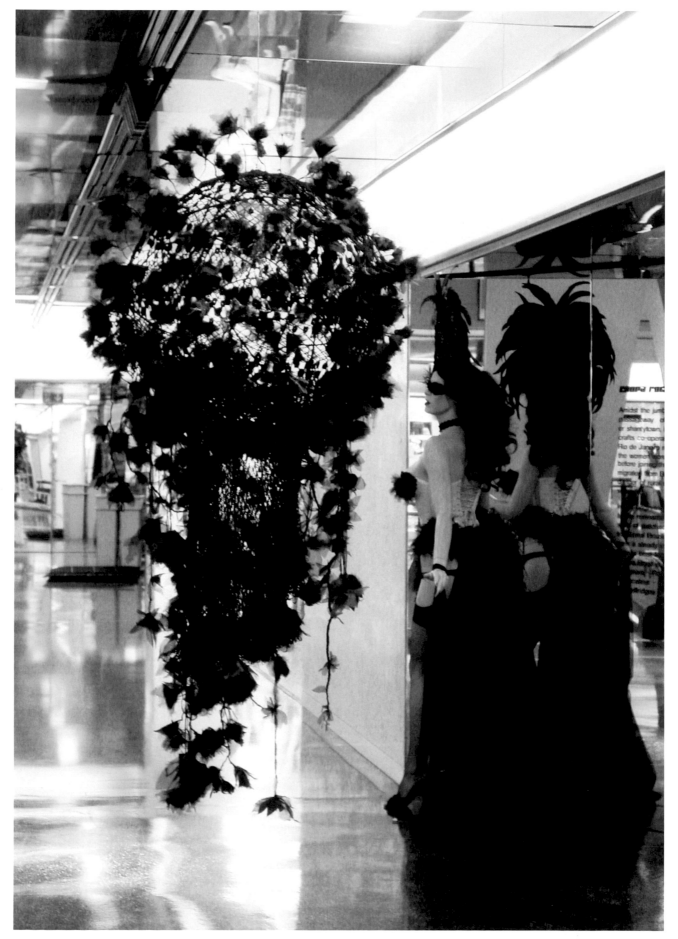

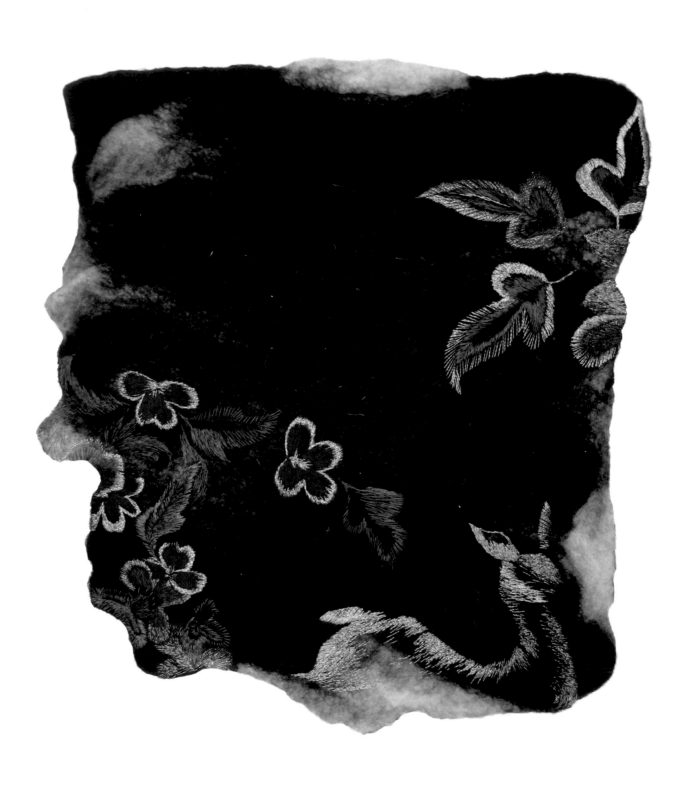

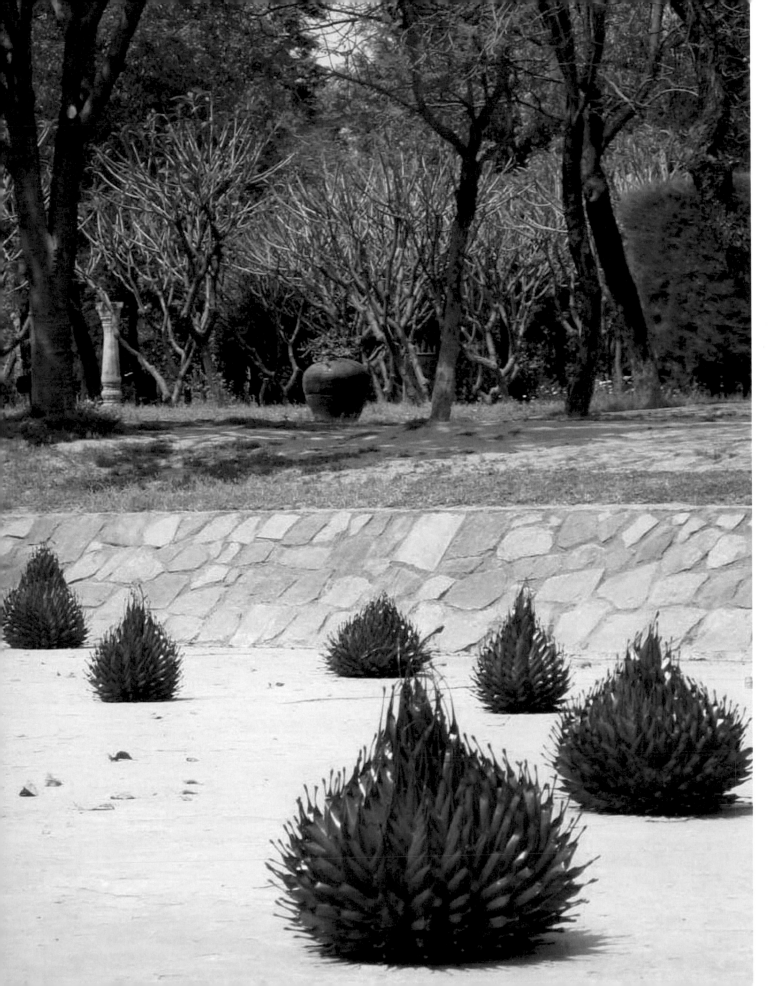

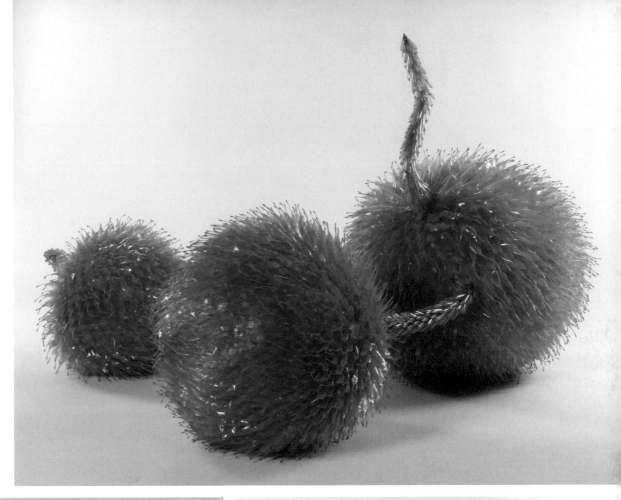

Ornament Sometimes love of nature goes through a process of mental appropriation. Our power to create reproduces a Nature that suits our own tastes and desires. So that it shall match an overall effect, we "arrange it" in good taste. But this can bring about the most inappropriate alterations: surprisingly, the so-called "natural" pose of a hunting trophy reveals an expressive element in the animal kingdom. The enormous skill of the taxidermist who can make a cougar look sad or give a wild boar a friendly smile!

Nature, considered as decoration, makes it possible to include original material in a fabricated environment; but, although the use of natural ornament implies an action that is by definition under control, it brings in an element of the unpredictable. It often develops under its own laws, goes beyond the limits. To use Nature as decoration is to express some fantasy and creativity; and it also lends a gentle touch of chance to an environment dismally stuffed with objects. Contrary to expectation, nature can be synonymous with boldness. In an escape from an exaggeratedly restrained austerity, it subtly undermines the surrounding rationality by giving rein to a little extravagance.

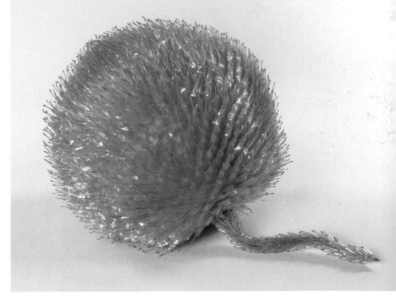

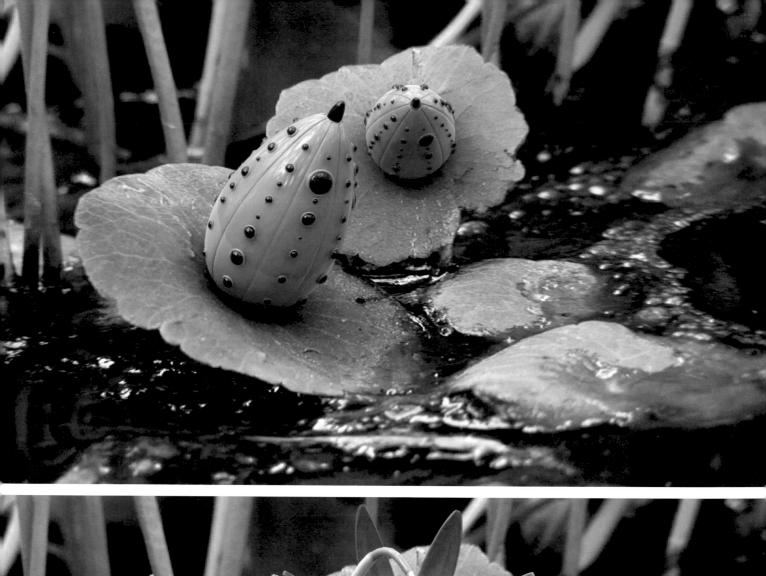

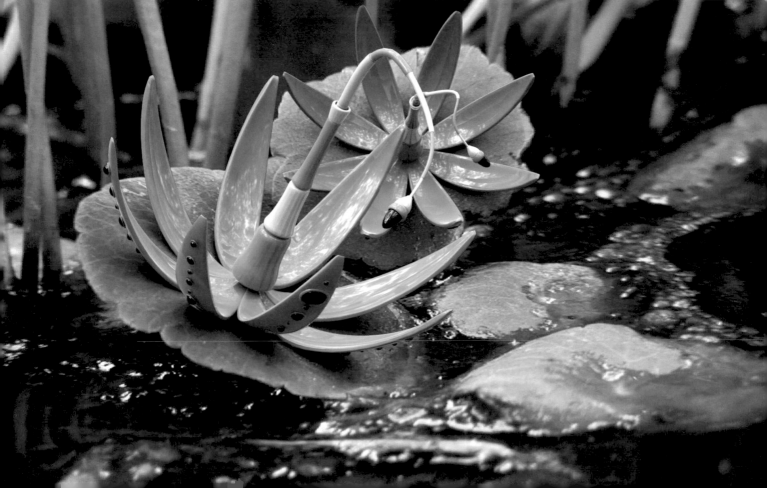

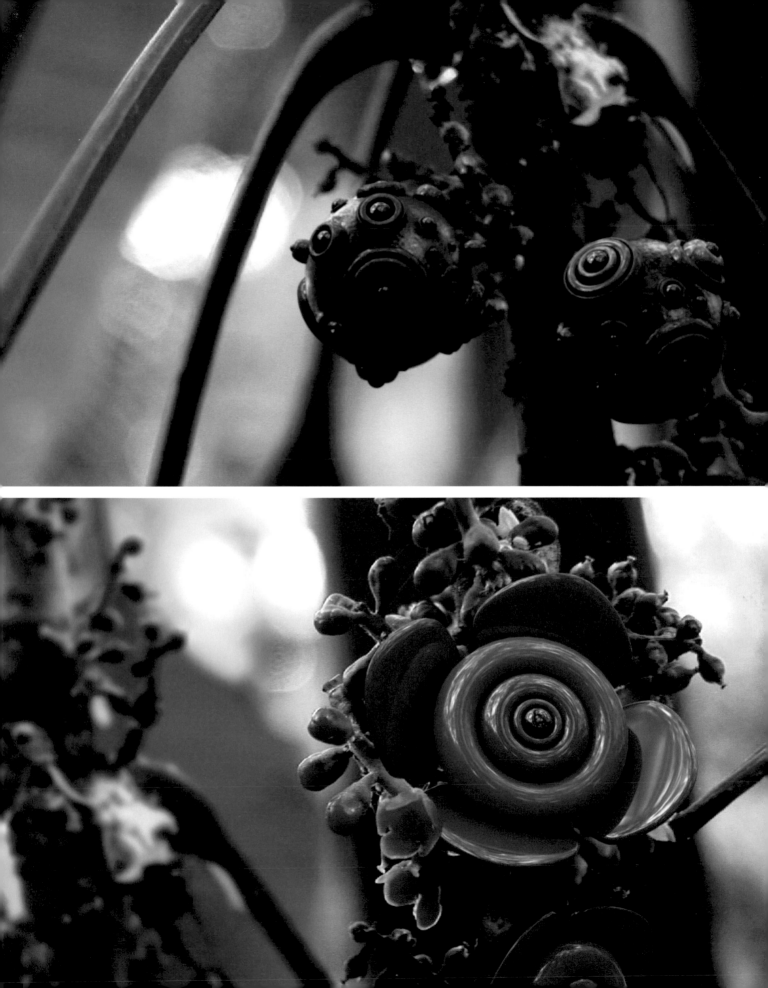

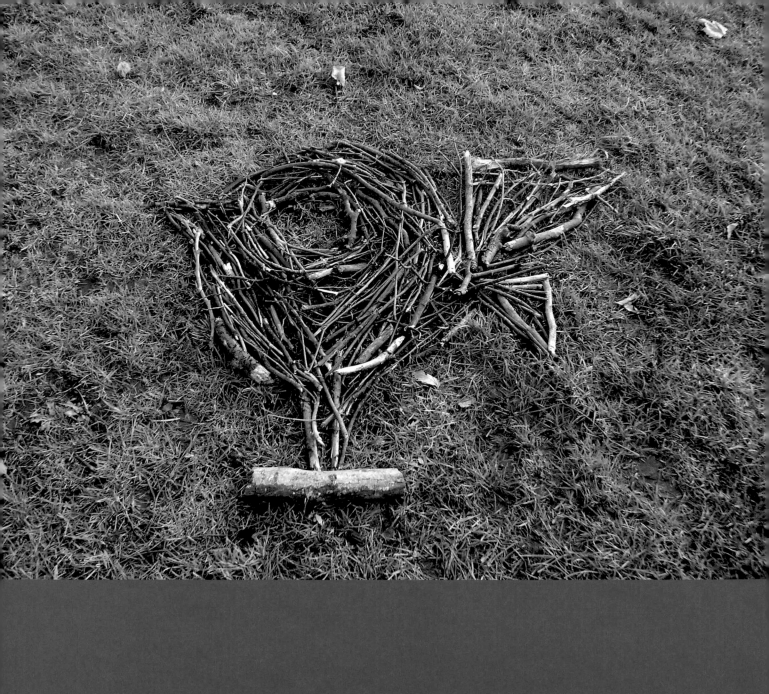

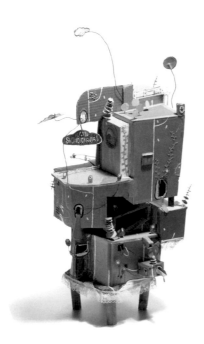

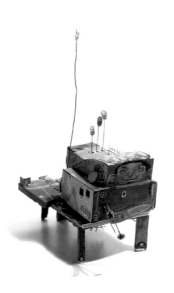

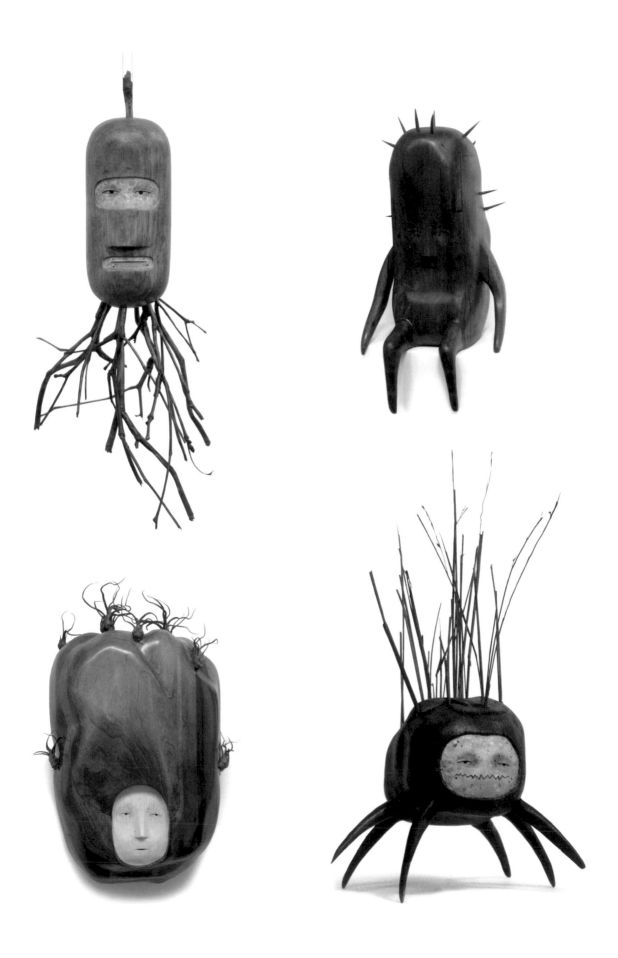

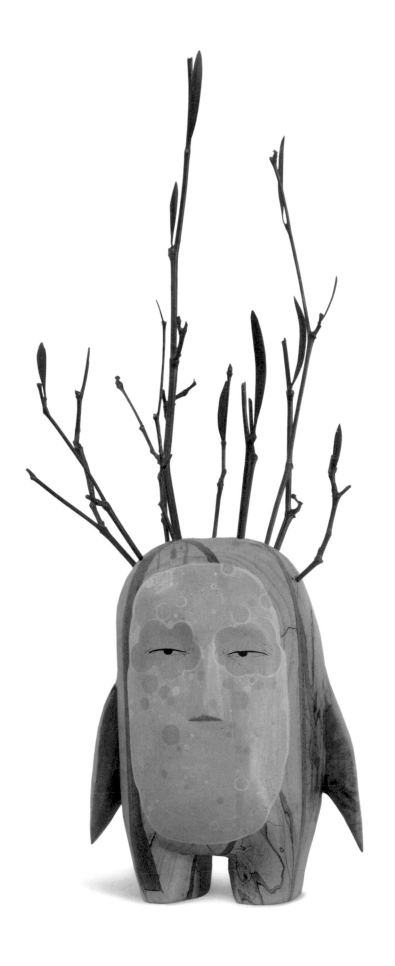

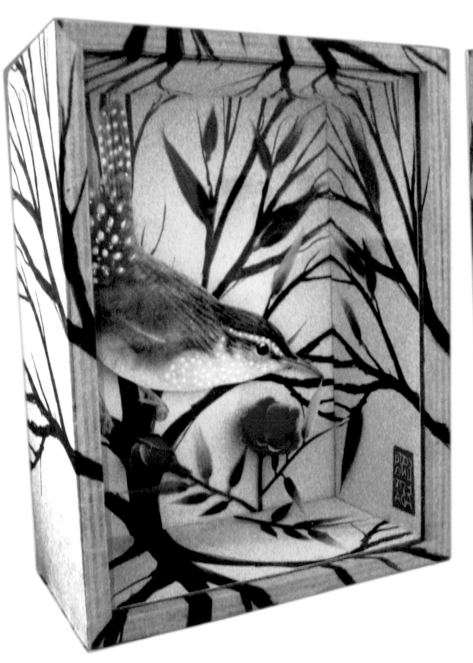

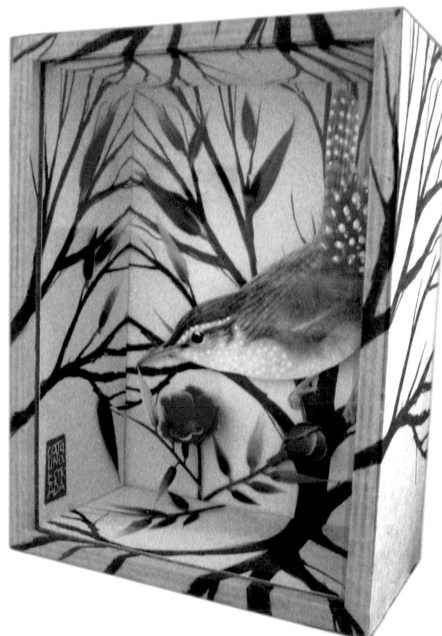

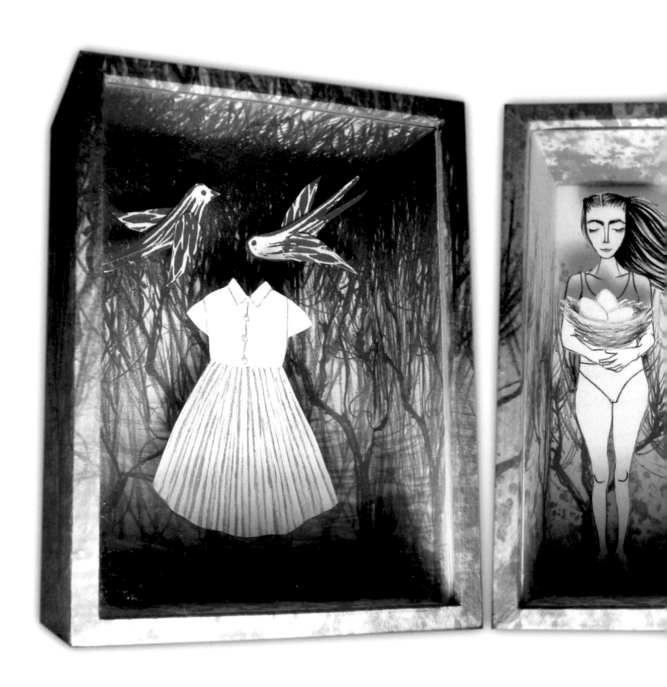

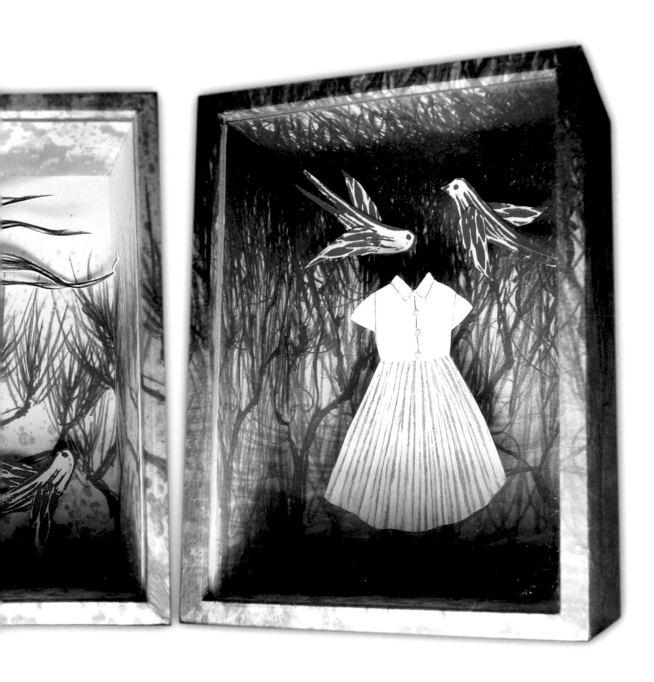

affix
skull
here

Stick the small
plaque on to here

Please note that the
coloured areas overlap
the score lines

cut
score
glue guides

antlers here!

10x

cut
score
glue guides

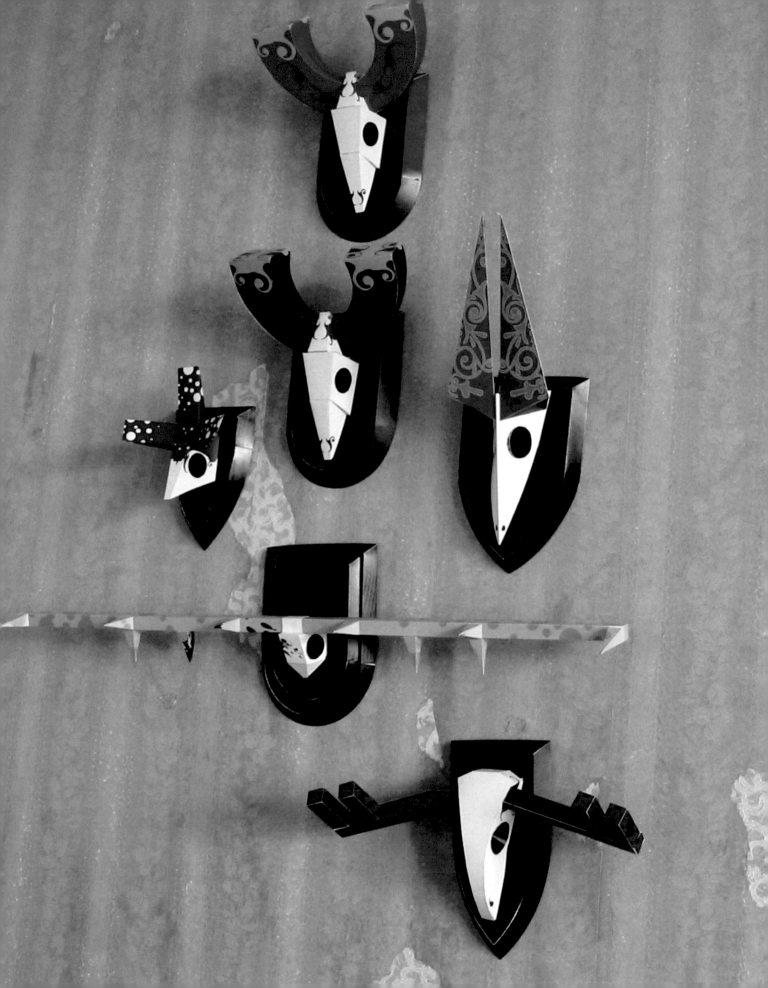

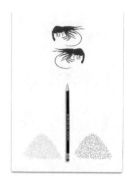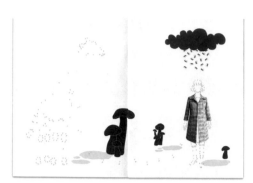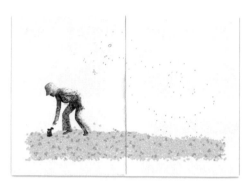

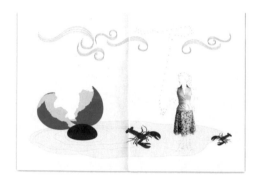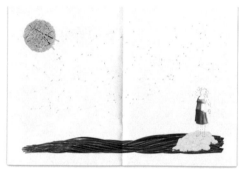

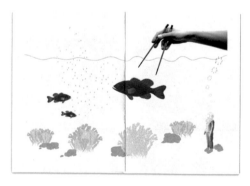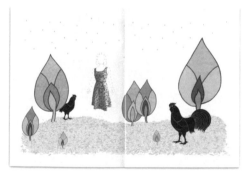

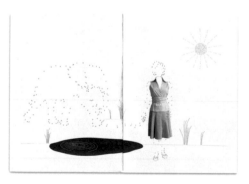

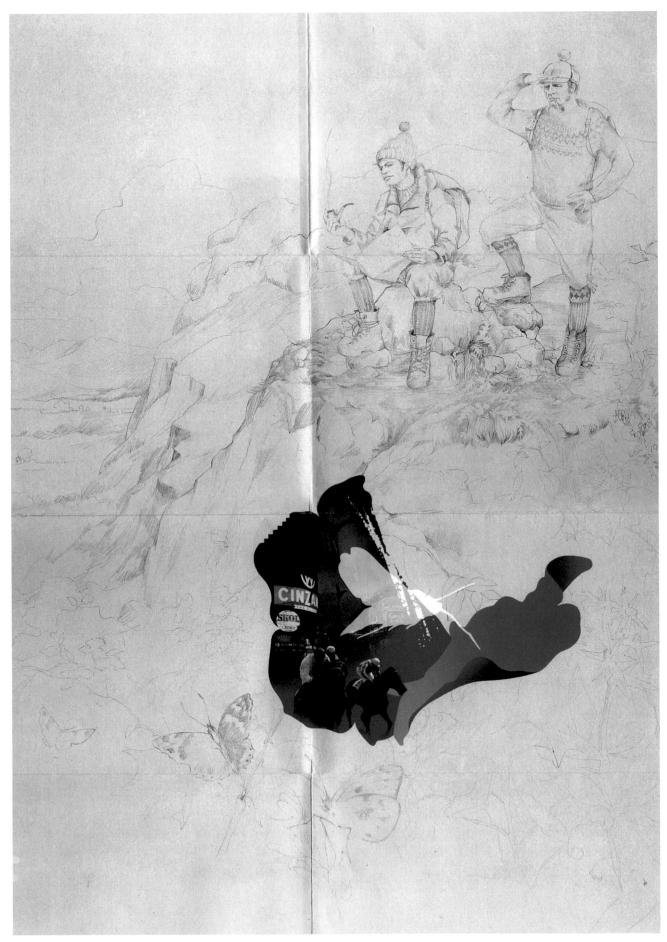

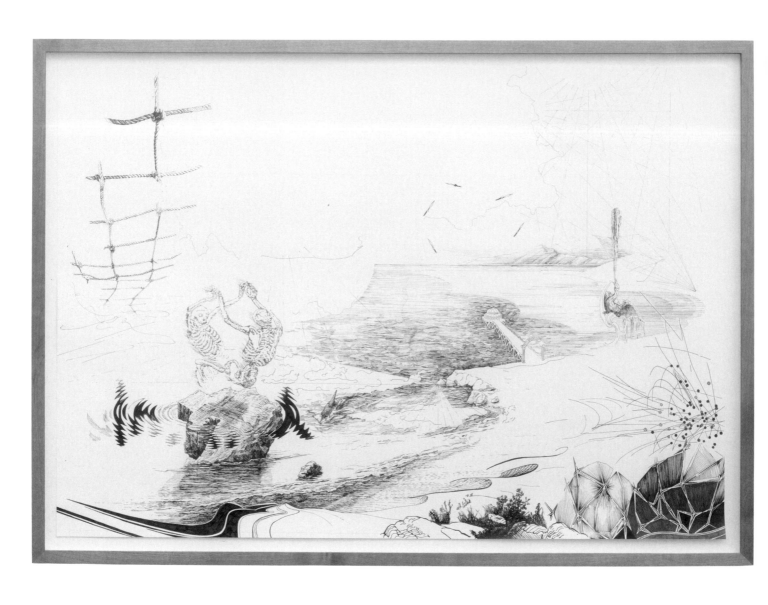

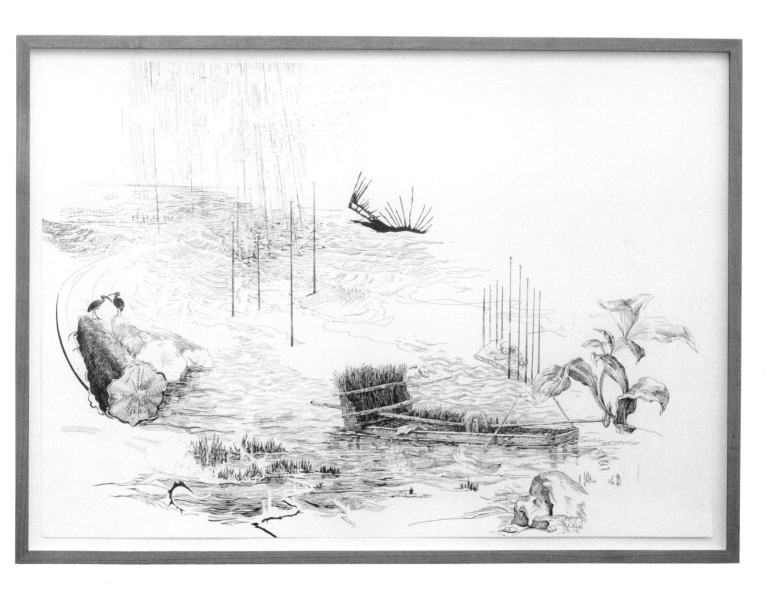

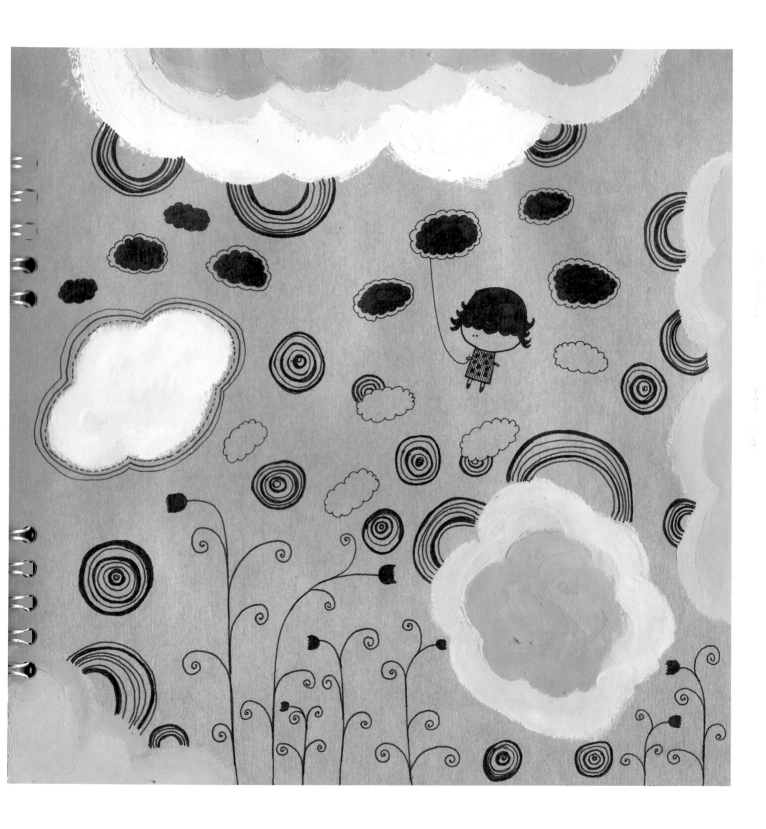

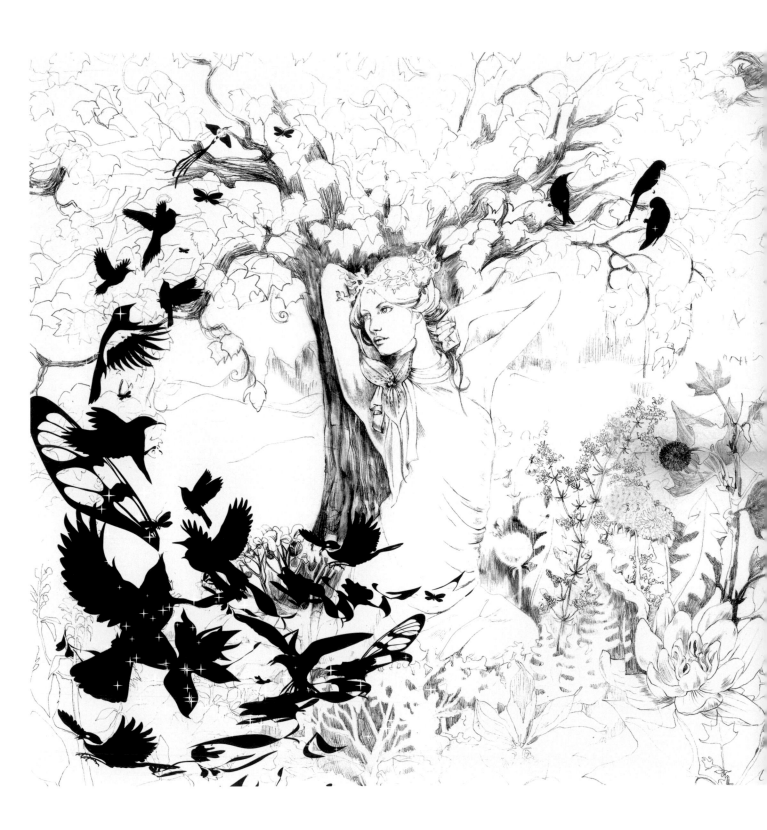

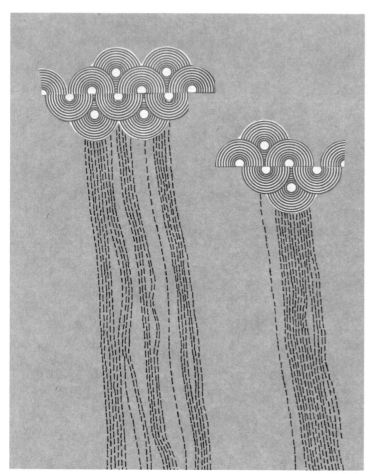

插圖：黃美玲

木木

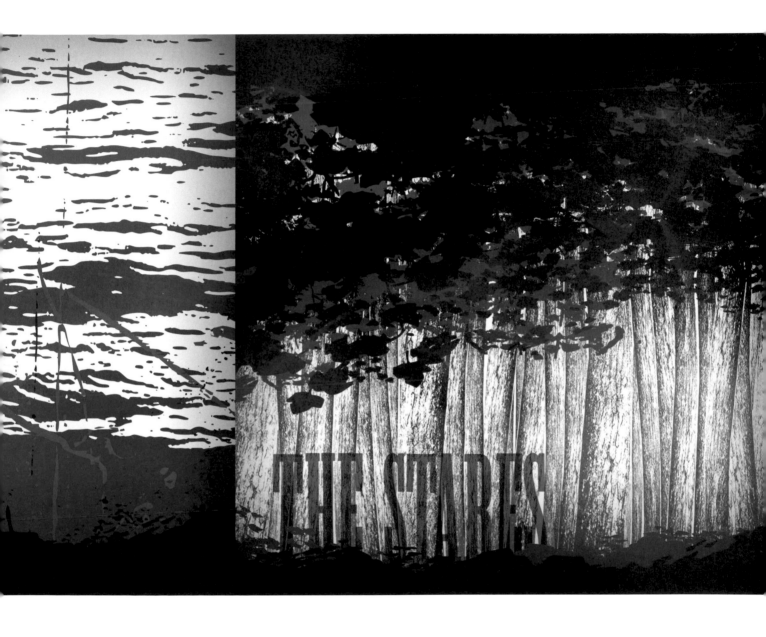

THE STARES

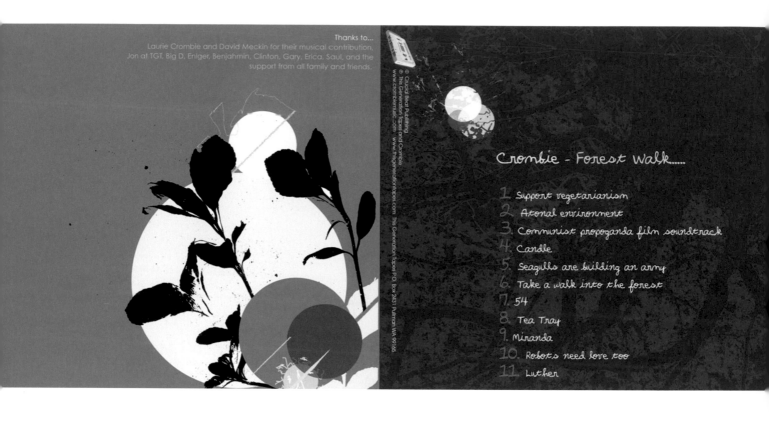

Thanks to...
Laurie Crombie and David Meckin for their musical contribution,
Jon at TGT, Big D, Enlger, Benjahmin, Clinton, Gary, Erica, Saul, and the
support from all family and friends.

© Crucial Beat Publishing
© www.tcrombiemusic.com Tapes and Crombie
The Generation Tapes P.O. Box 2431 Pullman WA 99166
www.thegenerationtapes.com

Crombie - Forest Walk......

1. Support vegetarianism
2. Atonal environment
3. Communist propoganda film soundtrack
4. Candle
5. Seagulls are building an army
6. Take a walk into the forest
7. 54
8. Tea Tray
9. Miranda
10. Robots need love too
11. Luther

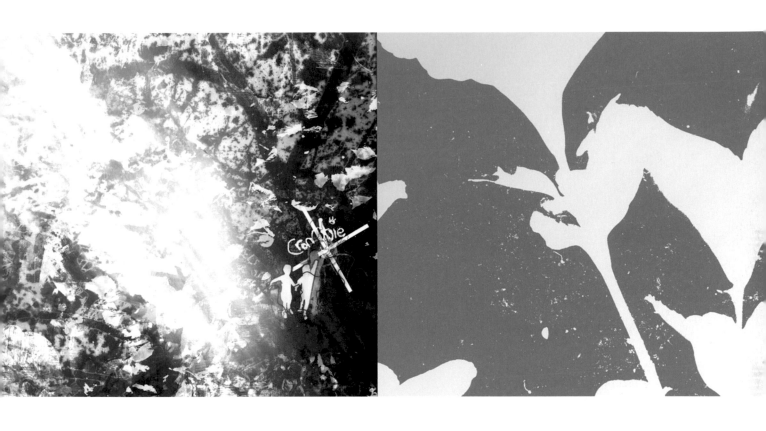

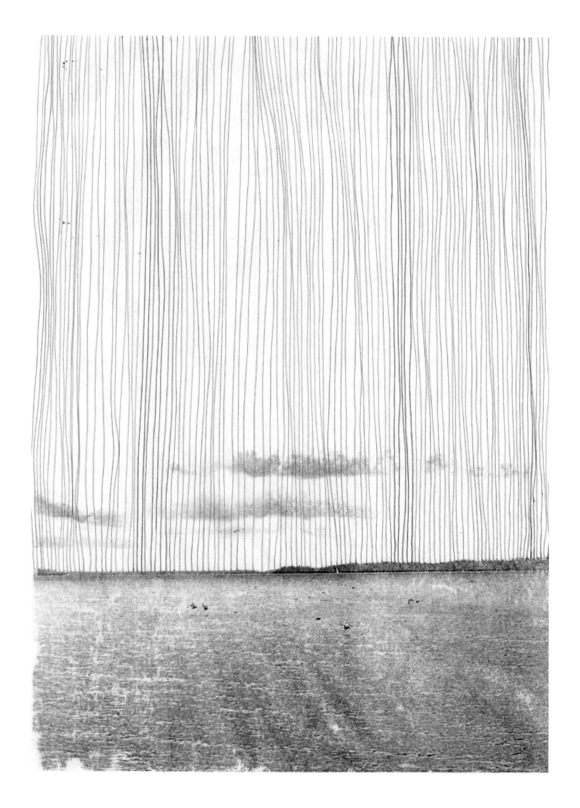

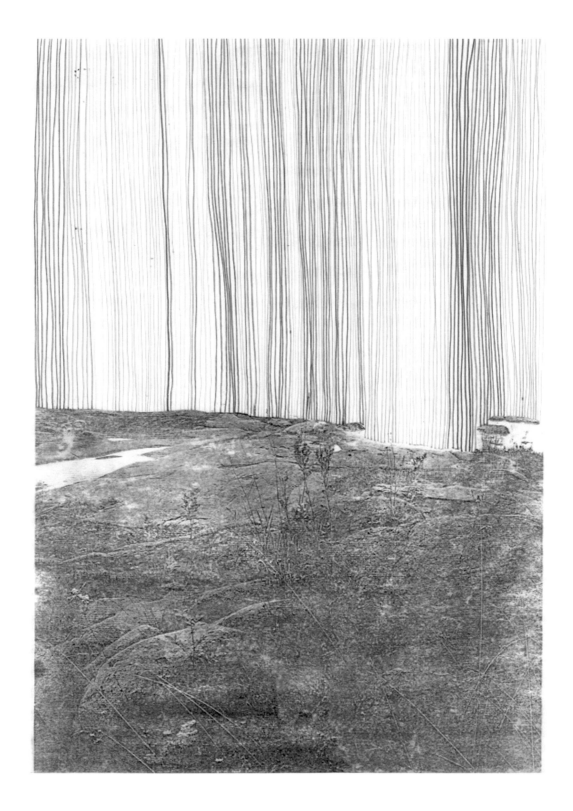

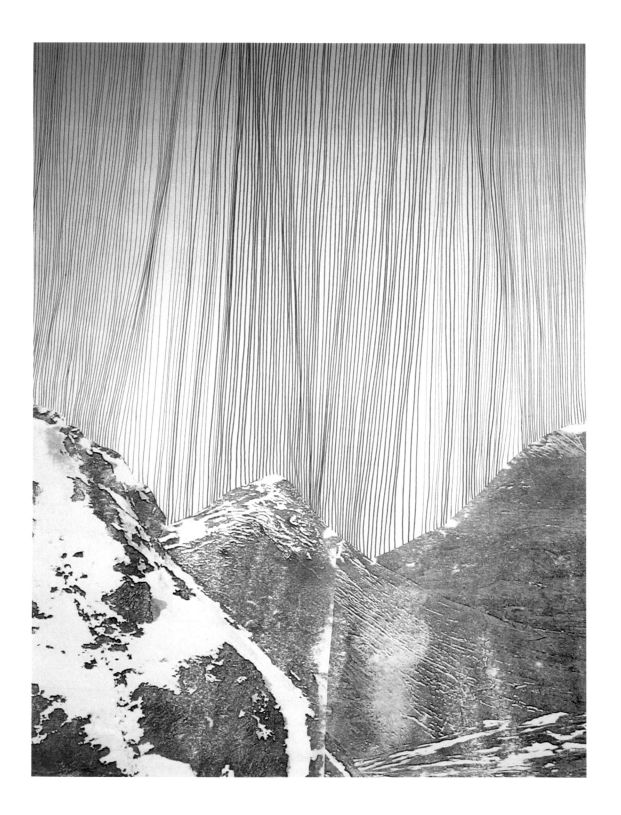

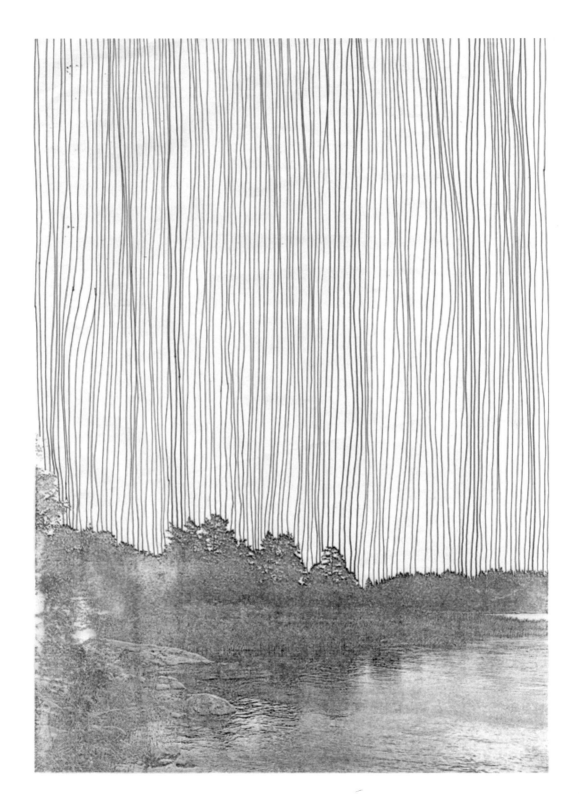

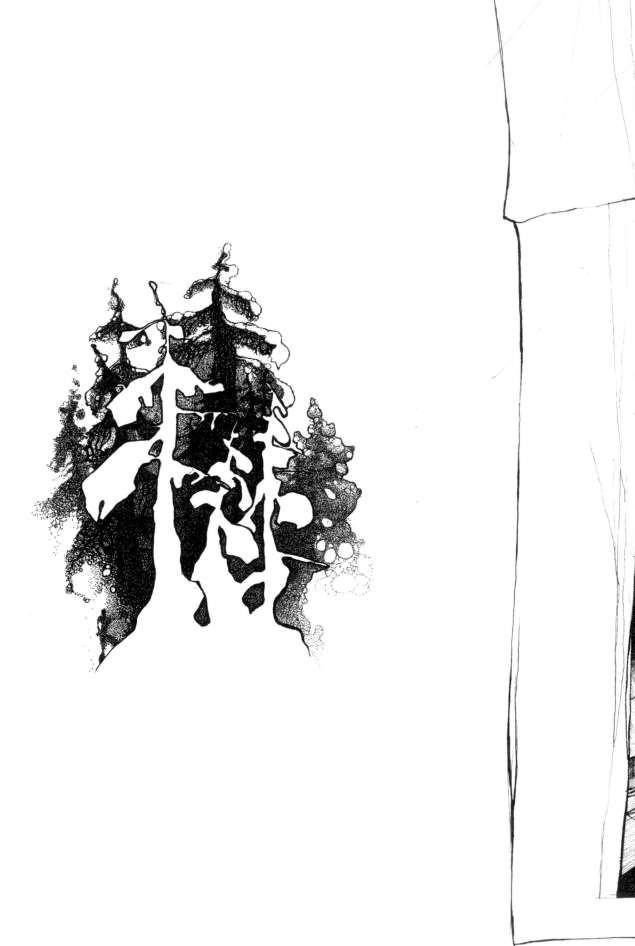

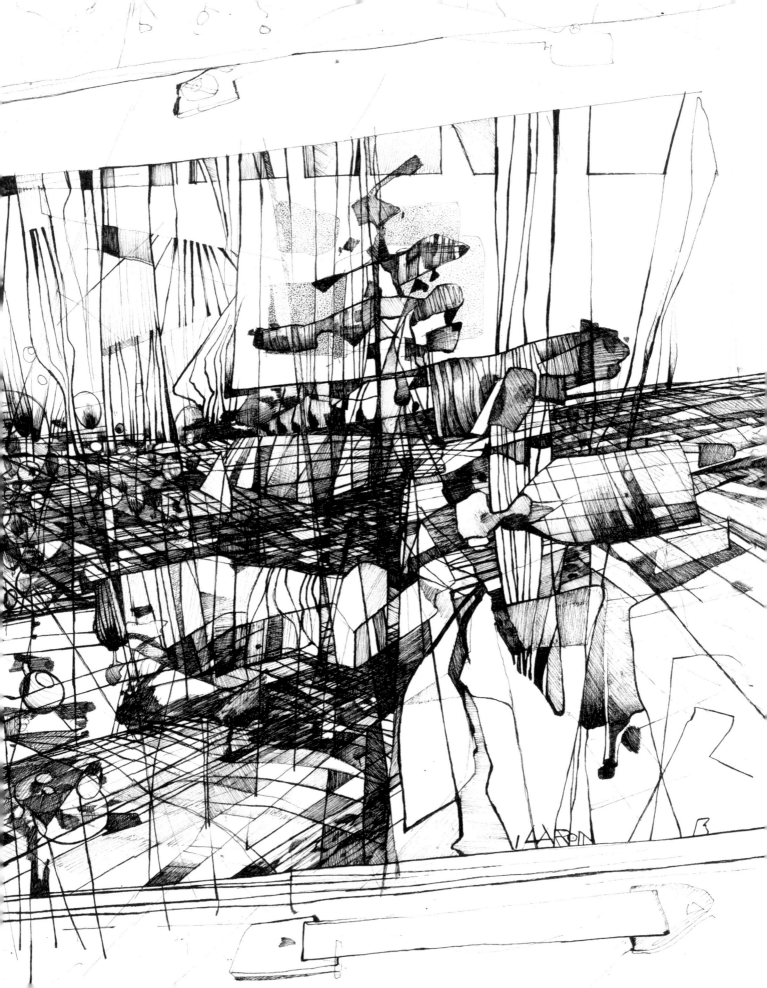

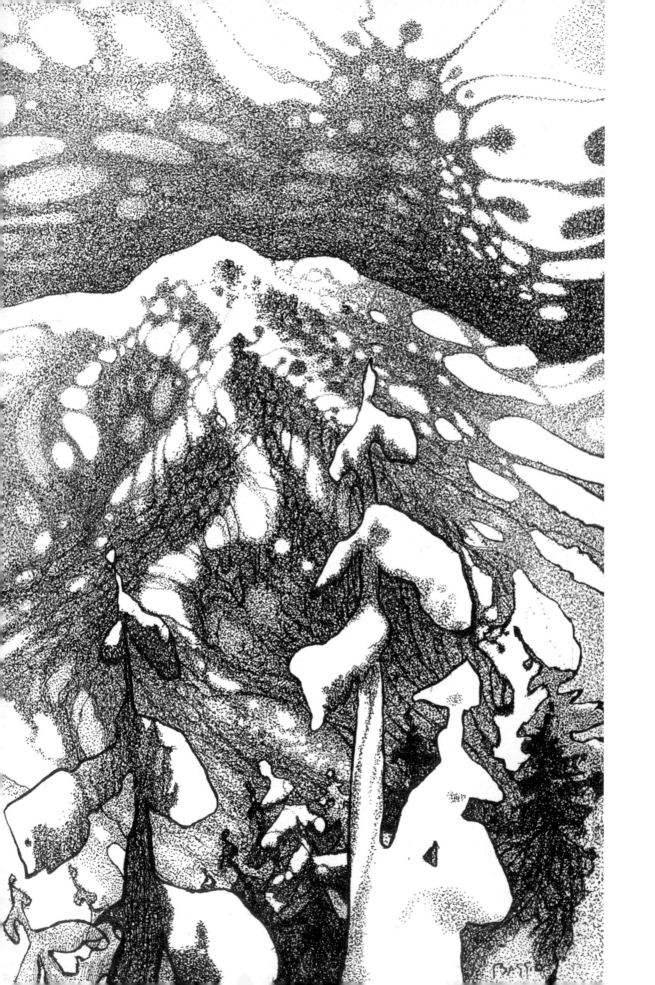

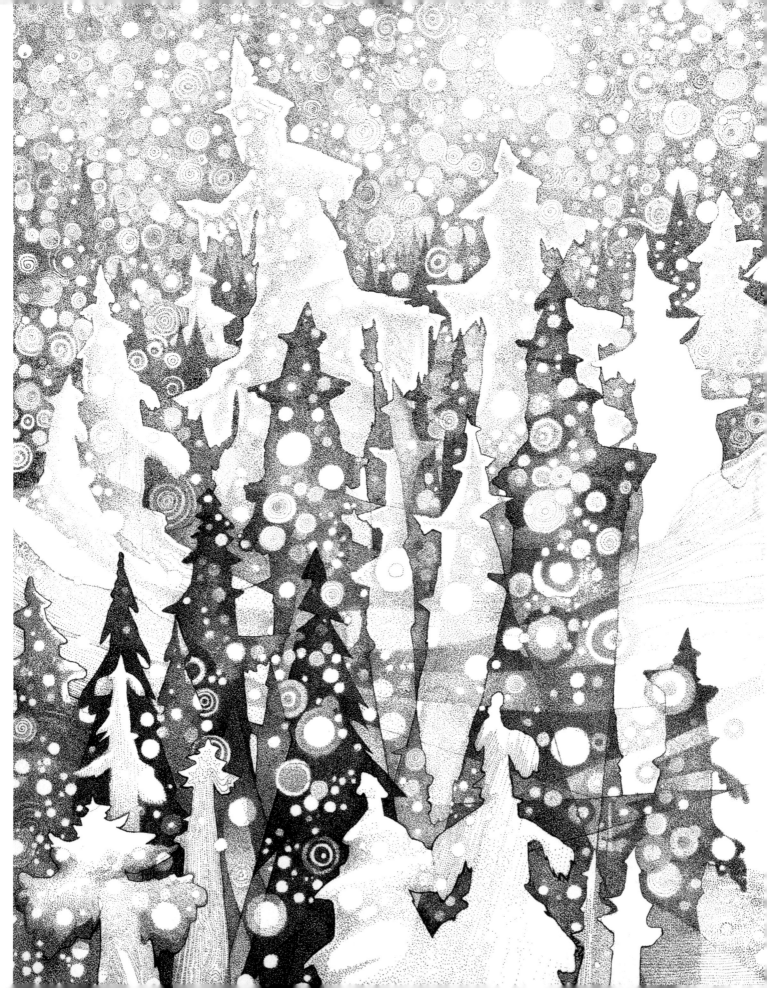

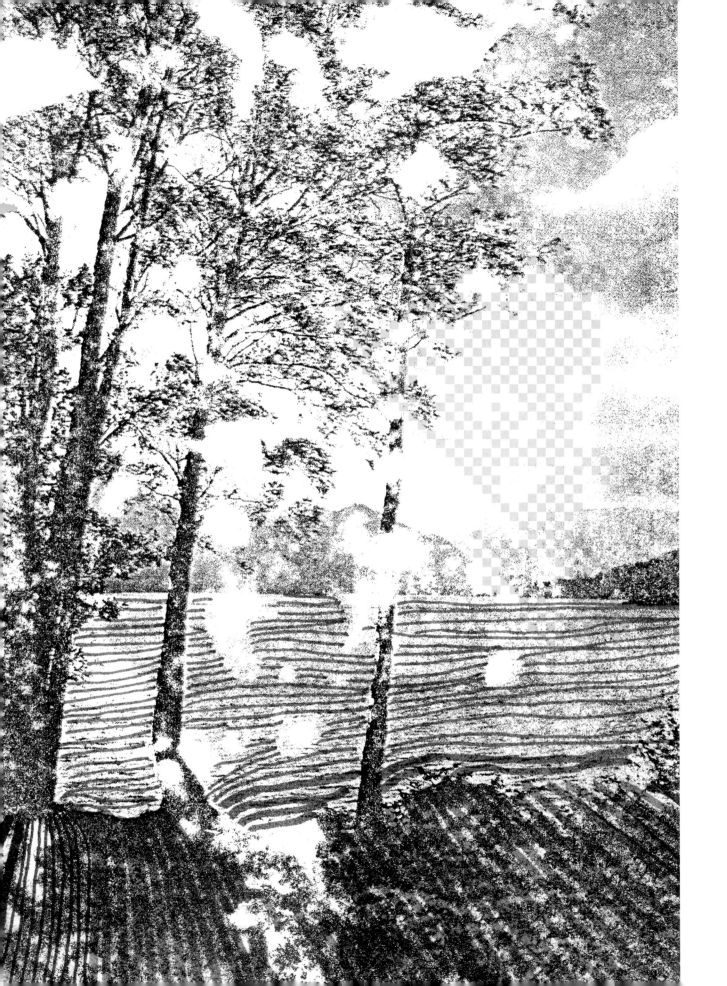

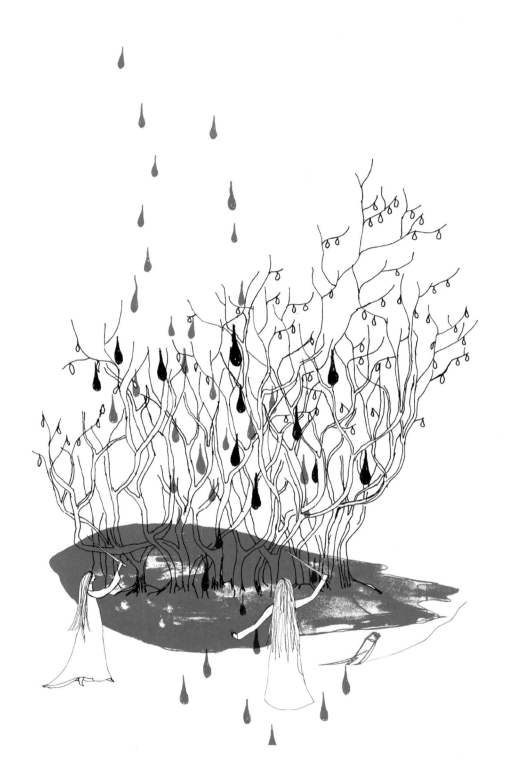

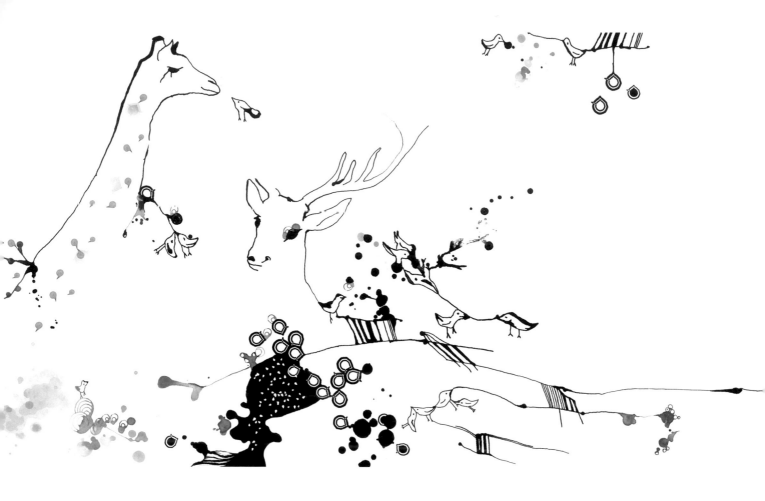

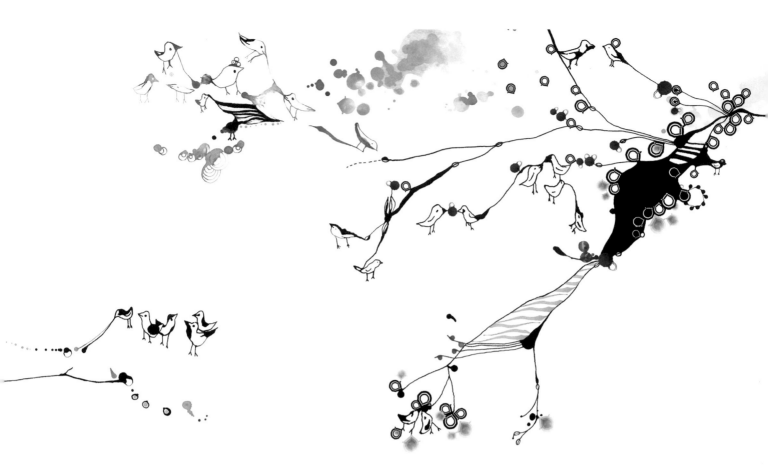

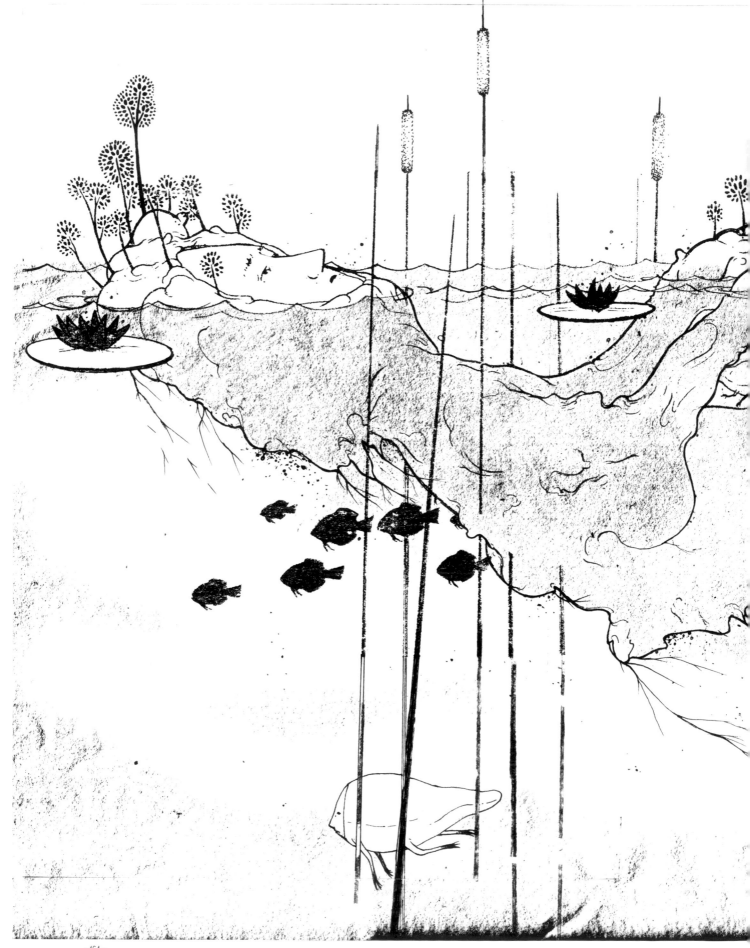

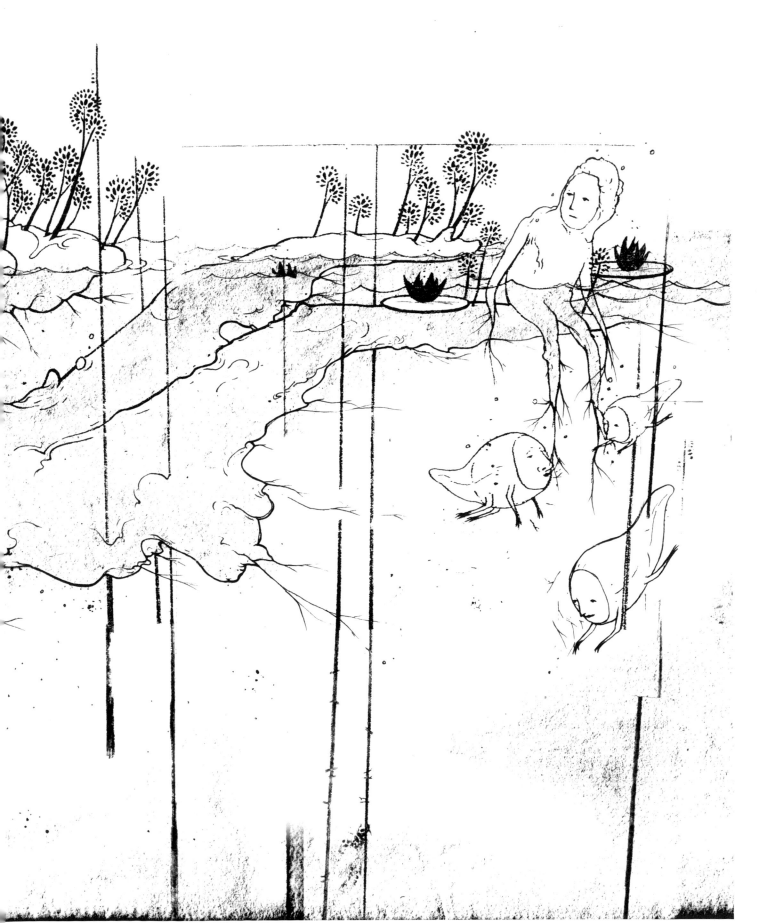

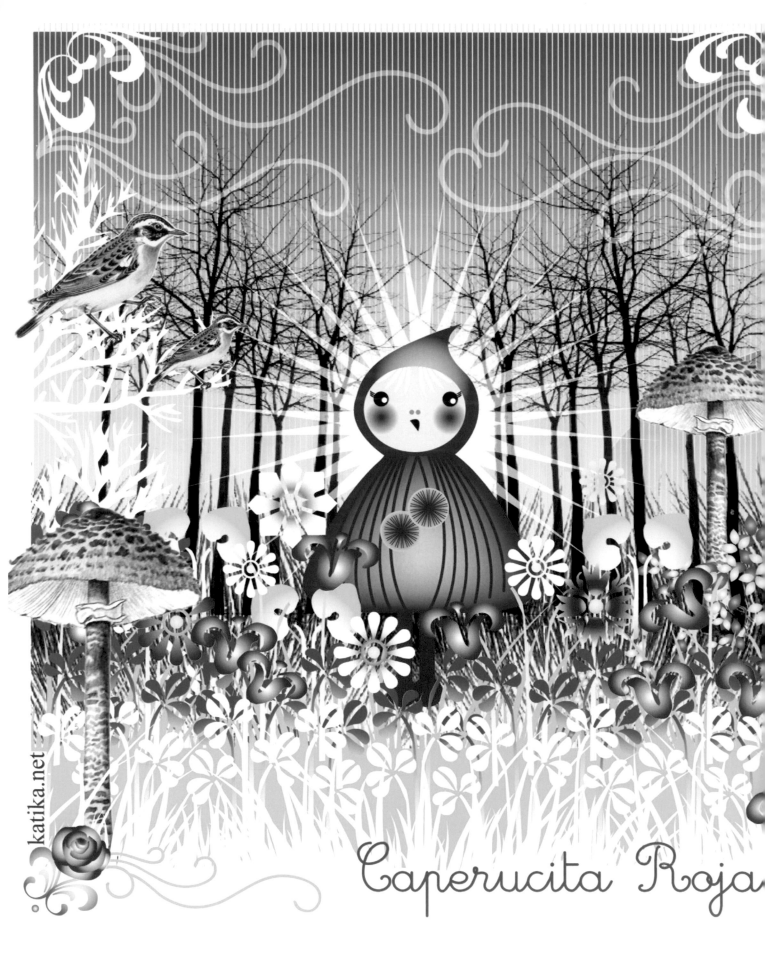

Caperucita Roja

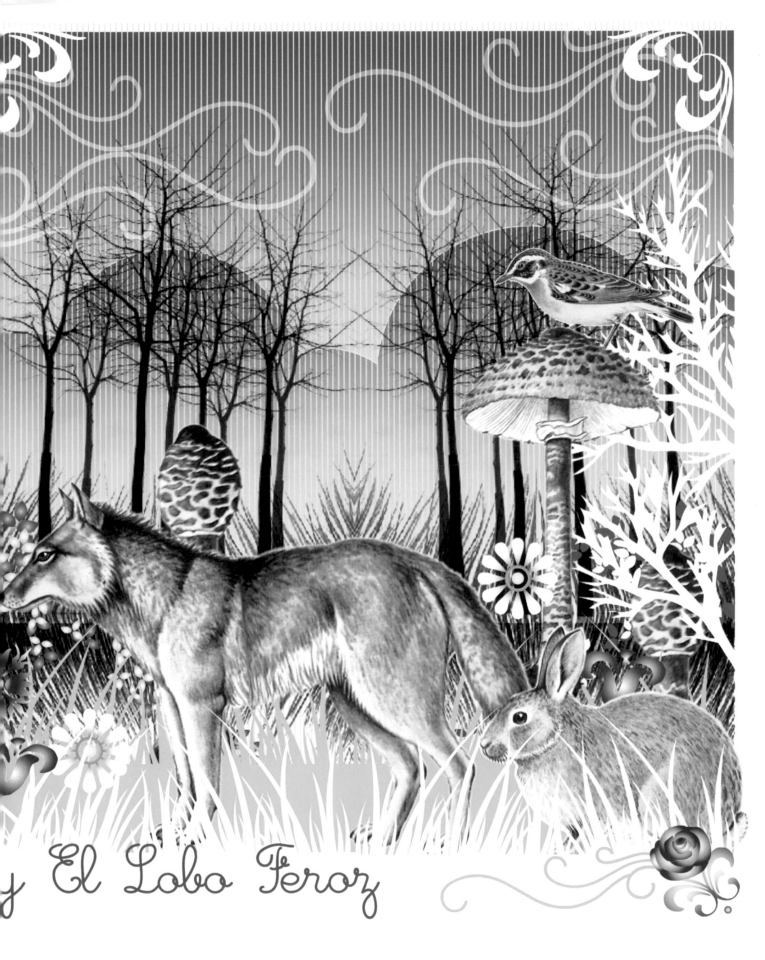

y El Lobo Feroz

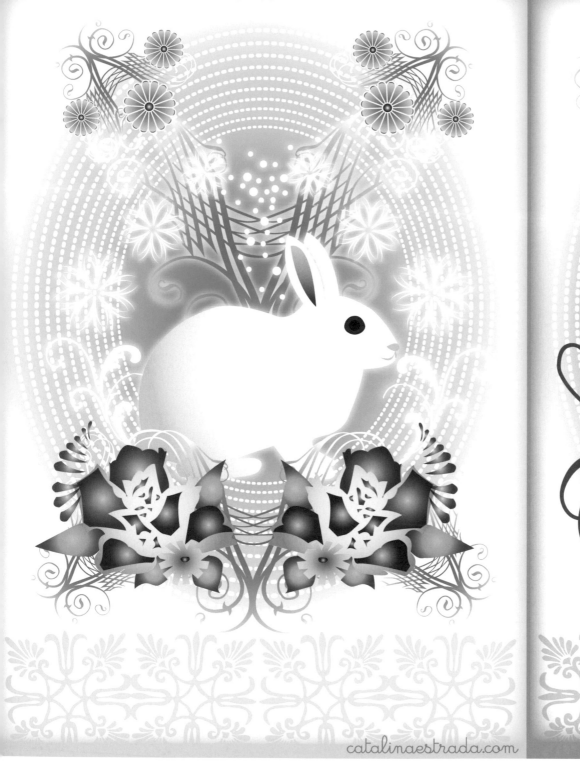
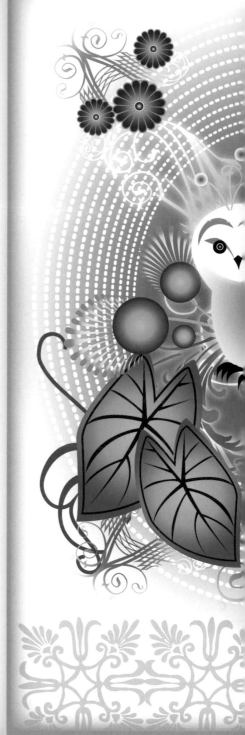

catalinaestrada.com

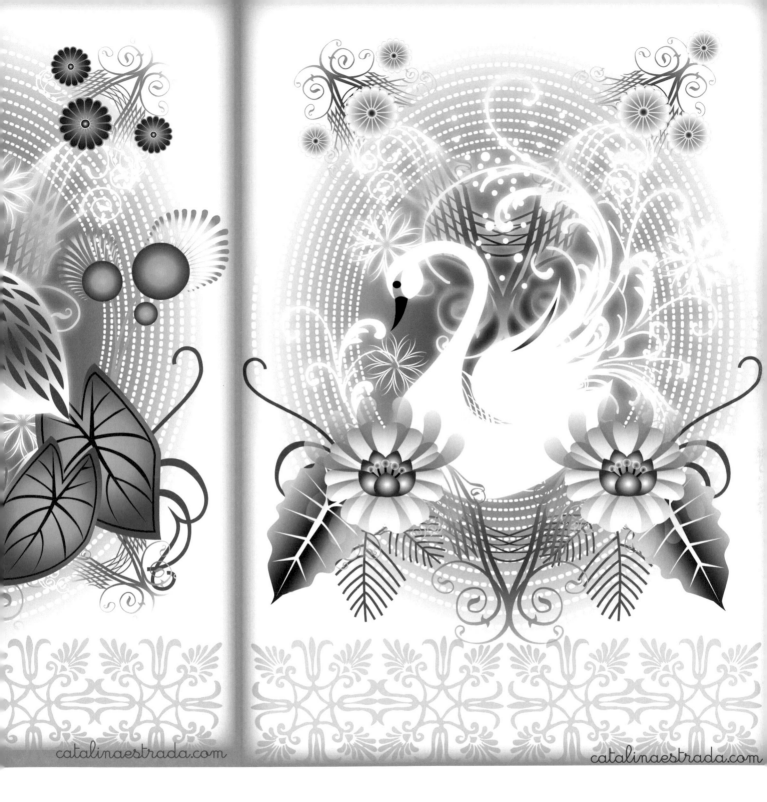

catalinaestrada.com

catalinaestrada.com

Graphic In the landscape overloaded with visual information, the ecology of the sign acts as an escape route. Using elements taken from Nature, draughtsmanship borrows its flexible curves and takes from its abundance and eccentricity. Like a wolf on the fold, drawing sweeps down on the letters.

Within, a jungle of contrasting colours that takes no account of any kind of restraint. Manichean, shade and light compete in their intensity. The flat colours allow of no realism whatsoever, black and white create abstraction. A form of Darwinian selection is at work, the separate forces crowd in. Line is their witness. It highlights detail and settles the disputes.

From the height of the forest canopy technology rules. It reinterprets this environment in accordance with the codes of its software. Nature is the tool that introduces poetry and frankness. From infinite repeatability is born continuous evolution. The endless cycle leads to renewal.

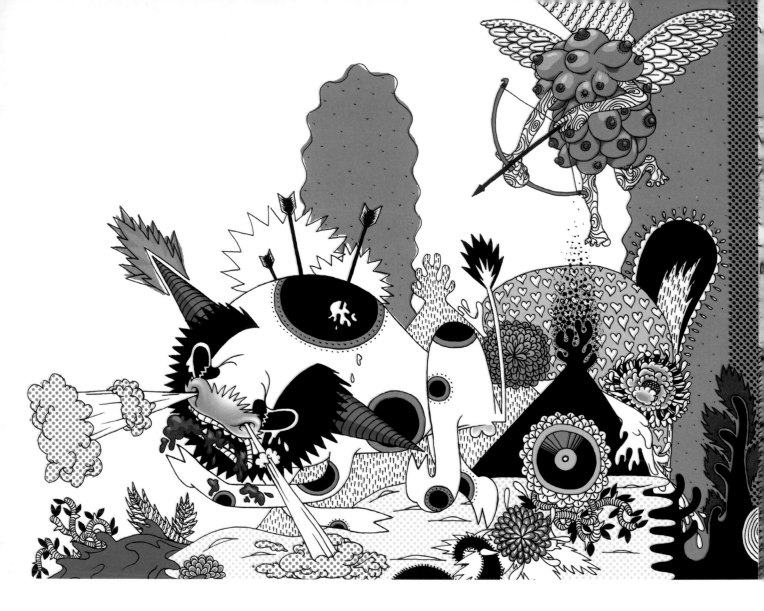

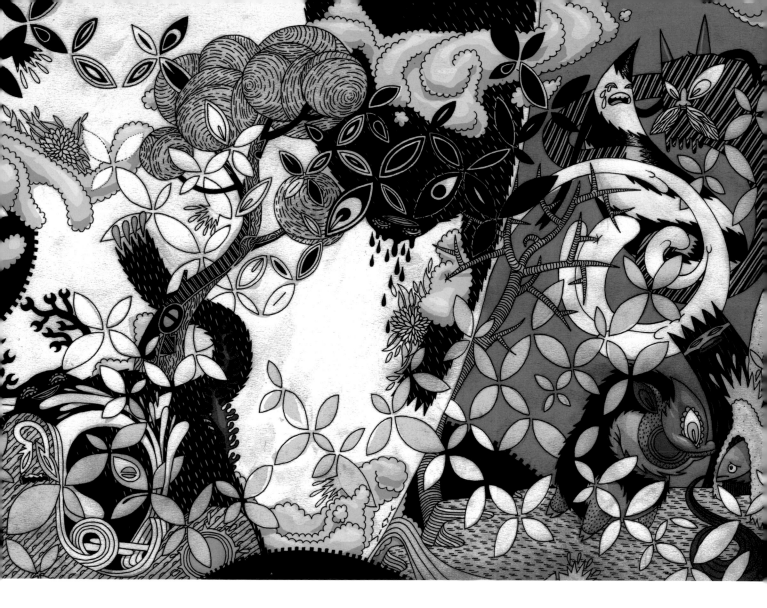

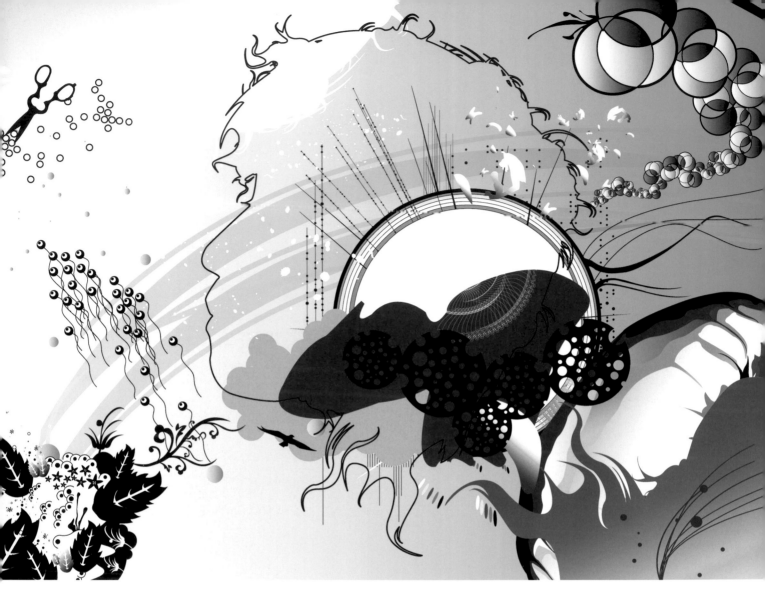

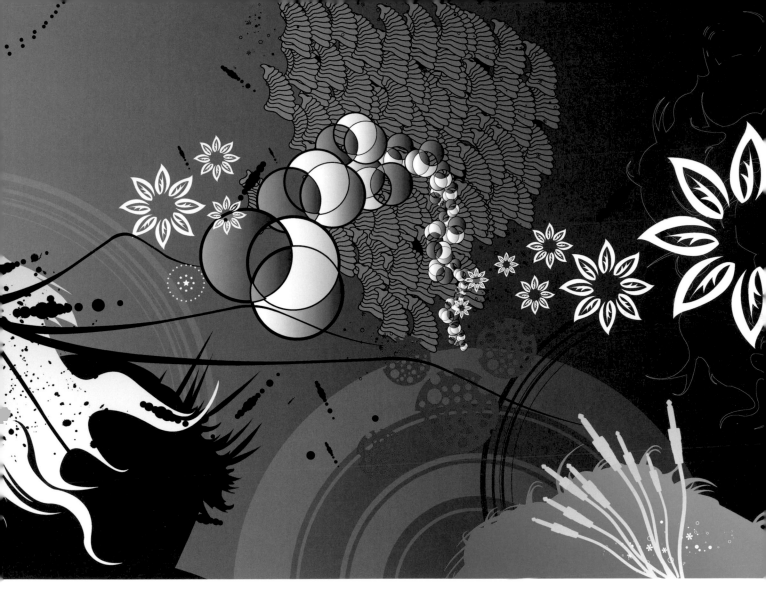

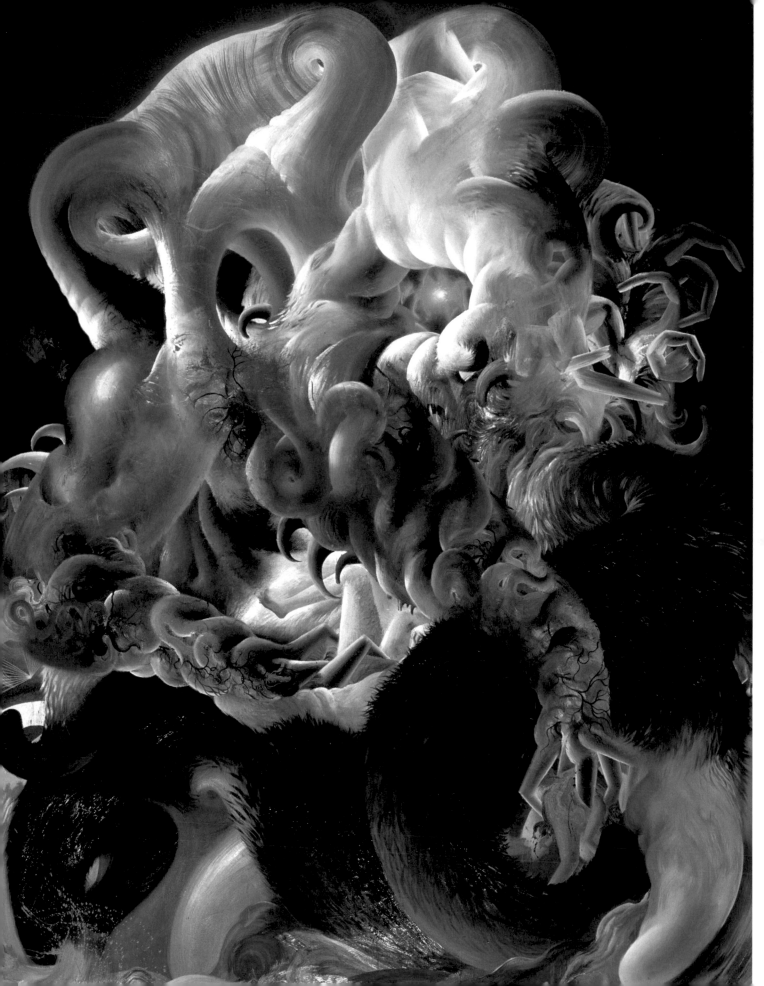

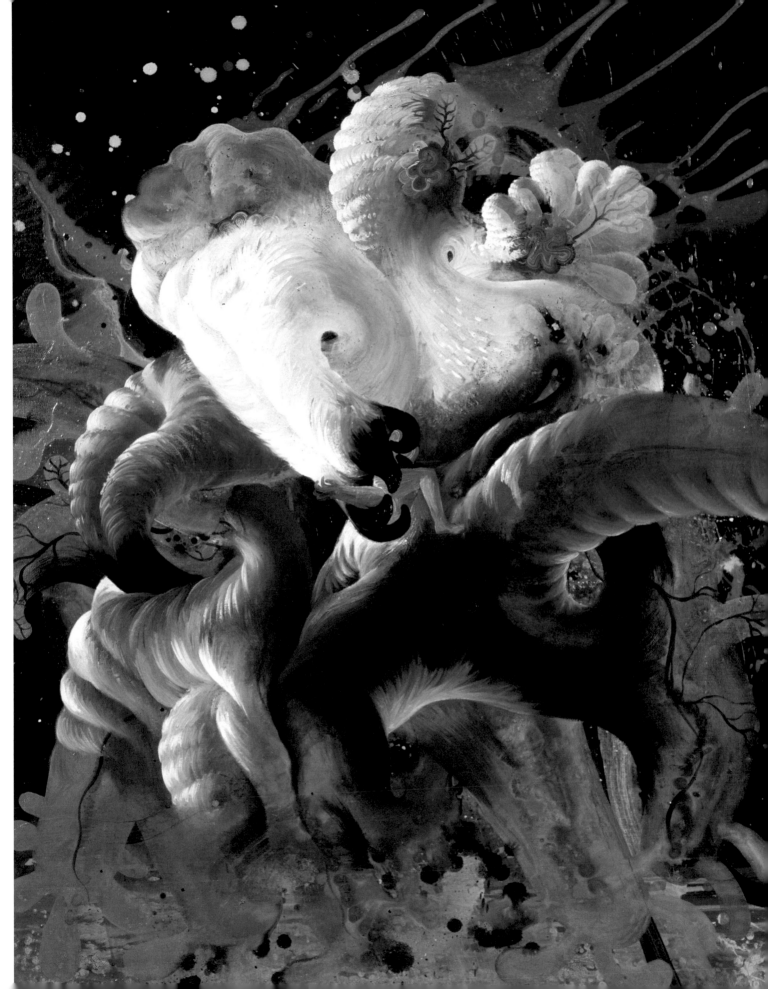

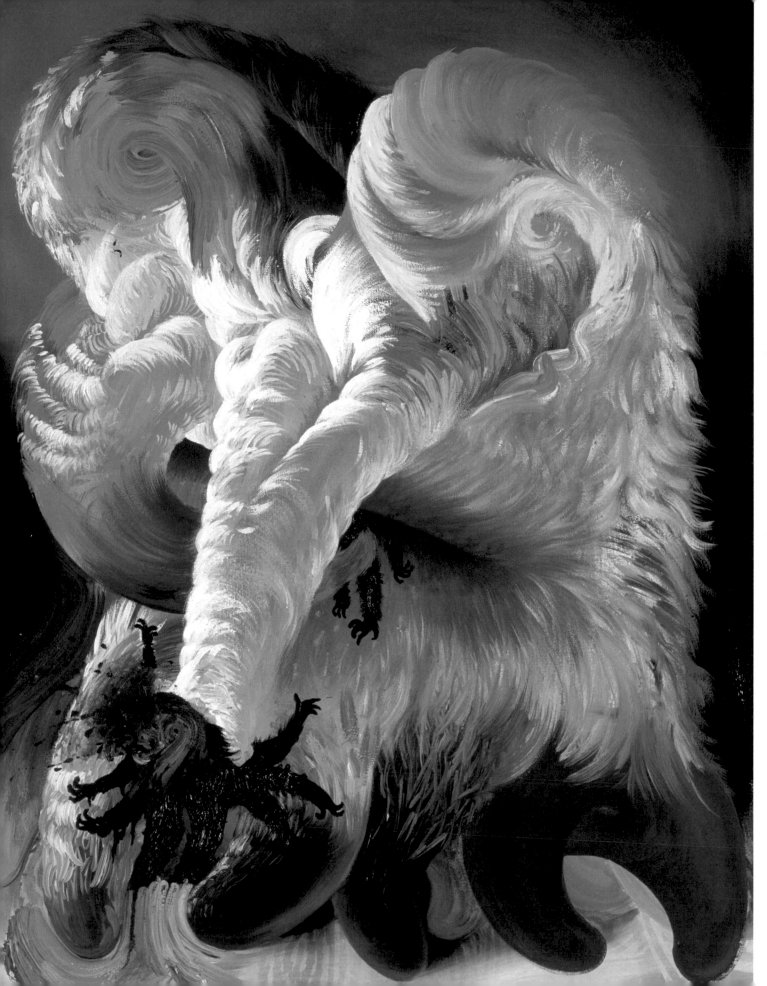

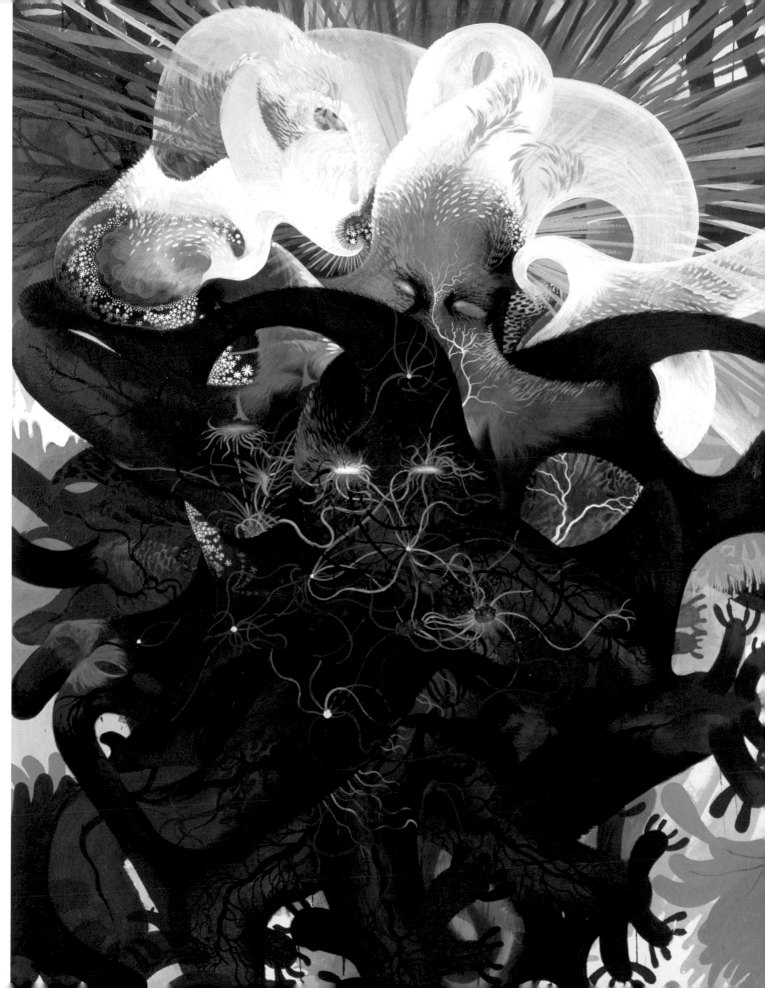

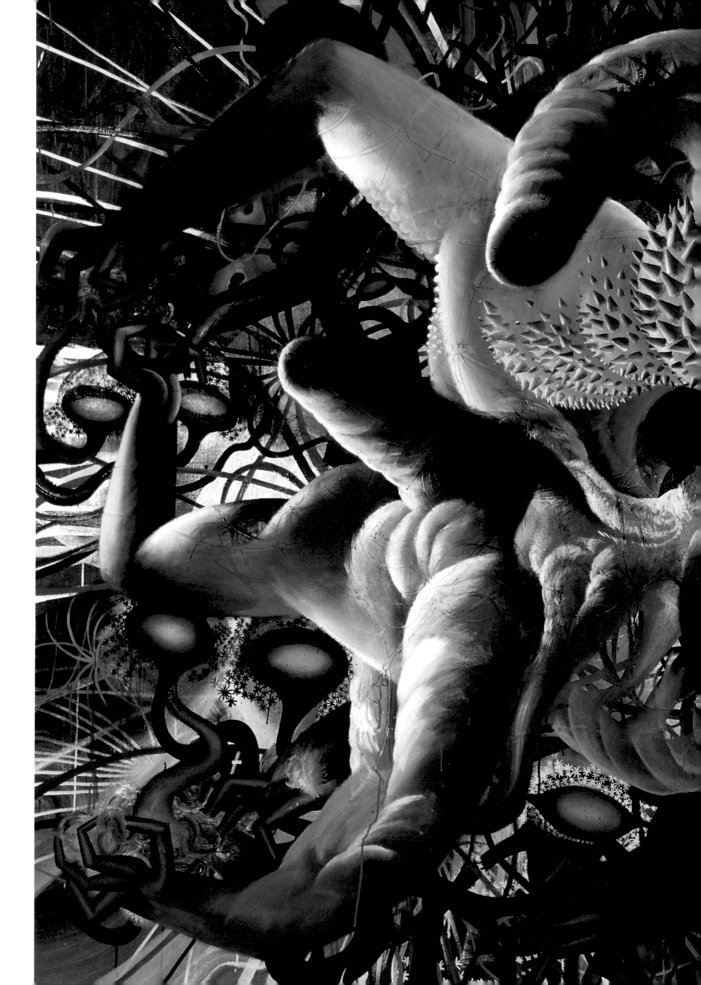

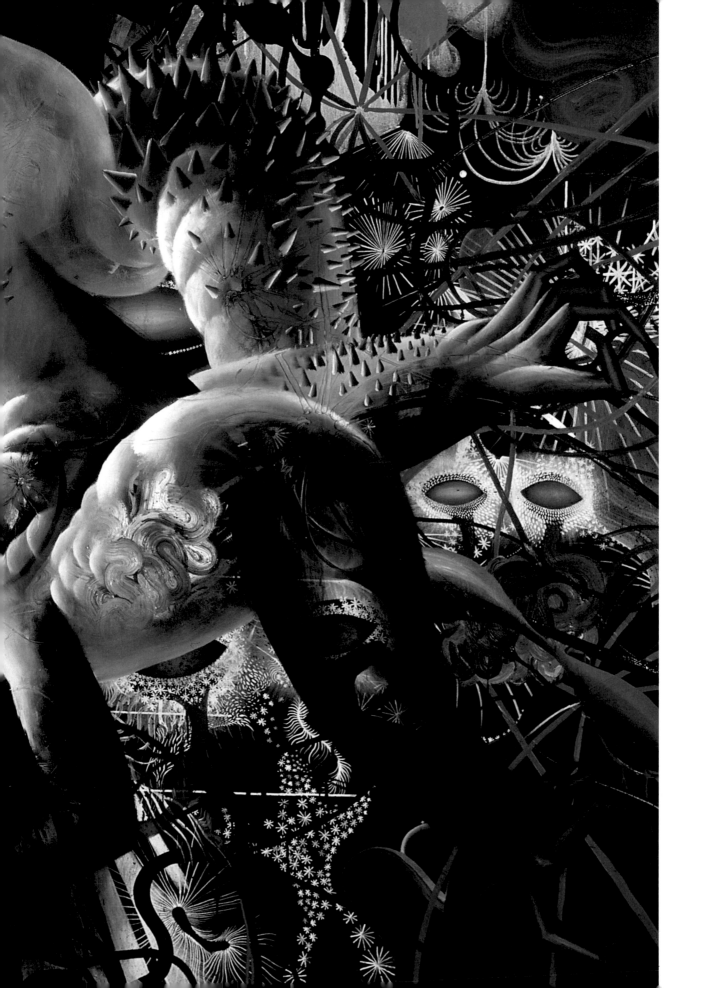

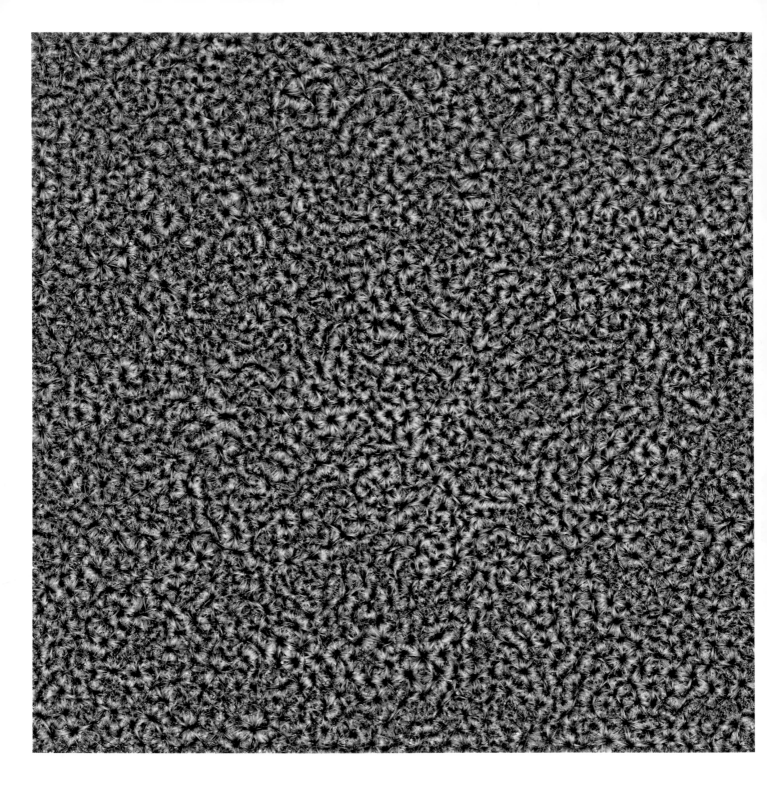

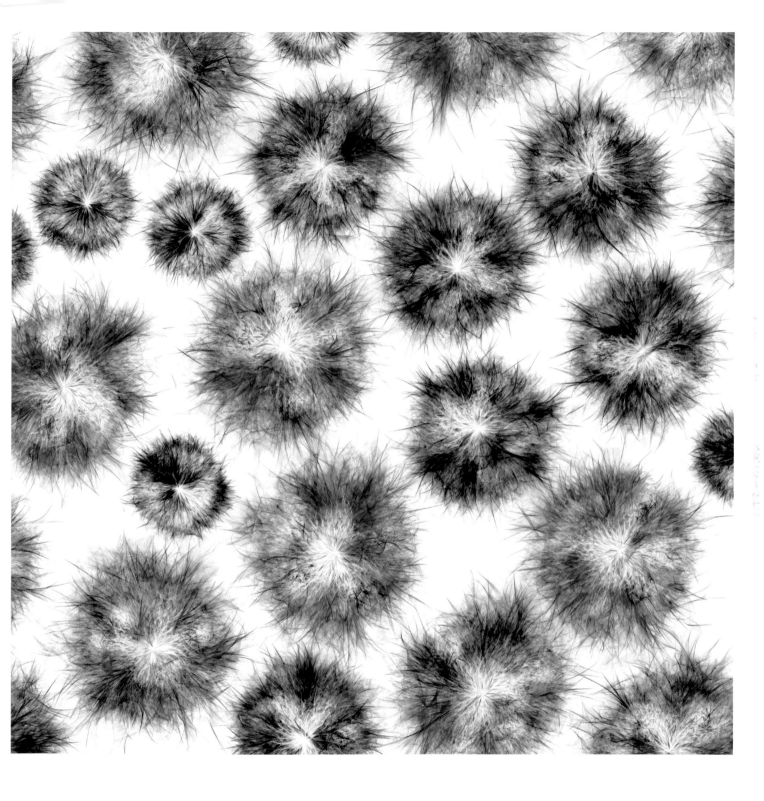

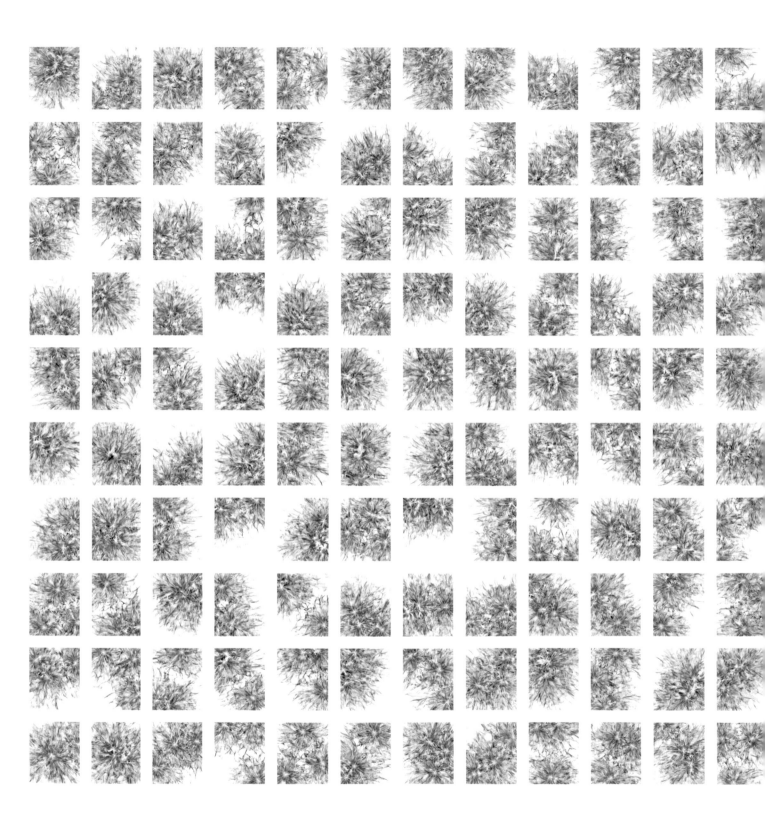

Abstraction Fruit micro-ceramides, active fruit concentrate, phyto-aromatic, beta-hydroxyacide, essential oils and natural plant extract, natural enzymes... Industrial chemistry has it own rich poetry. Advertisements compare scientific details as they guarantee eternal youth.

Our mental idea of Nature drowns in this technological jargon and becomes abstract. We have a vague sense that Nature is infinitely small, concentrated, that it has changed into an extract.

Thus, exploitation of nature consists above all not in revealing its raw state, but in making it quite unidentifiable. Nature is an idea absorbed into a vast and sophisticated system of intangibility taken to extremes.

Nevertheless, although immediate and physical recognition of natural matter becomes impossible, it is, however, given a value. To caricature: the more the ingredients of a product are obscured, the more credible its effectiveness becomes. The collective mind has been so conditioned that it has a blind confidence in technology.

However, one day the evidence will have to be faced: although Nature can today be used in its tiniest particles, it works treacherously. No technology can work against time, which is as inelastic as ageing skin.

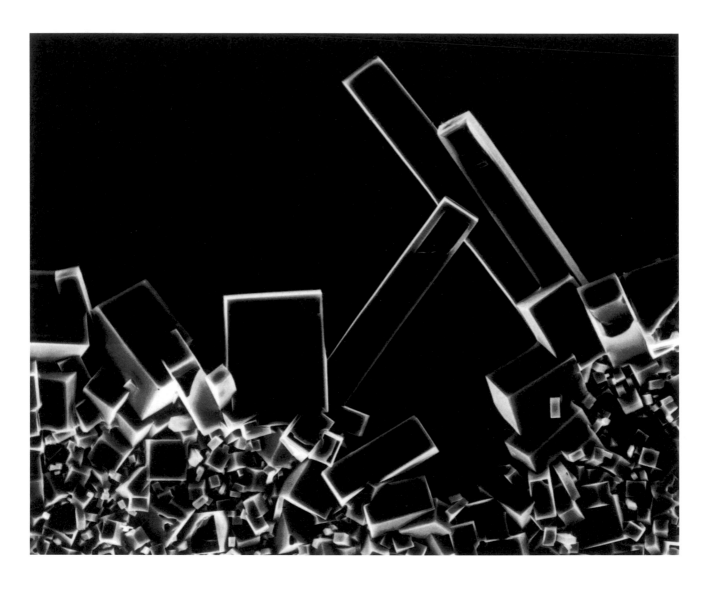

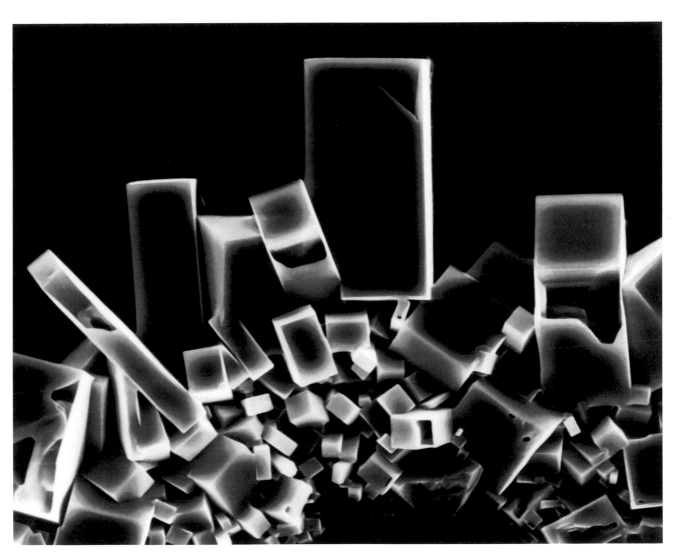

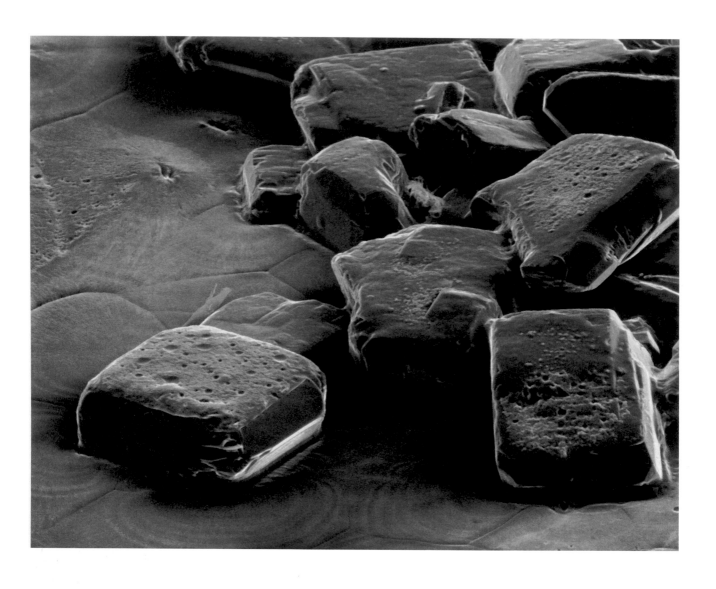

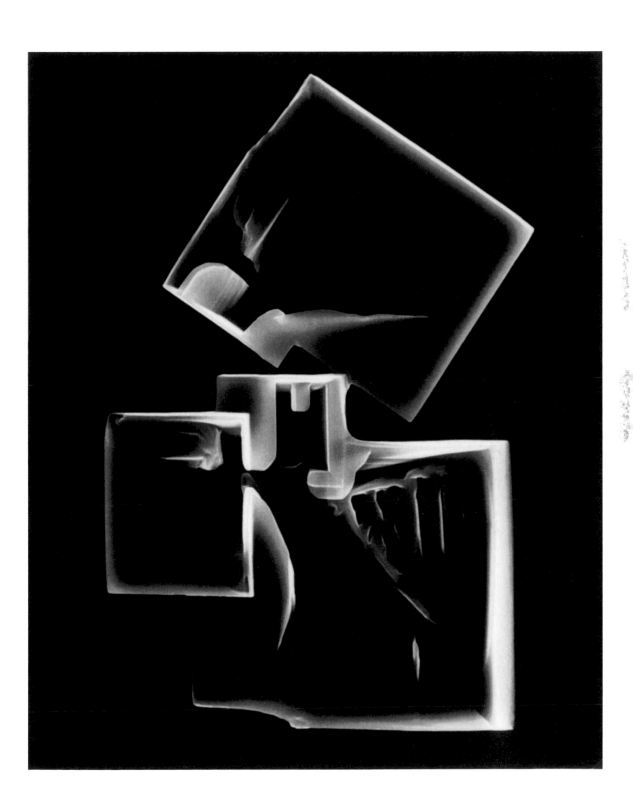

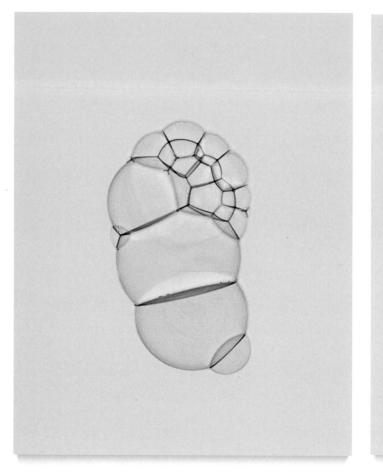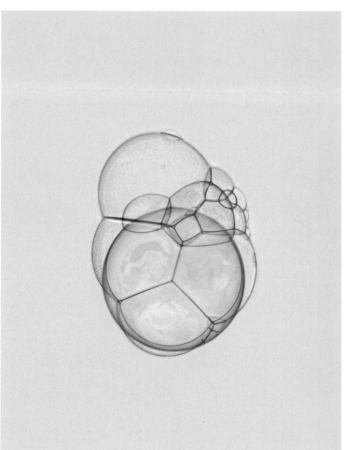

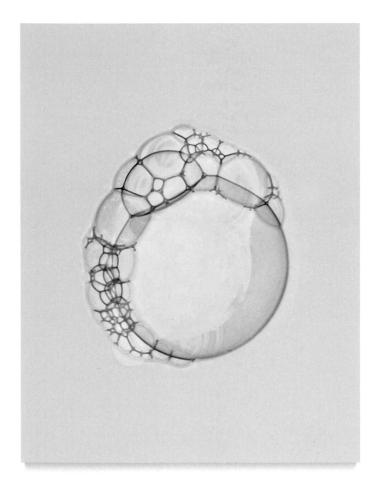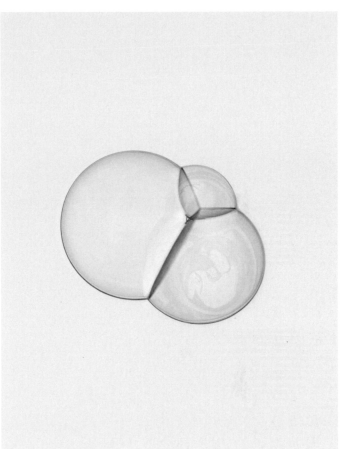

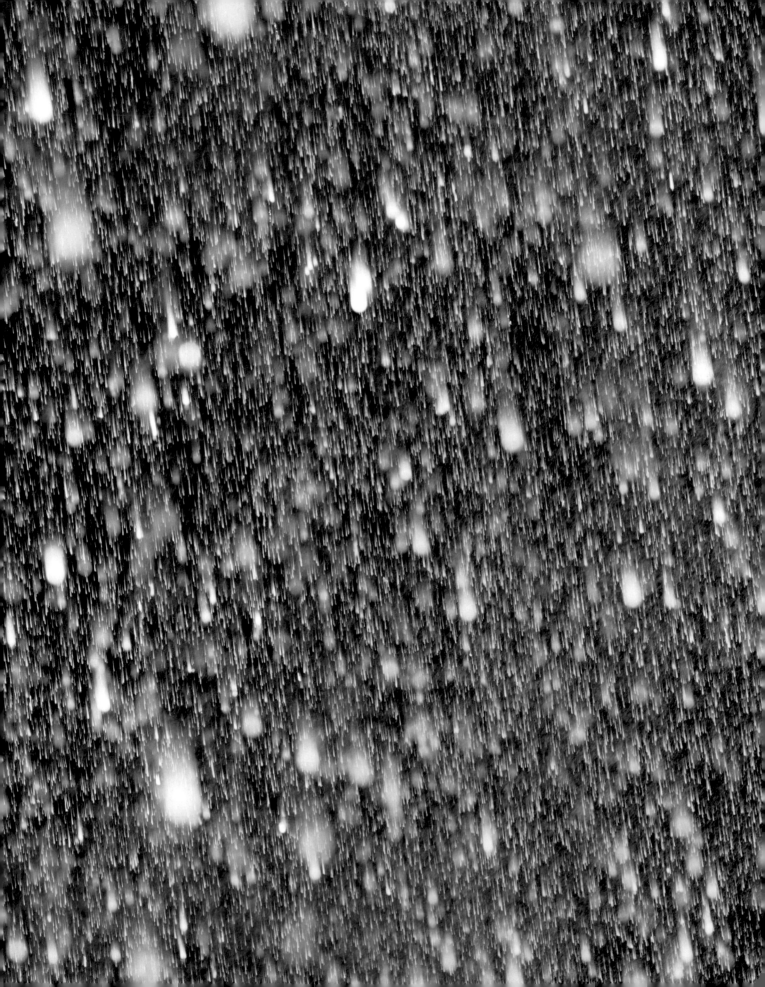

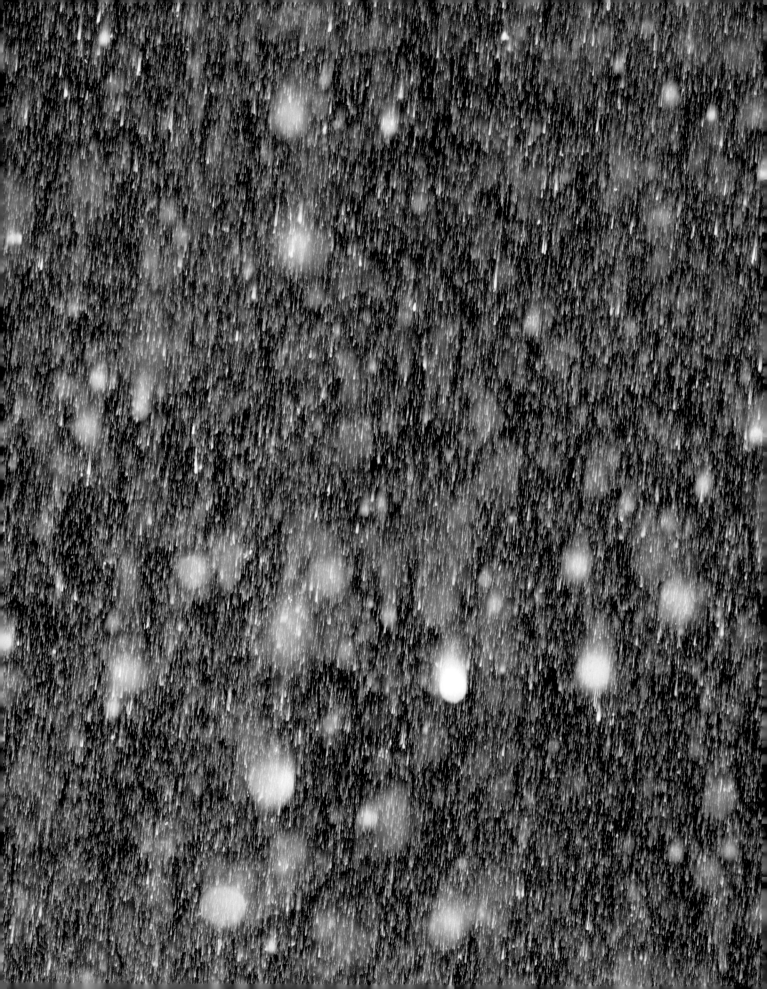

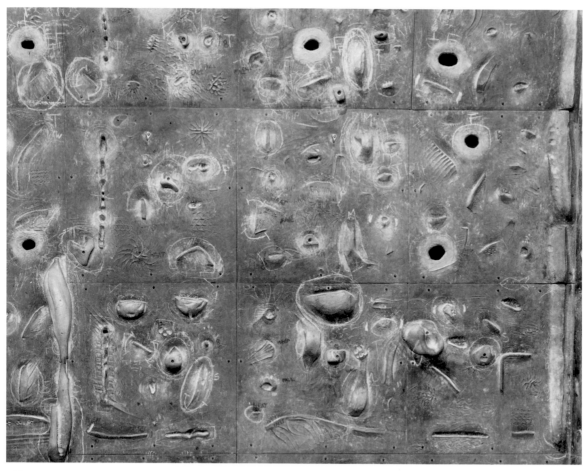

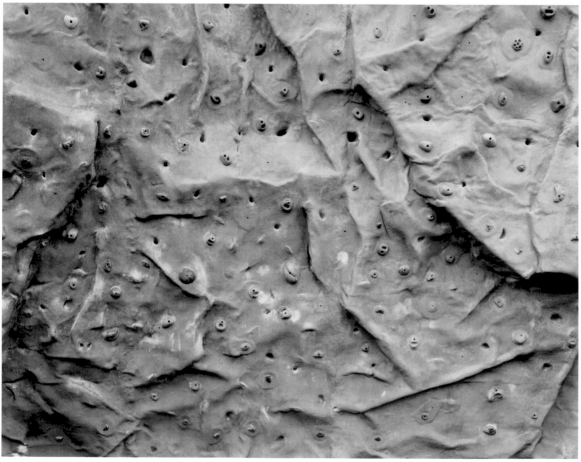

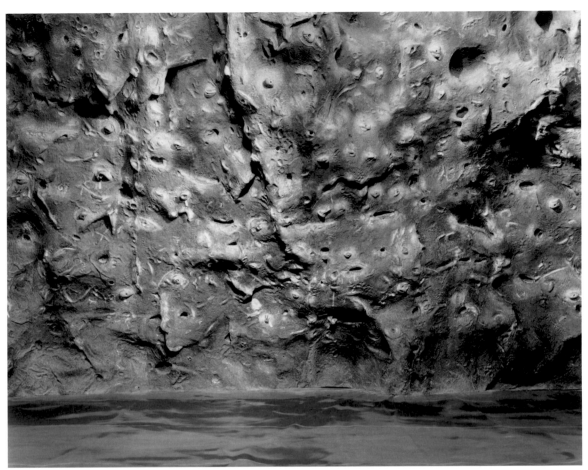

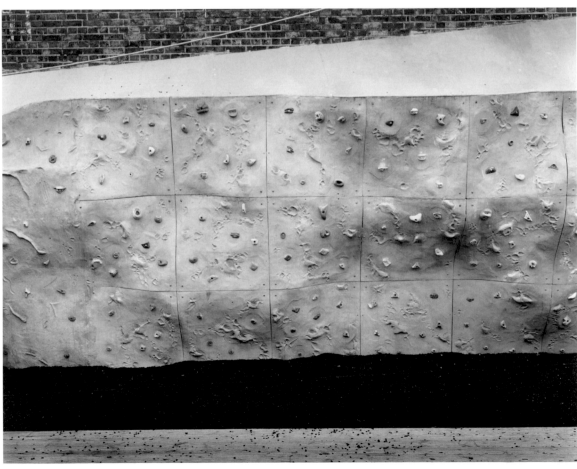

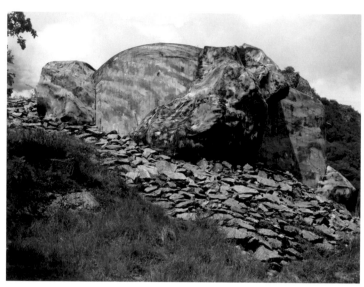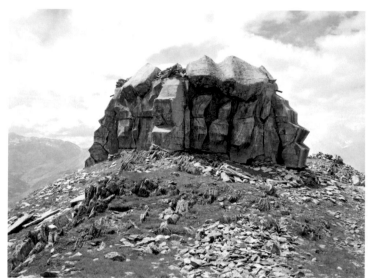
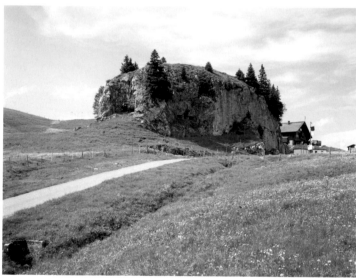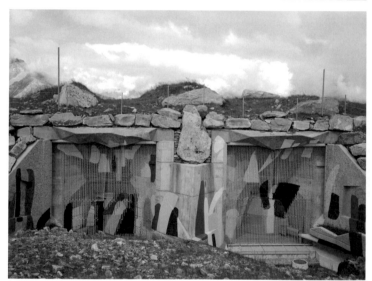

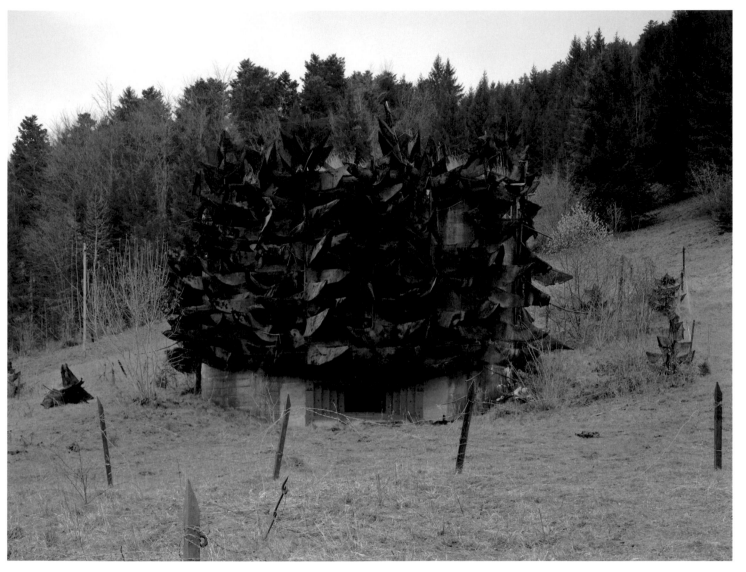

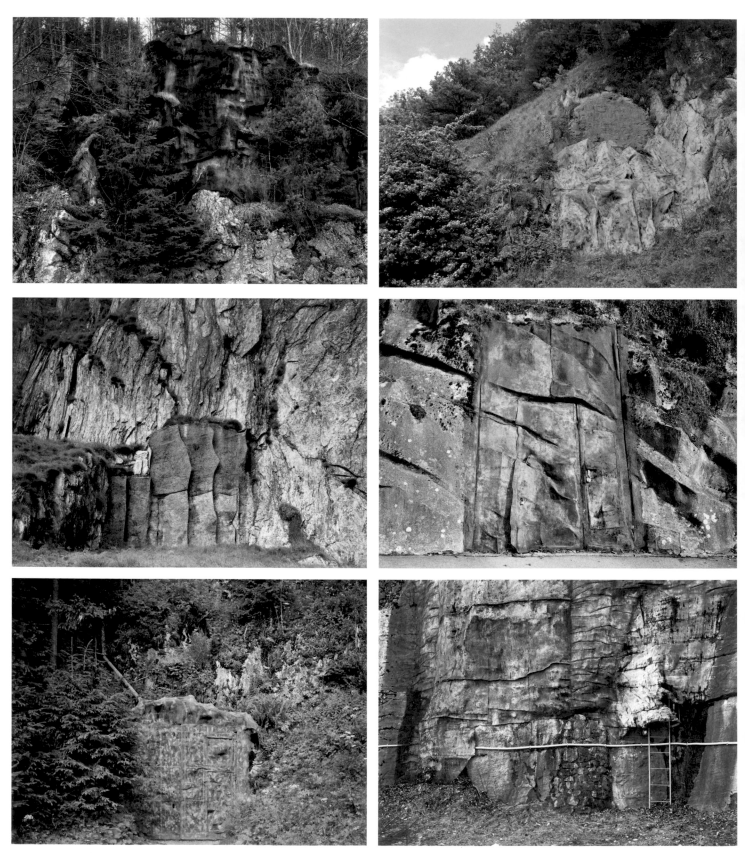

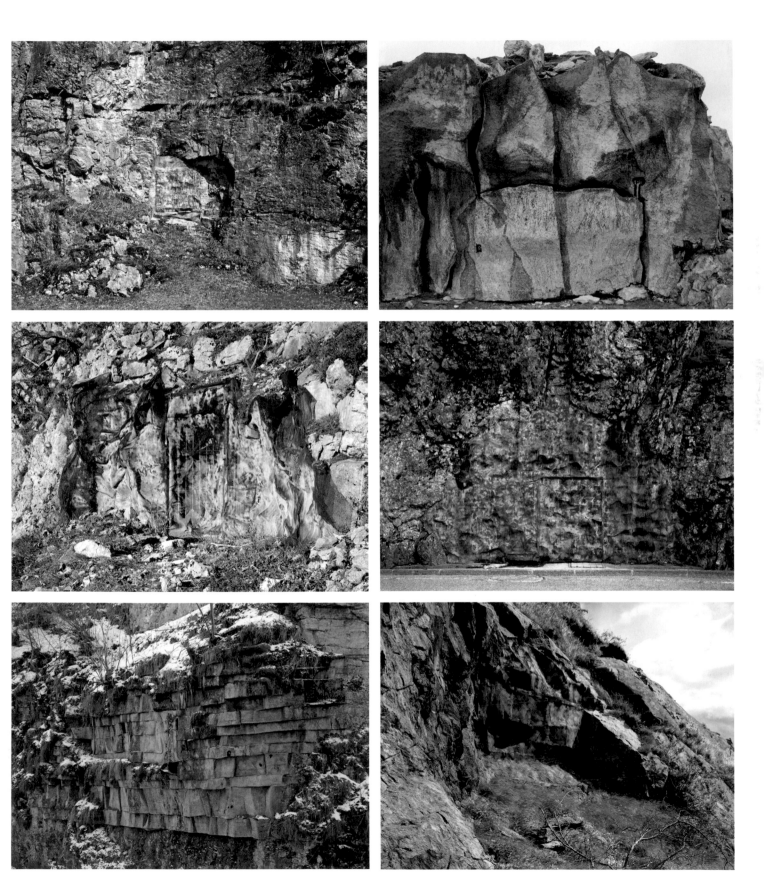

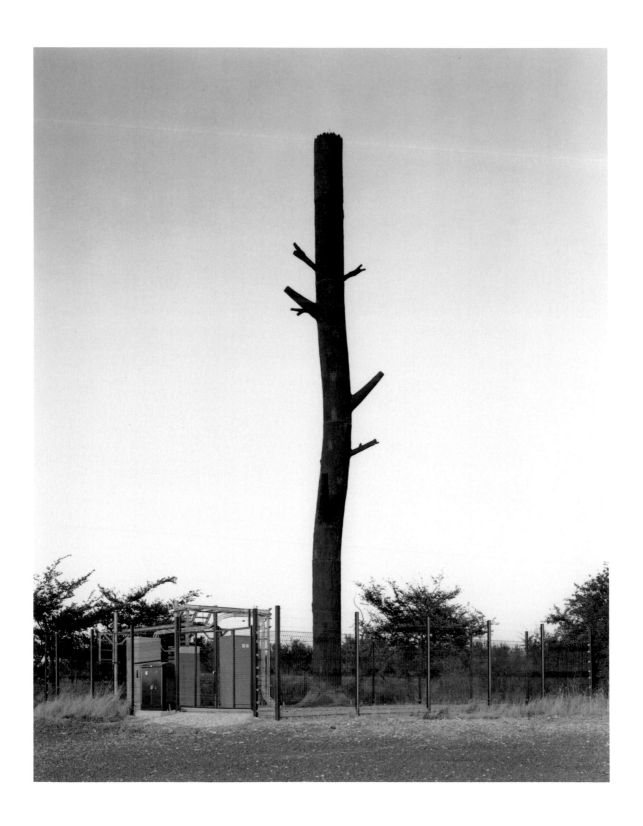

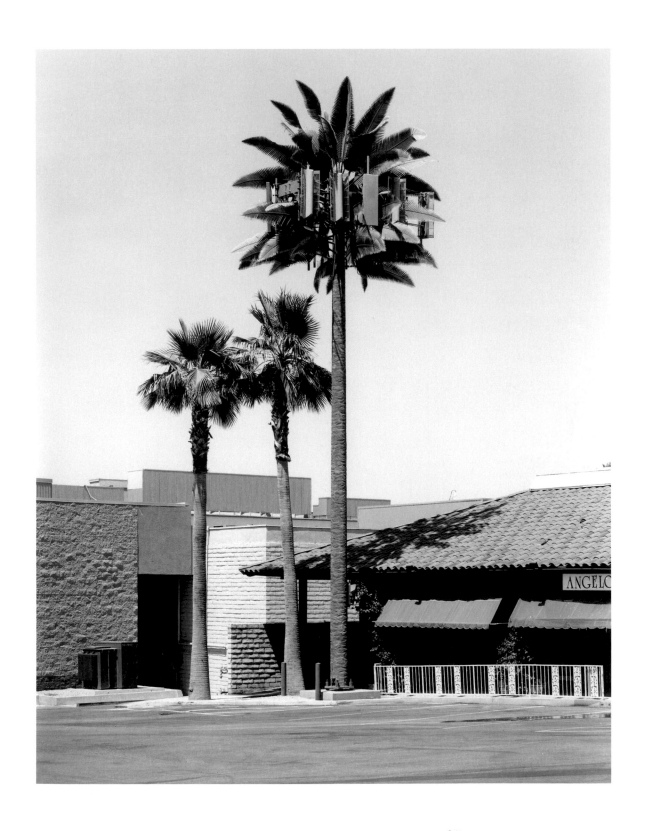

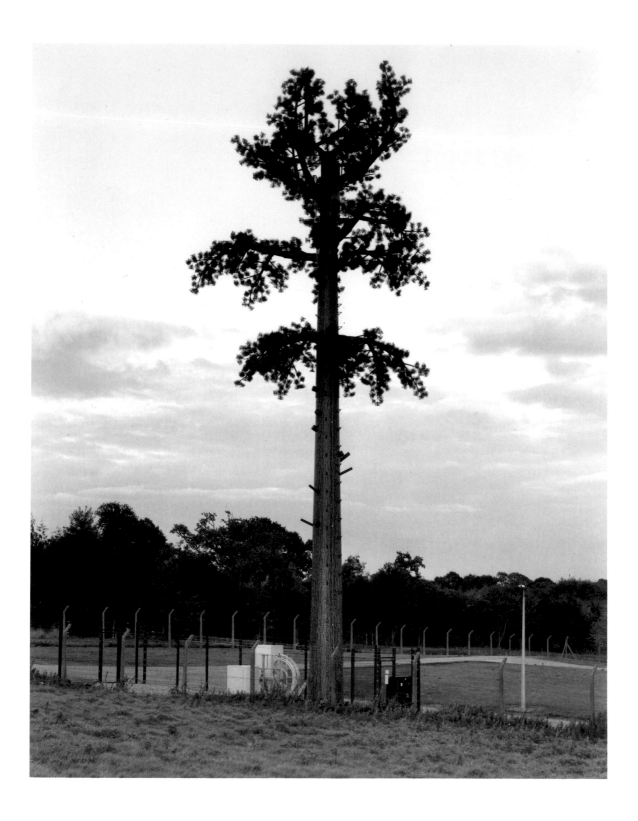

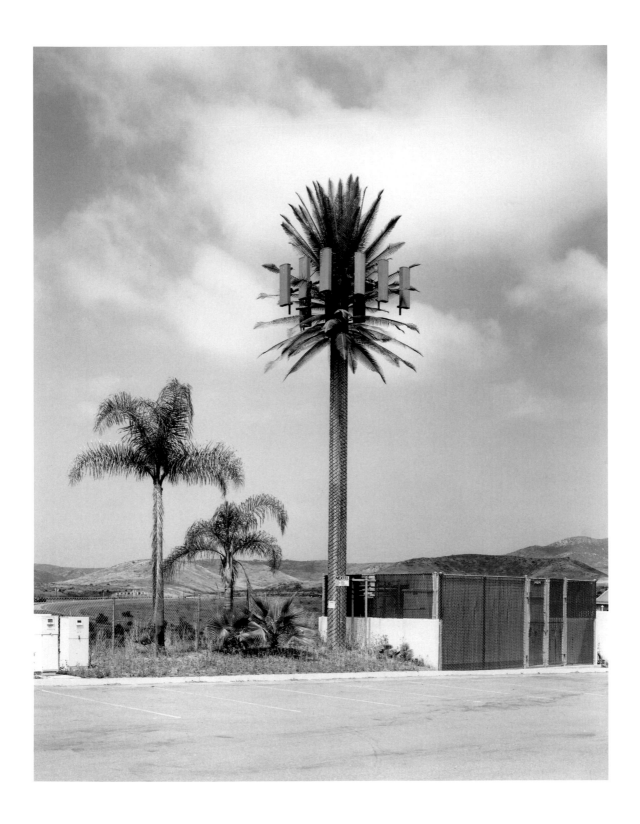

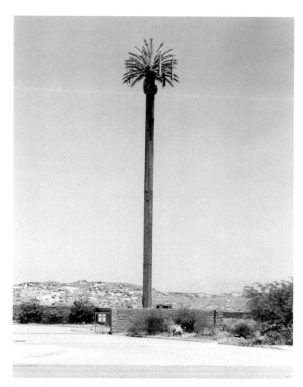
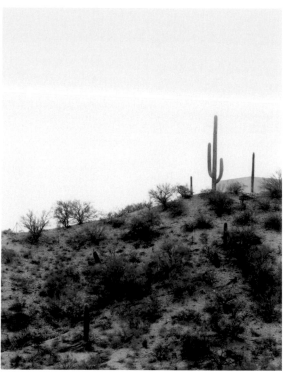
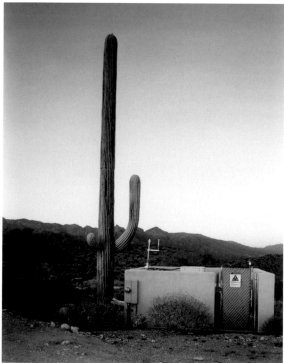
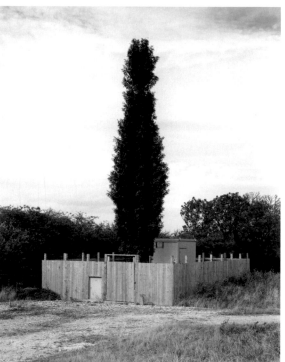

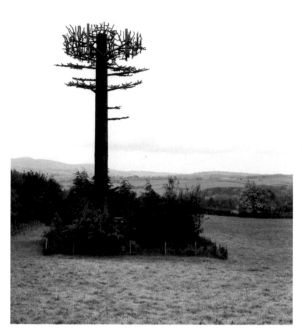

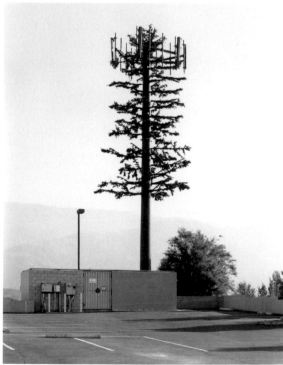

Imitation "What a beautiful day! The lawn shines a bright green, the fountain clicks softly. The neighbours are organising a party in their garden for their youngest daughter's birthday. I take advantage of the noise of their preparations to slip quietly into my car. I am alone on the road, which is prettily bordered by plane trees and palms. The sun beats down on the countryside and dazzles me a little. I drive slowly along the empty street. Ah! There's the farm. The farmer's wife comes to greet me as I park in the yard. Calves, cows, pigs, chickens – what a lot of animals! I notice one of them has a foot/leg missing! 'It wasn't me', says the farmer's wife. 'I lent it to one of my friends and he gave it back like that. I was annoyed, but it doesn't hurt him.' I then pick up the milk and eggs. I've been asked to bake a cake for the party. On the return journey I stop at the orchard. The apples are round and red, but I would prefer a fine pineapple. The sun is at its zenith, time to return. At the steering wheel of my car I whistle cheerfully. Oh, I'm not going forward any more! Something has lifted me into the air… There I am lying on the path to my house. What a hullabaloo/mess there is all of a sudden. The neighbours are upside down, the trees and gardens all mixed up. The sun has gone out and it's so dark now… however, I should get used to it: life is both glorious and unpredictable in the wonderful world of Playmobil."

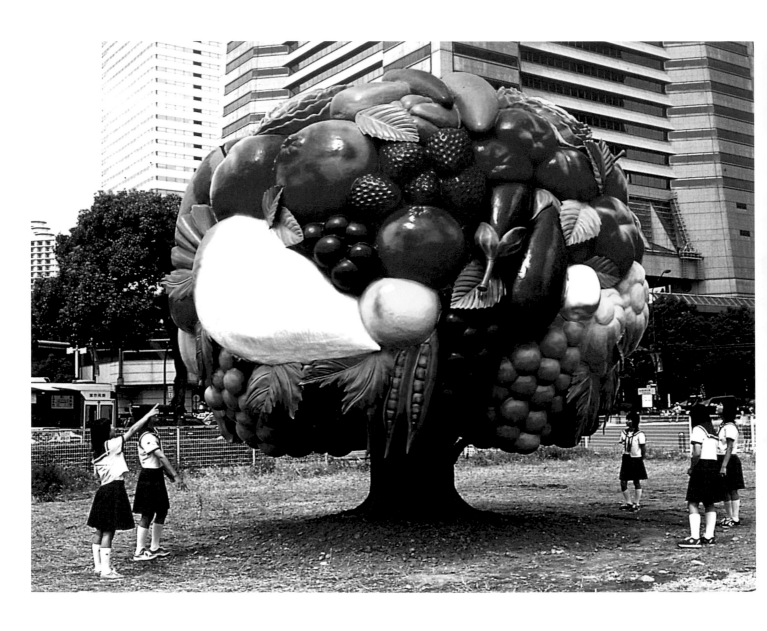

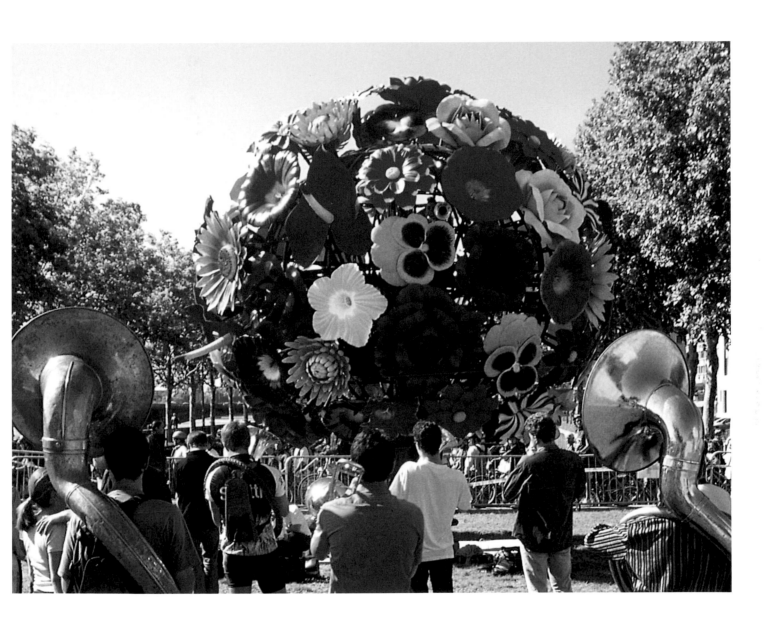

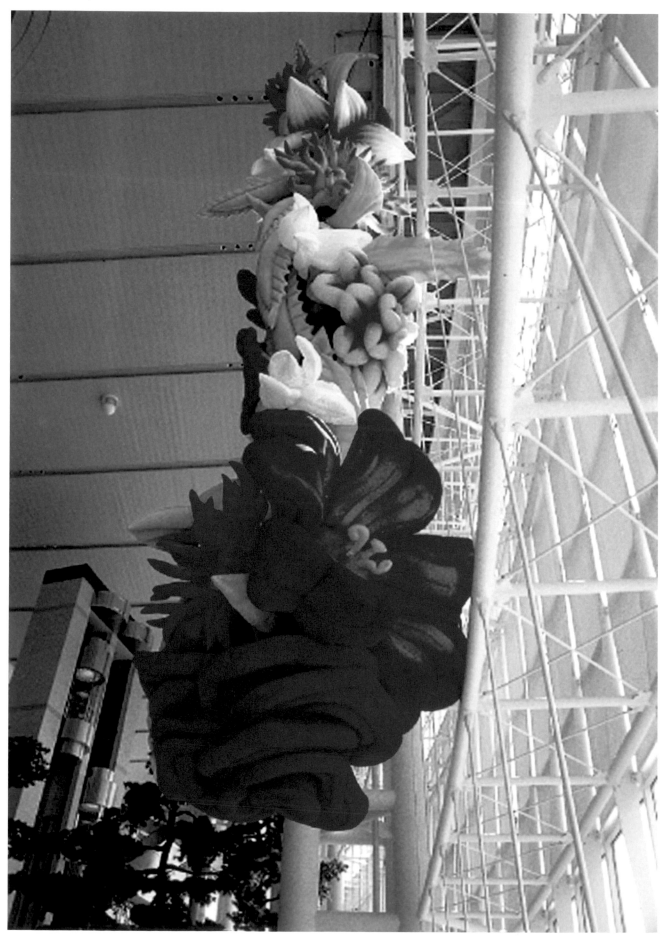

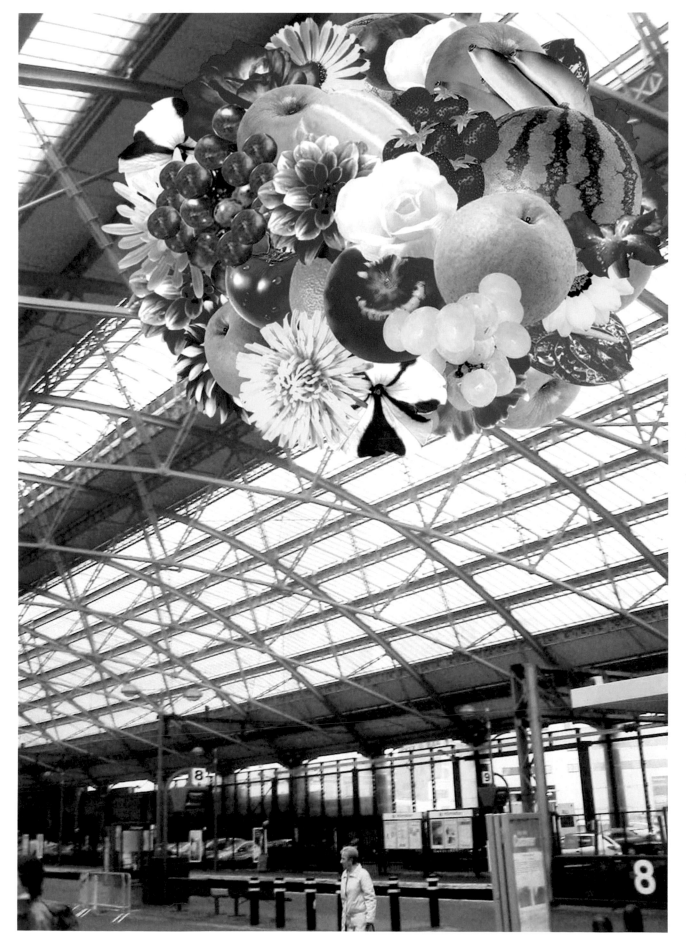

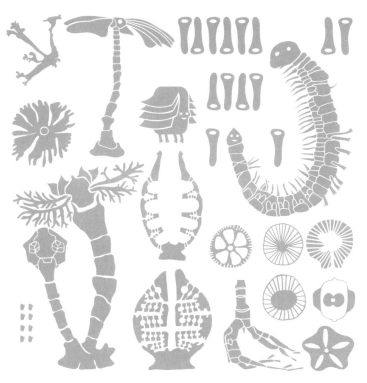

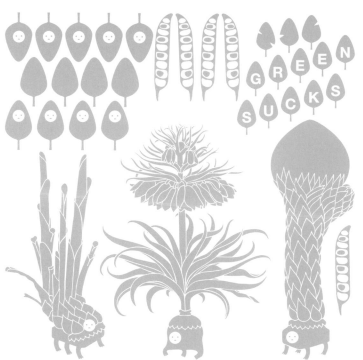

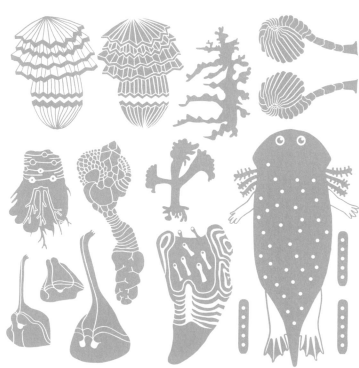

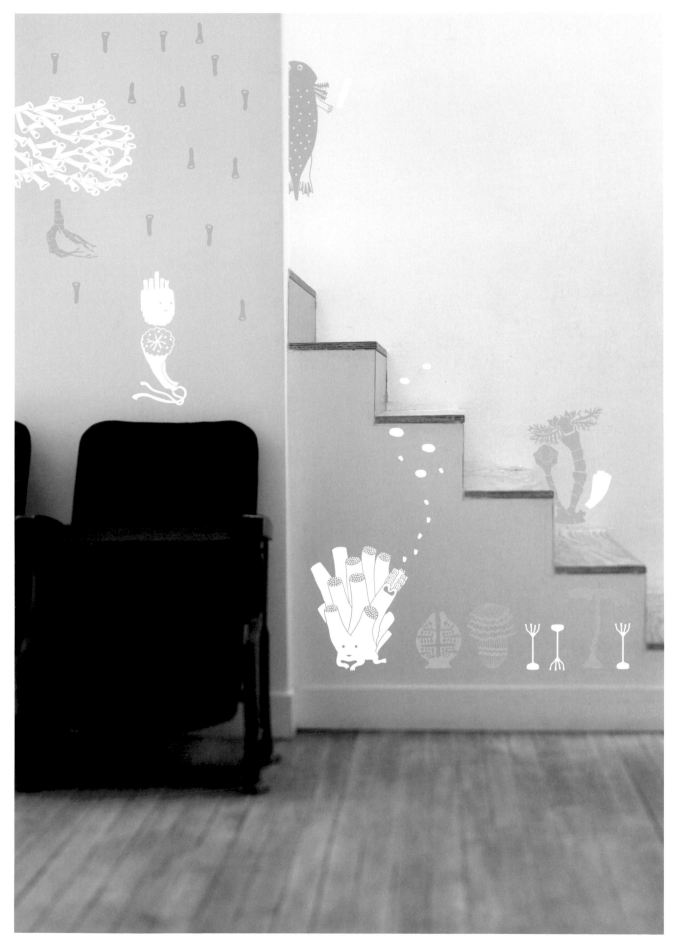

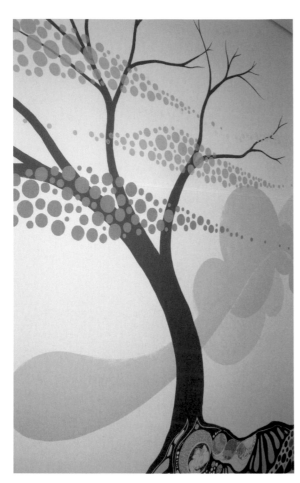

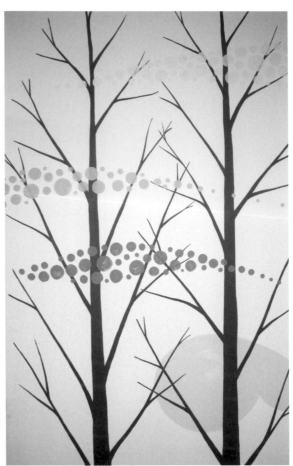

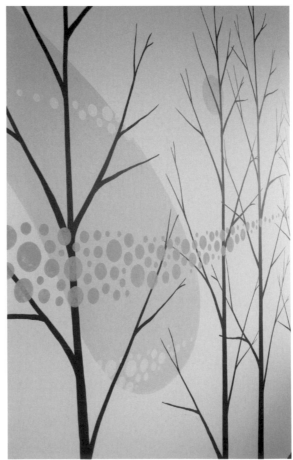

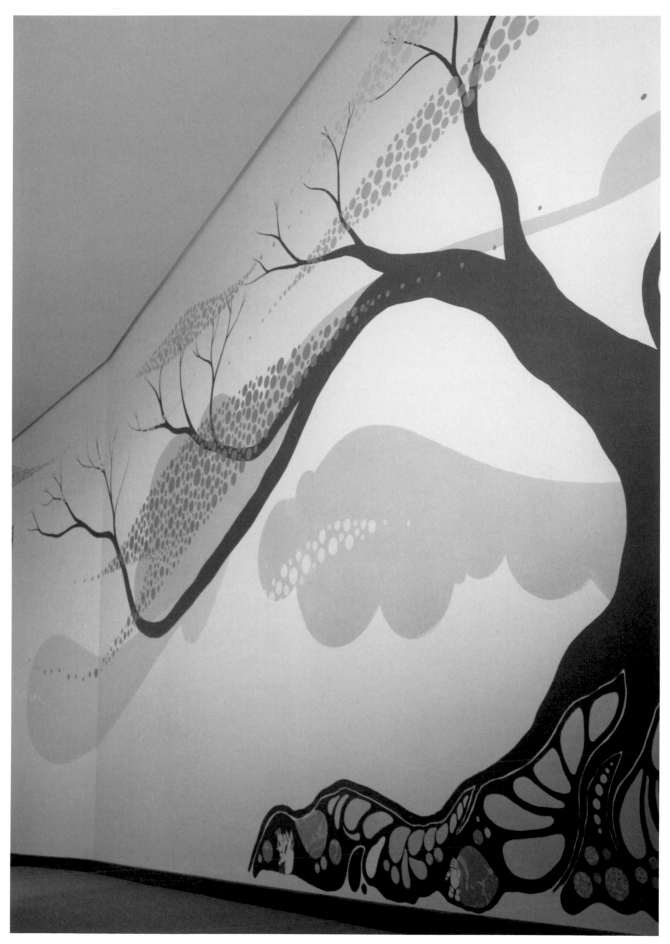

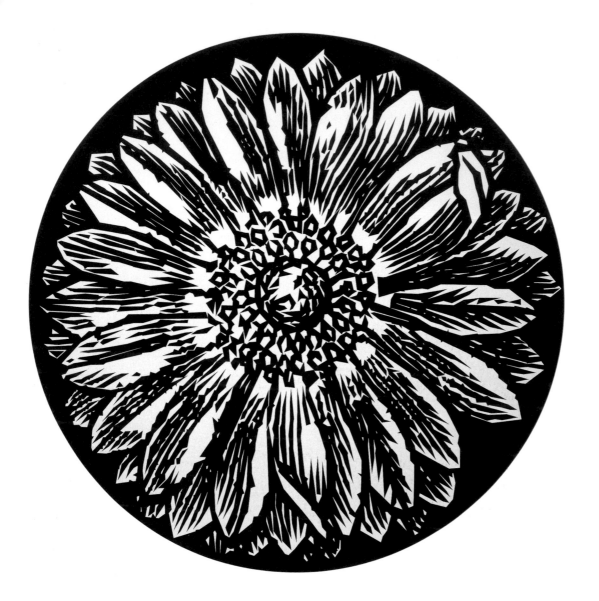

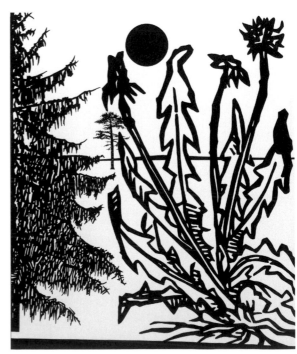

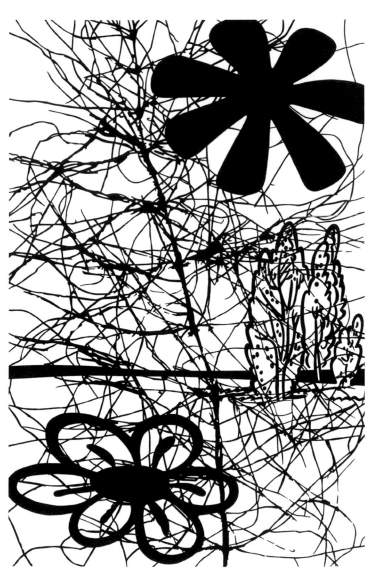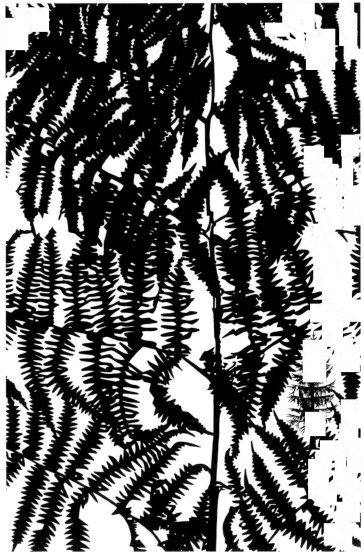

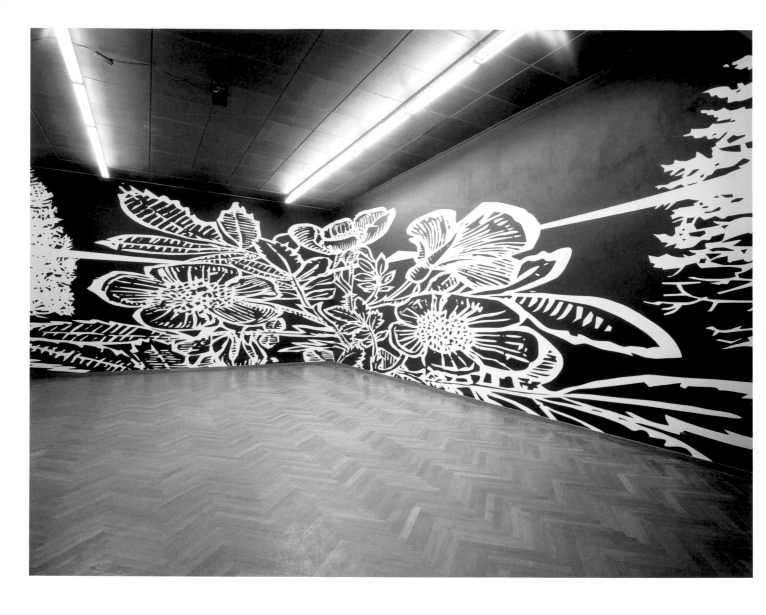

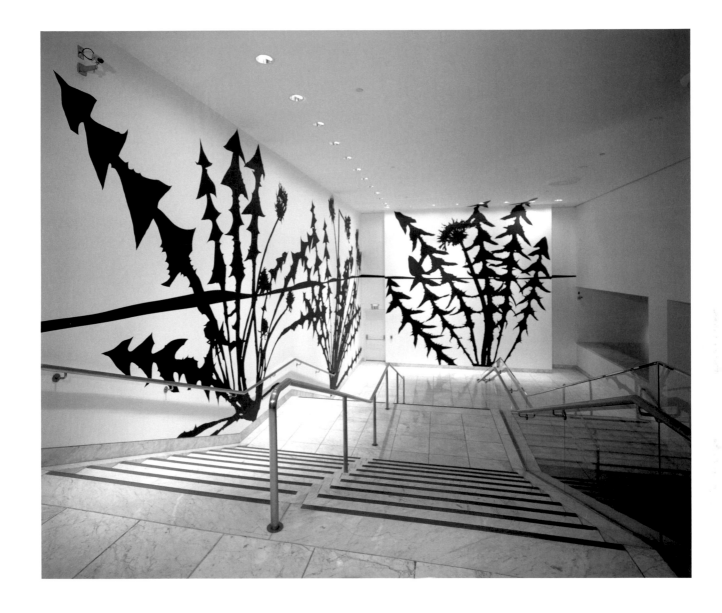

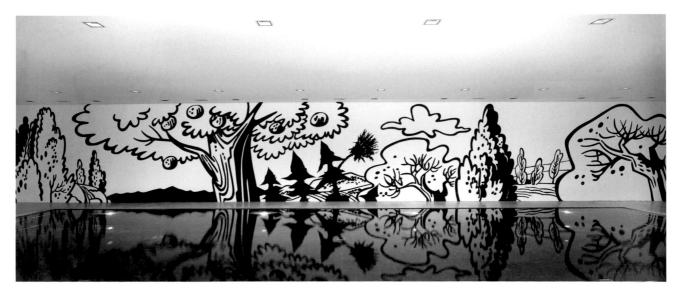

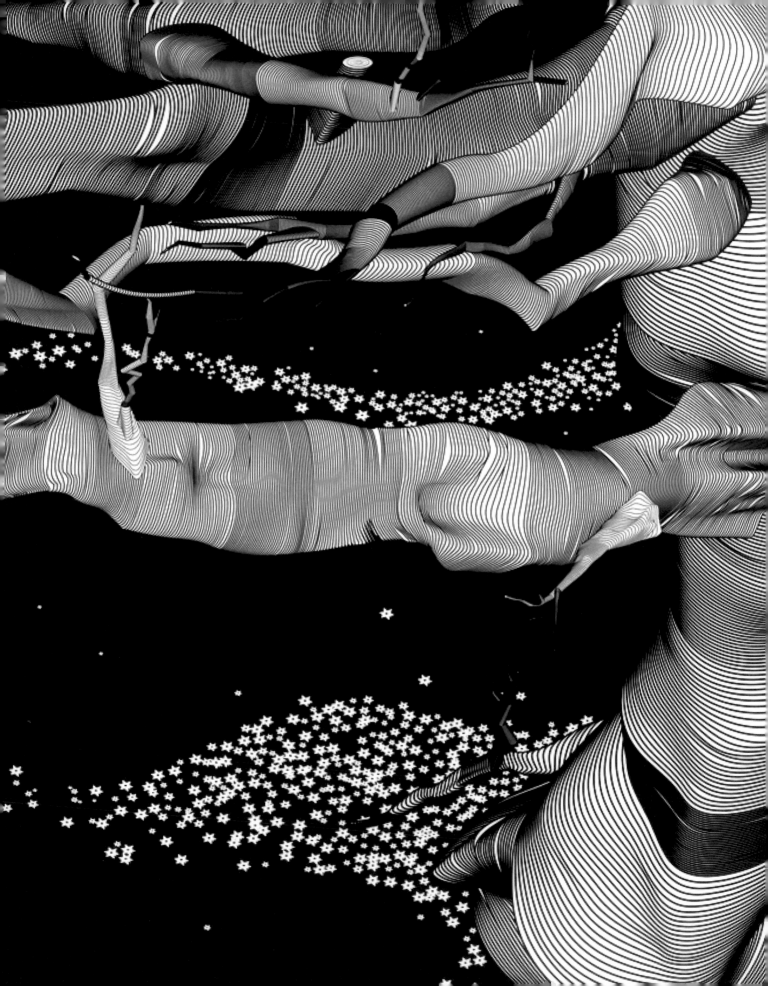

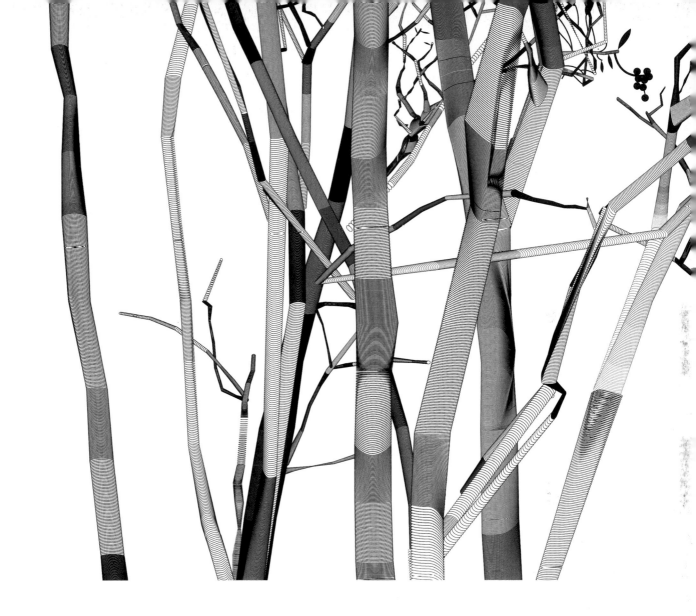

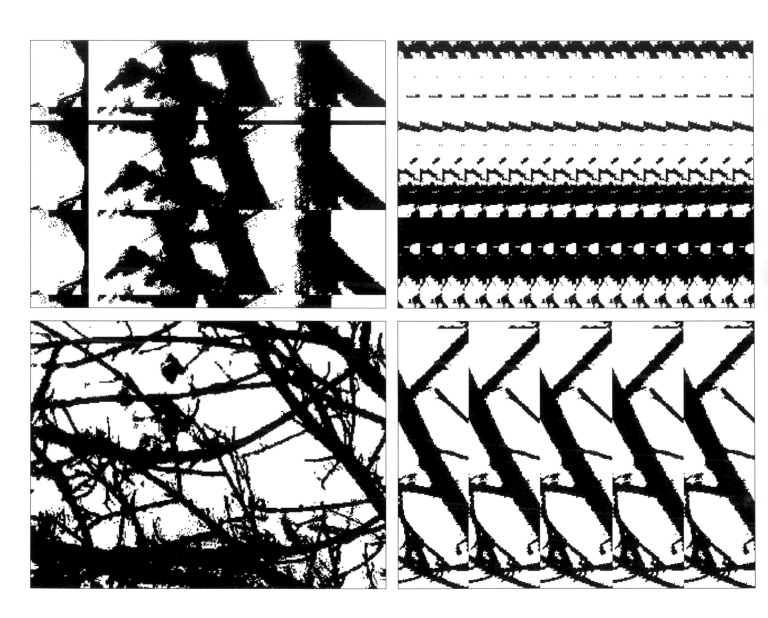

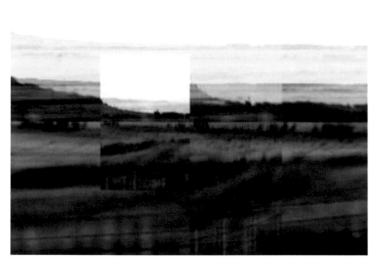
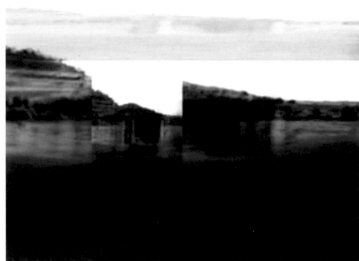
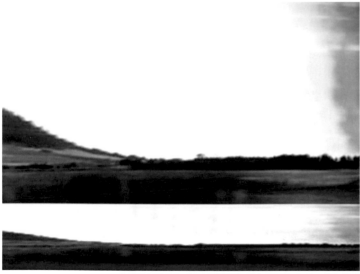

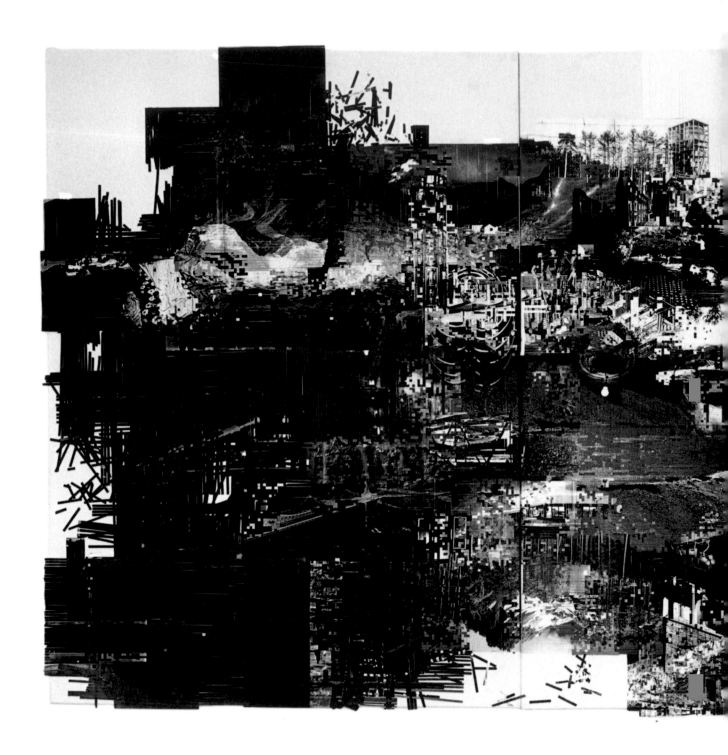

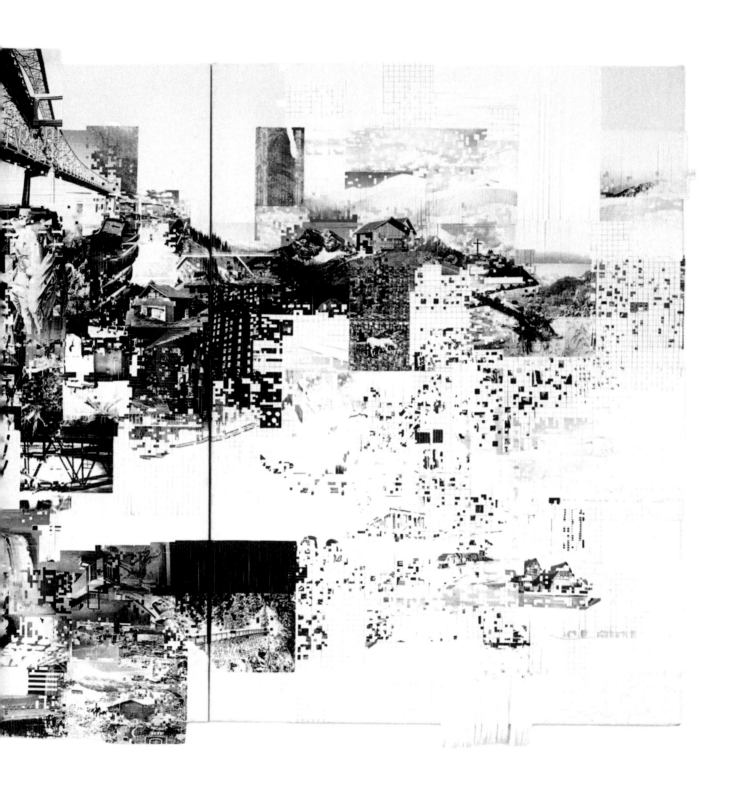

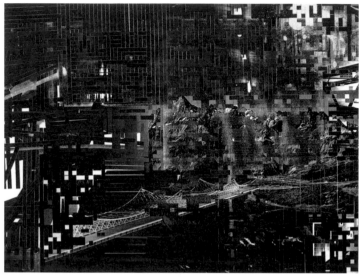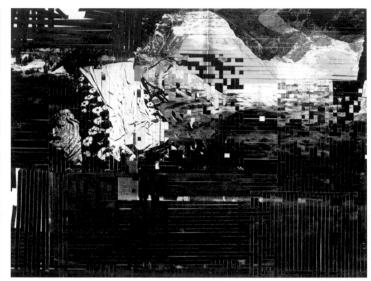
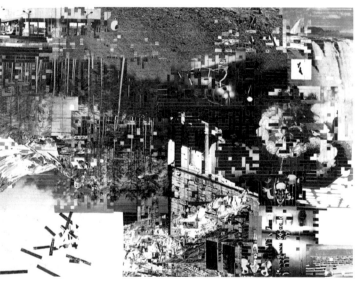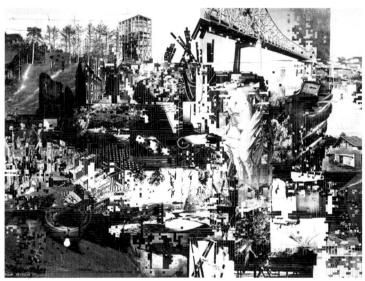

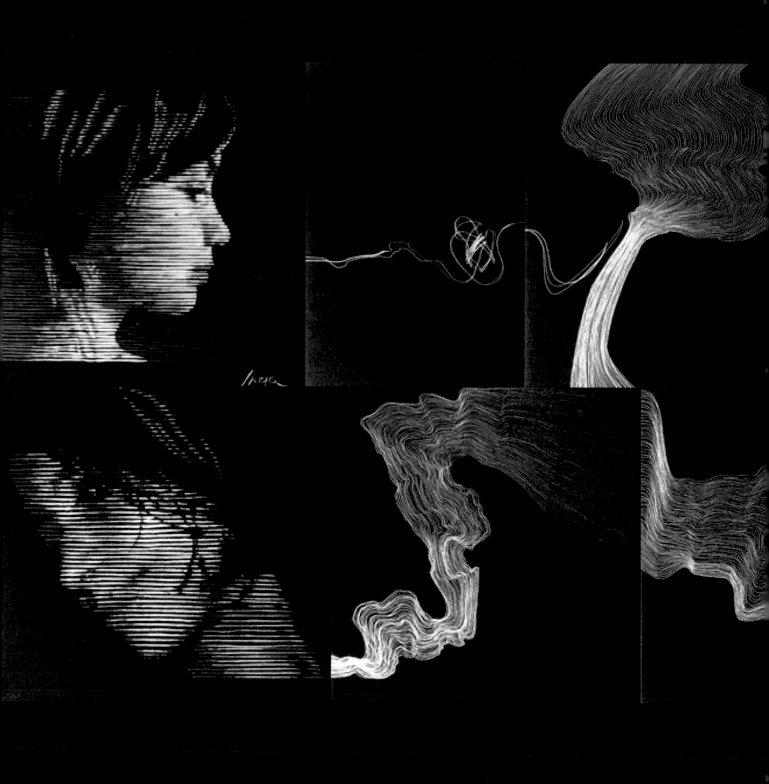

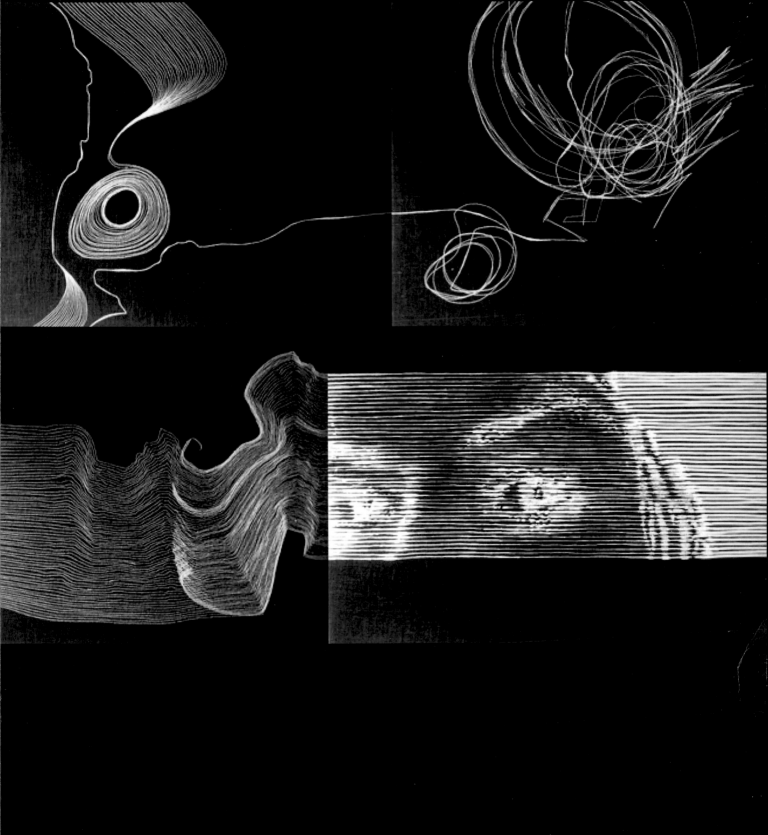

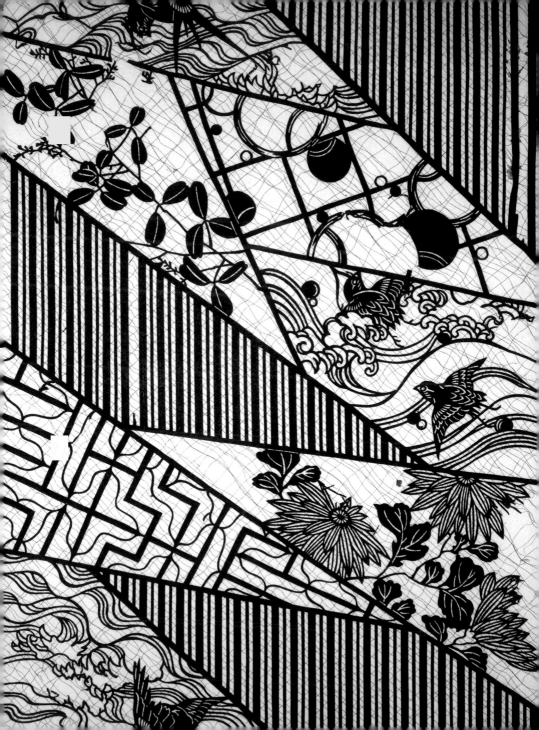

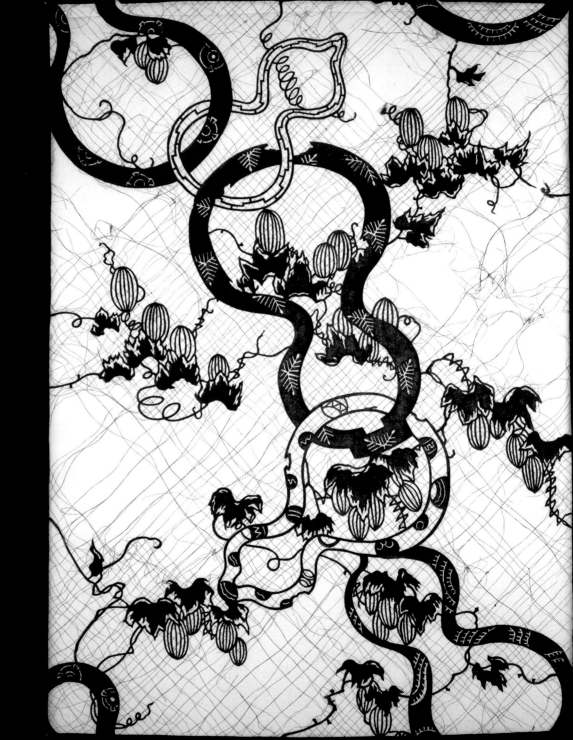

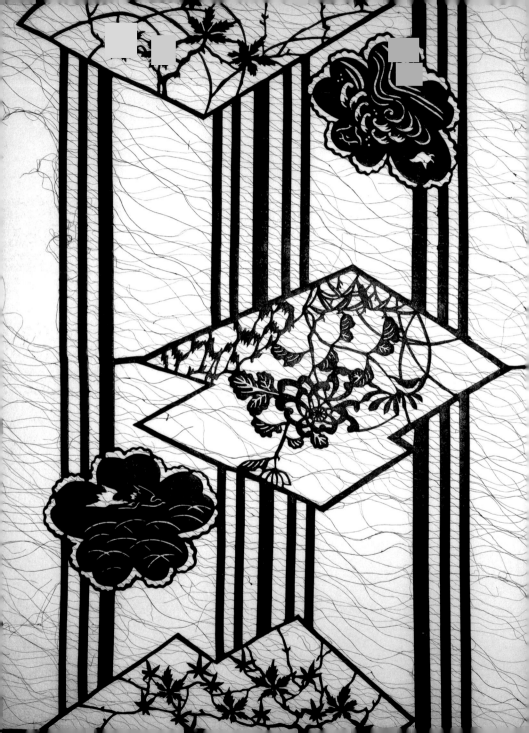

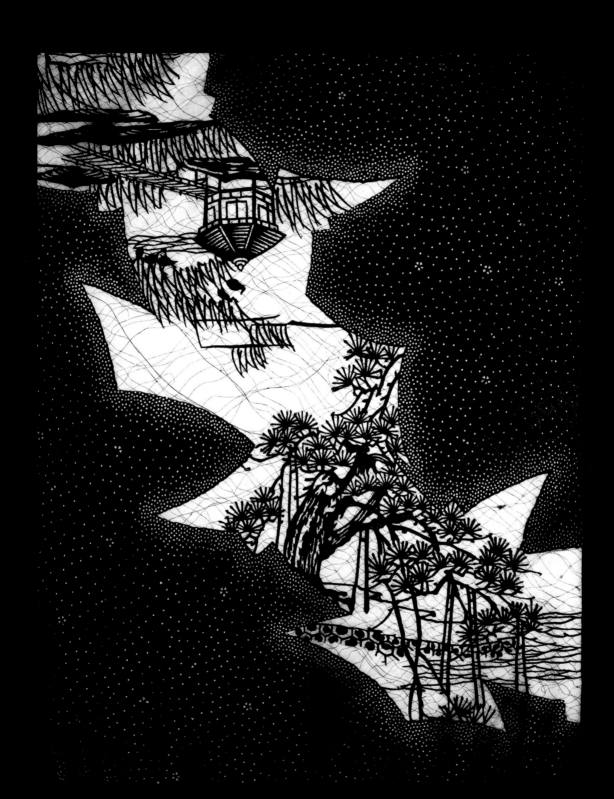

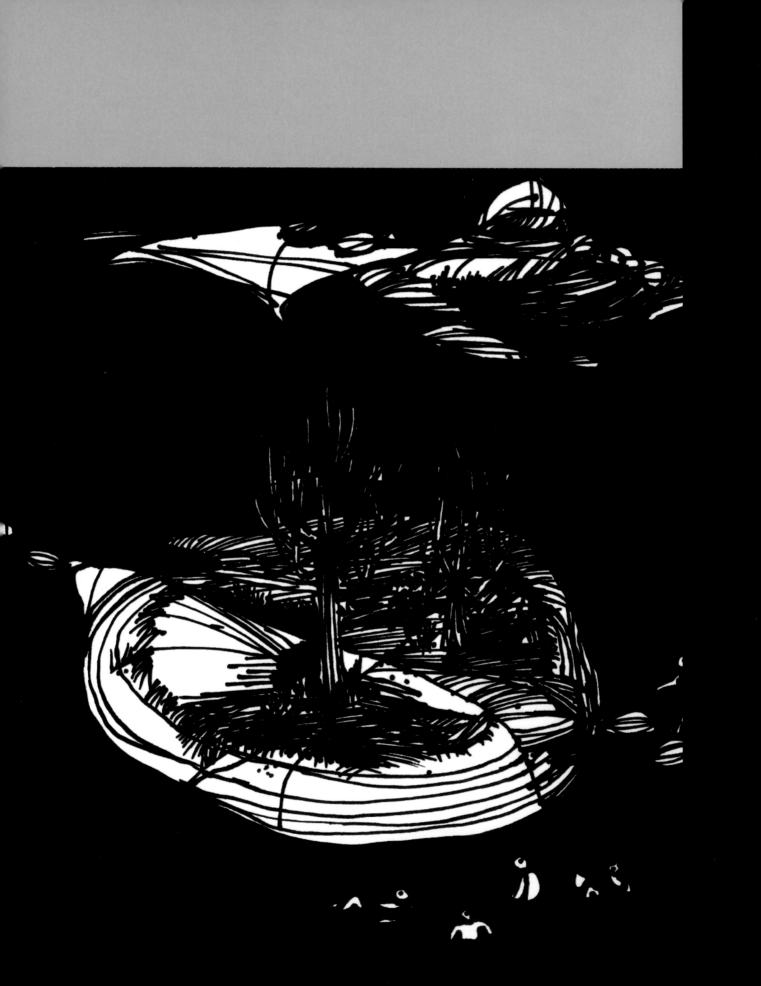

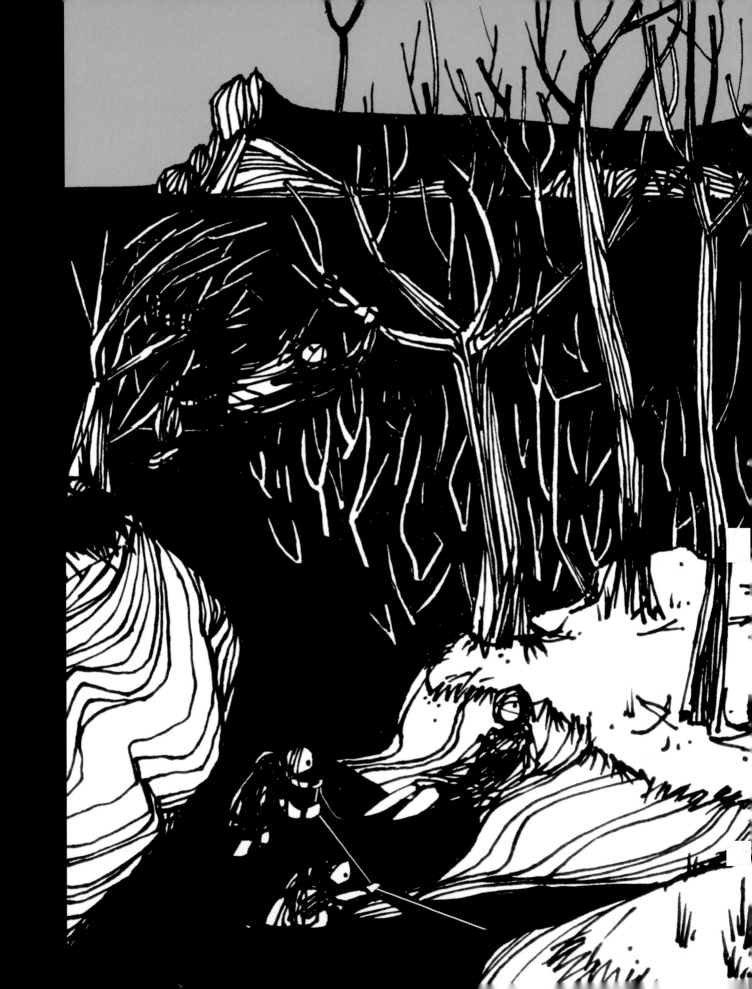

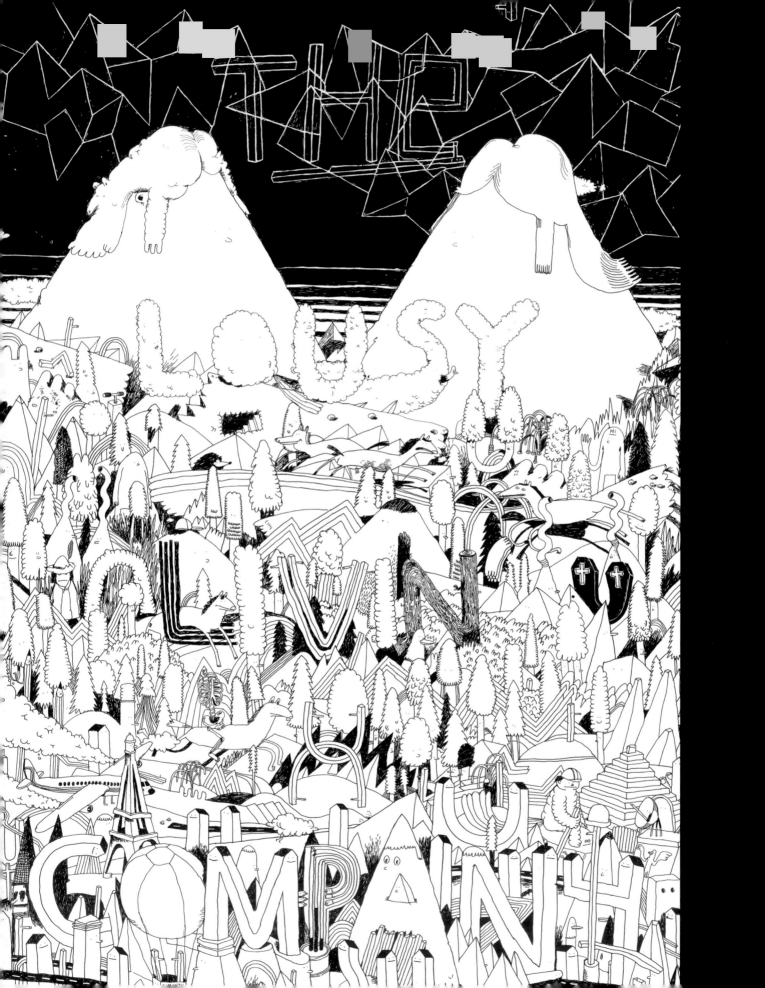

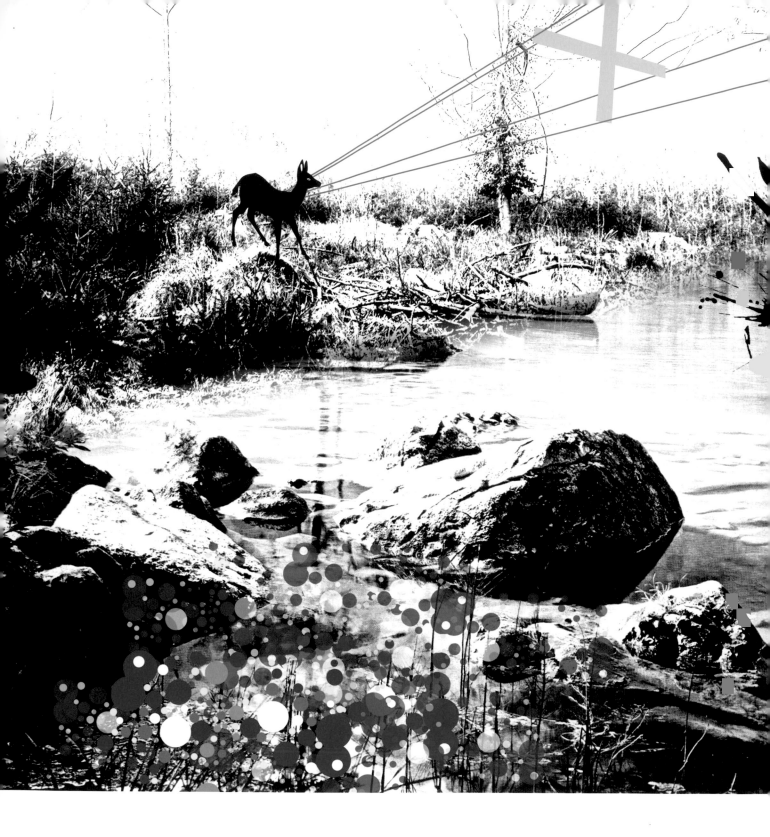

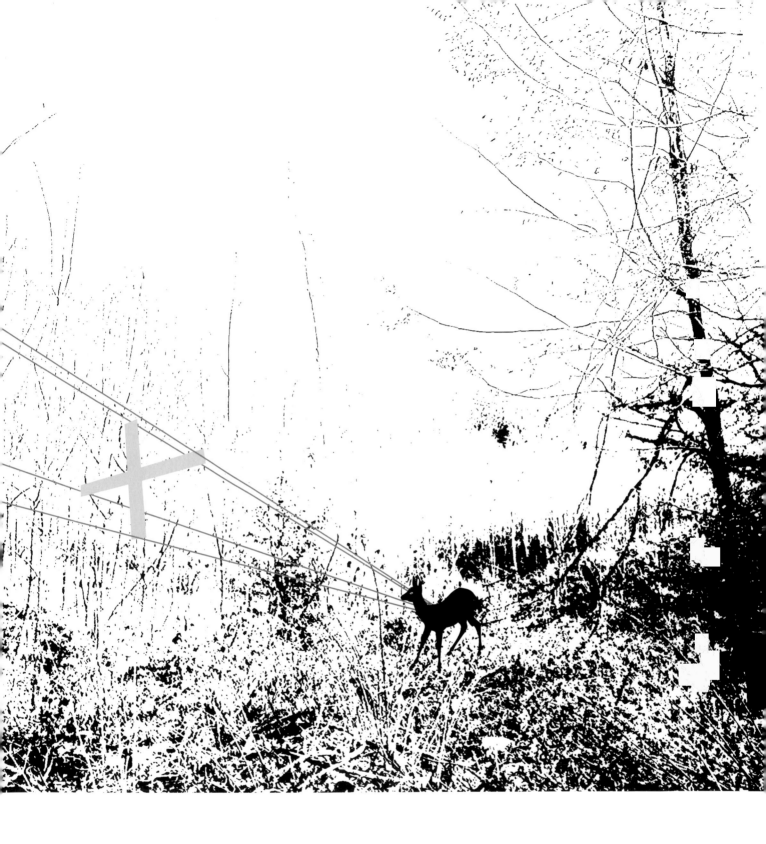

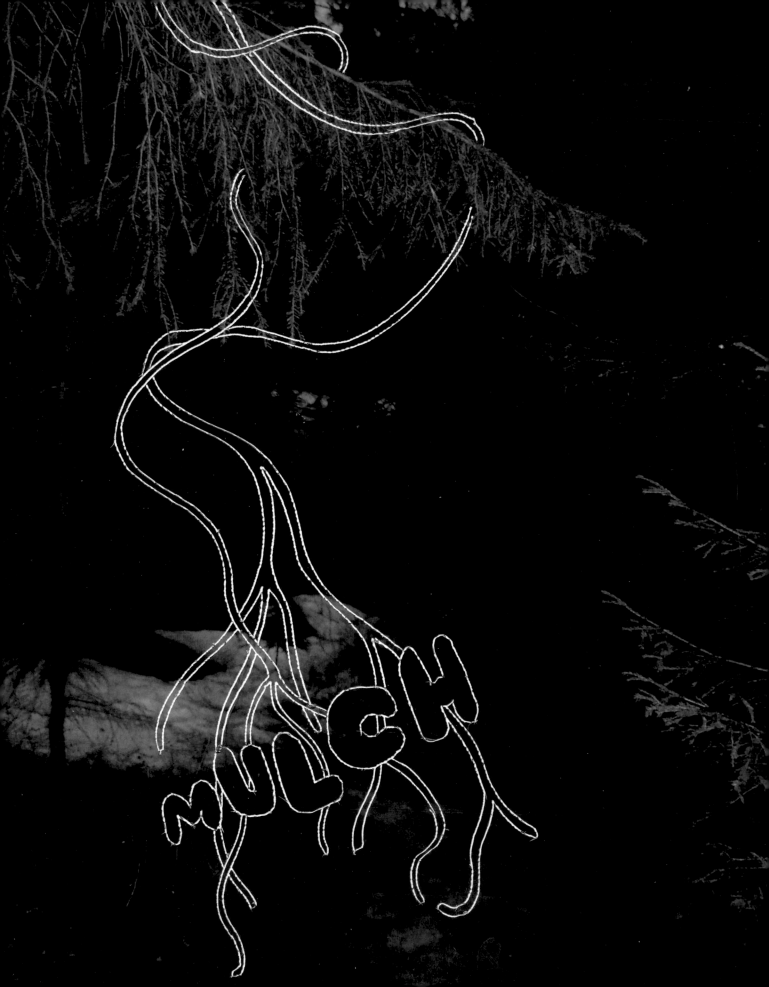

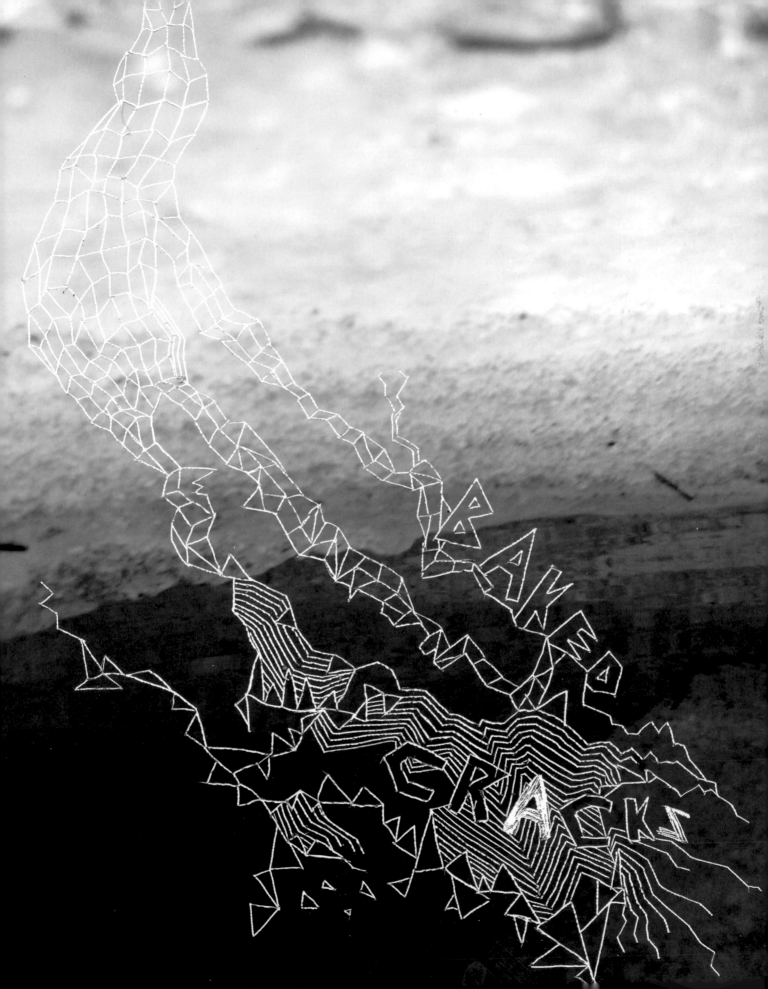

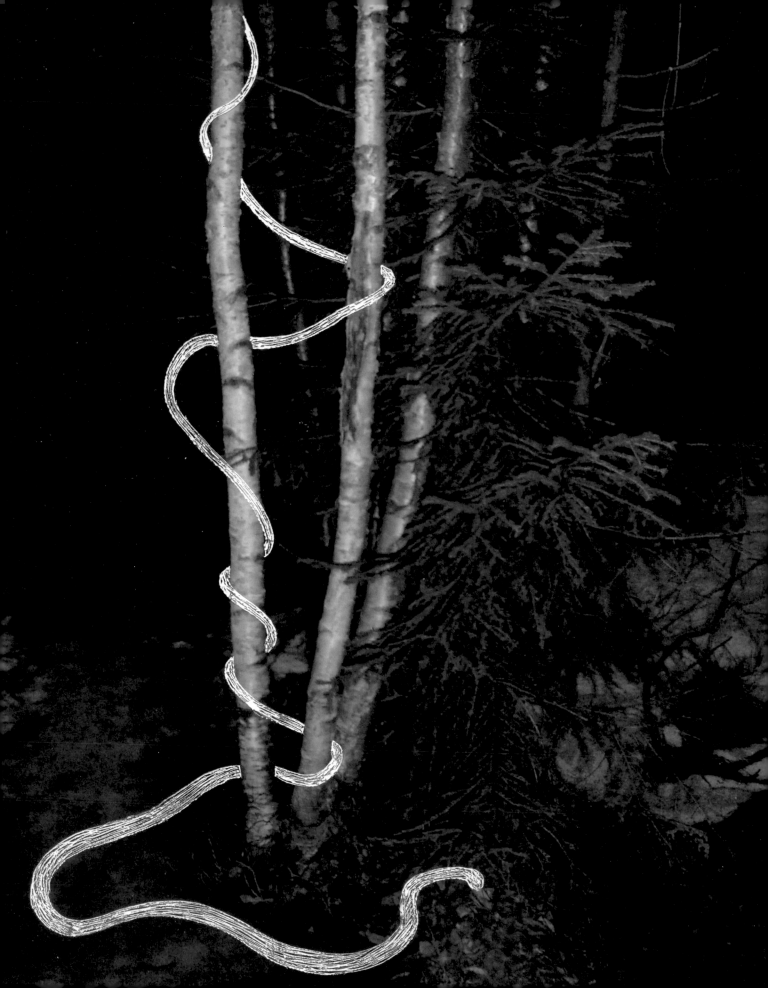

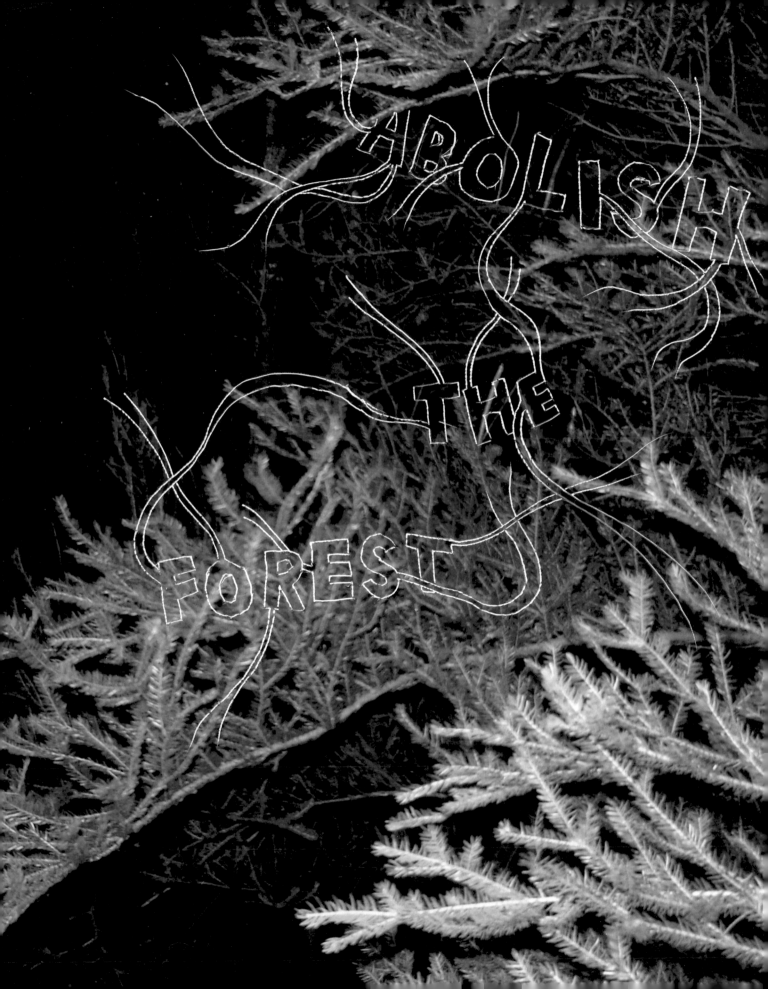

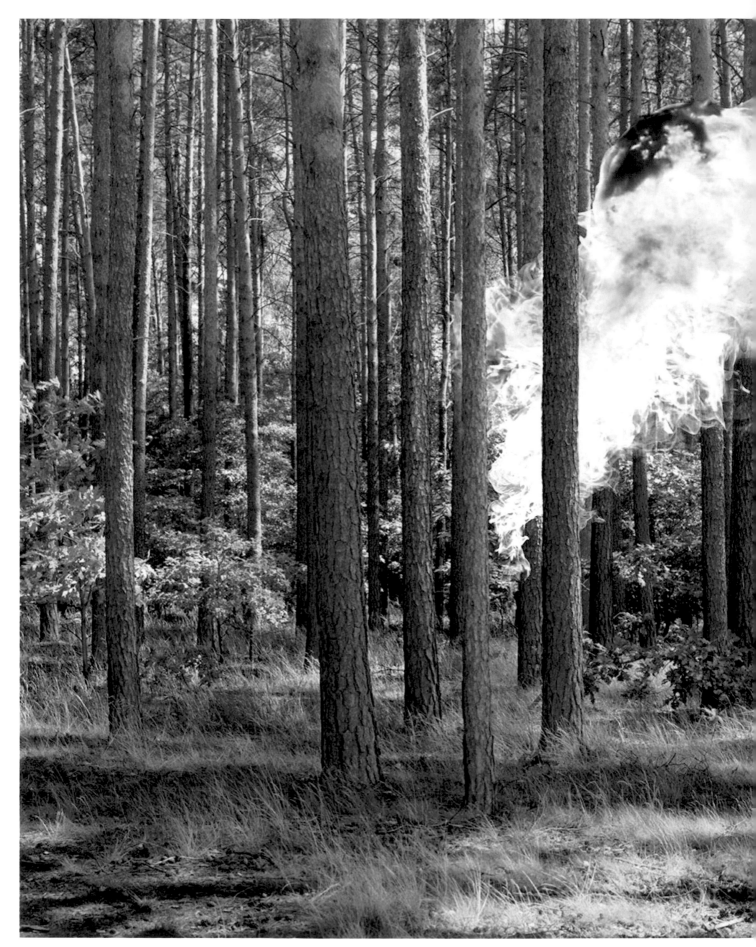

Threat

"Let us walk in the wood
While the wolf is not there.
If he were there,
He would eat us.
But as he's not there,
He won't eat us."

Stories for children take place in a universe borrowed
from Nature. So, Hansel and Gretel and Pinocchio venture
into the forest or go to sea only to meet with trials. The
moral tales associate an unknown and attractive Nature
with labyrinthine danger. In this metasphere the woods
are thorny, the animals voracious and wild (they can also
speak!), evil magicians prey on innocent children.
This vision of Nature as hiding a parallel world acts as a
warning. At once fascinating and diabolical, it is created
to inspire anxiety. "If you don't behave yourself, I'll leave
you here".
Age-old superstitions and beliefs ooze from the under-
growth and bring in their train the fantastic procession
of dark forces and spirits. This Nature gives expression
to disturbance and the unspeakable. It is a drawer for
corpses in which shame and regrets are carefully hidden
away. Beware, whoever opens Pandora's box!

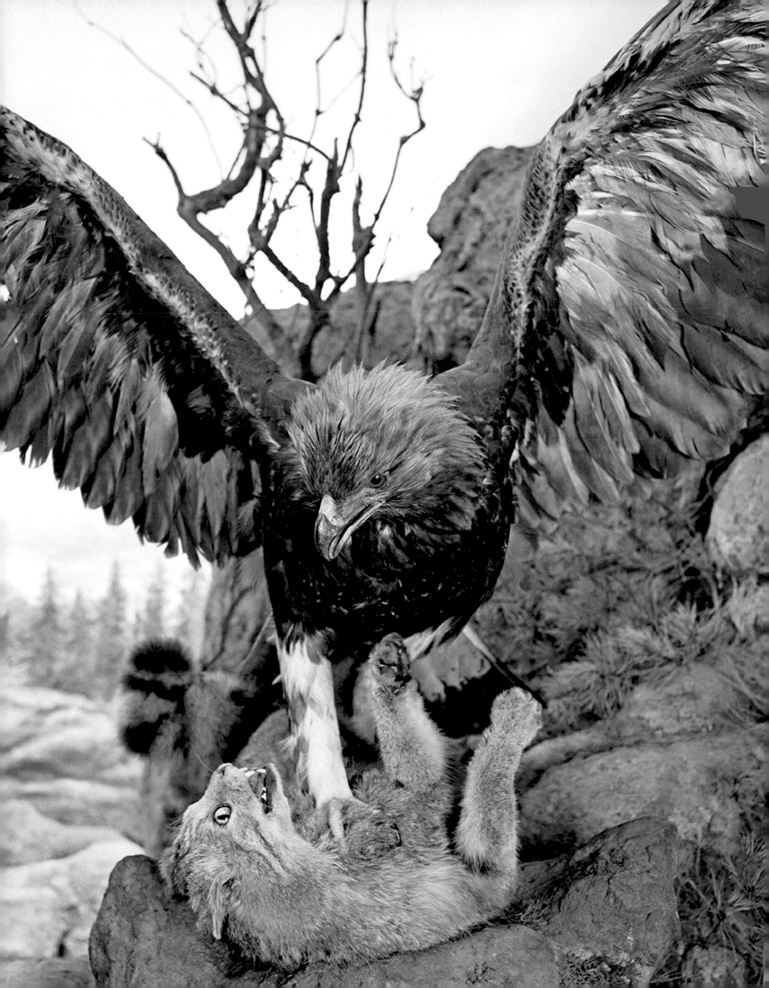

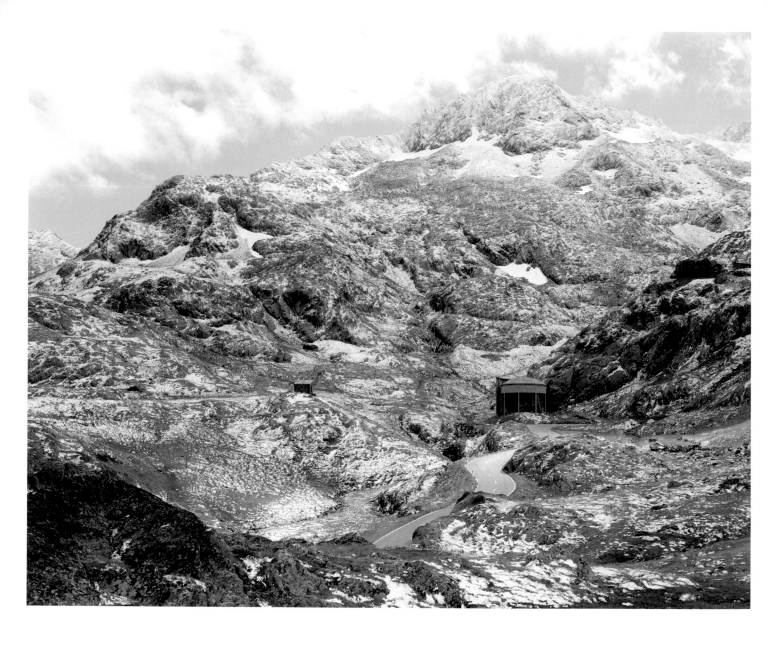

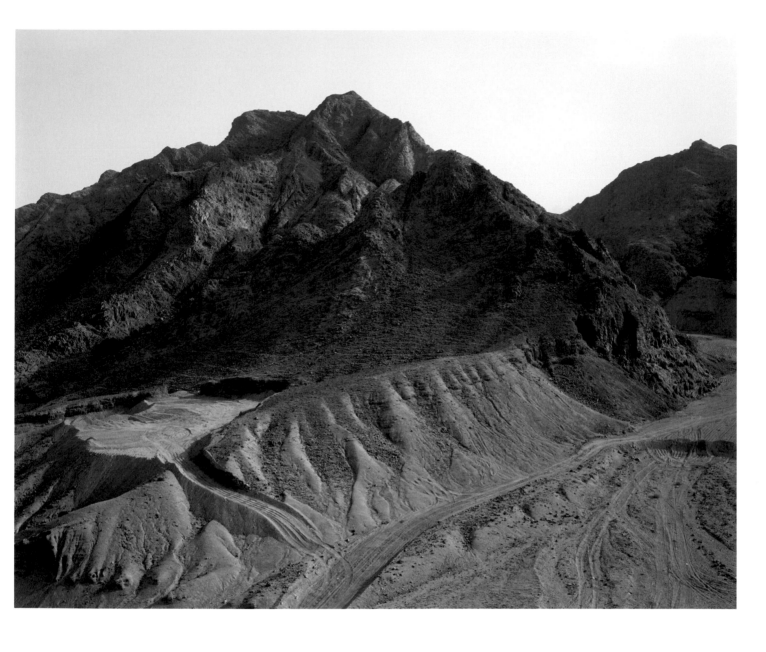

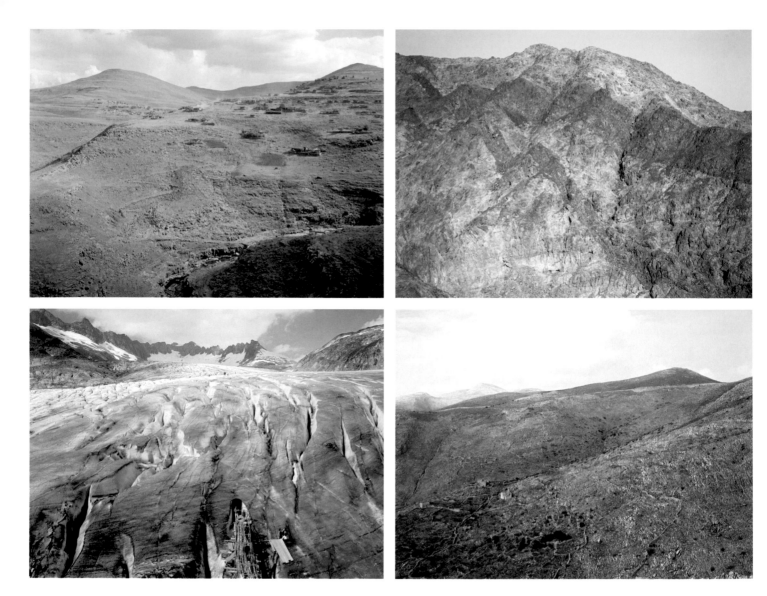

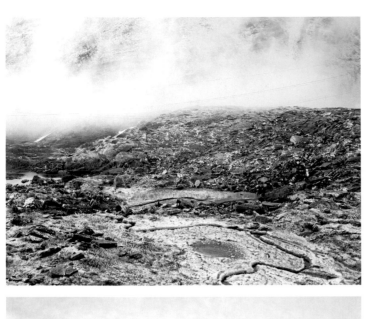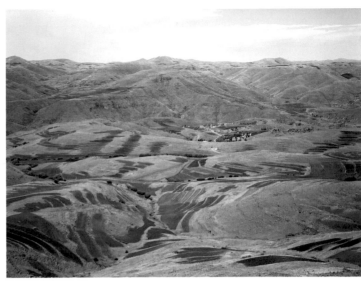

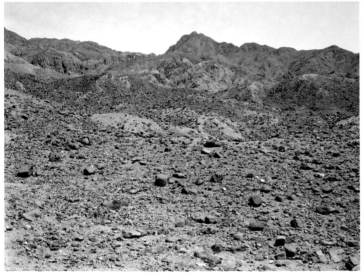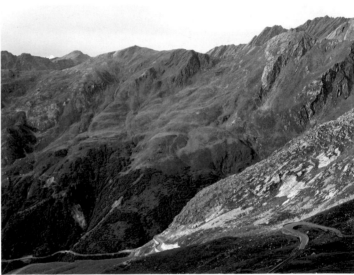

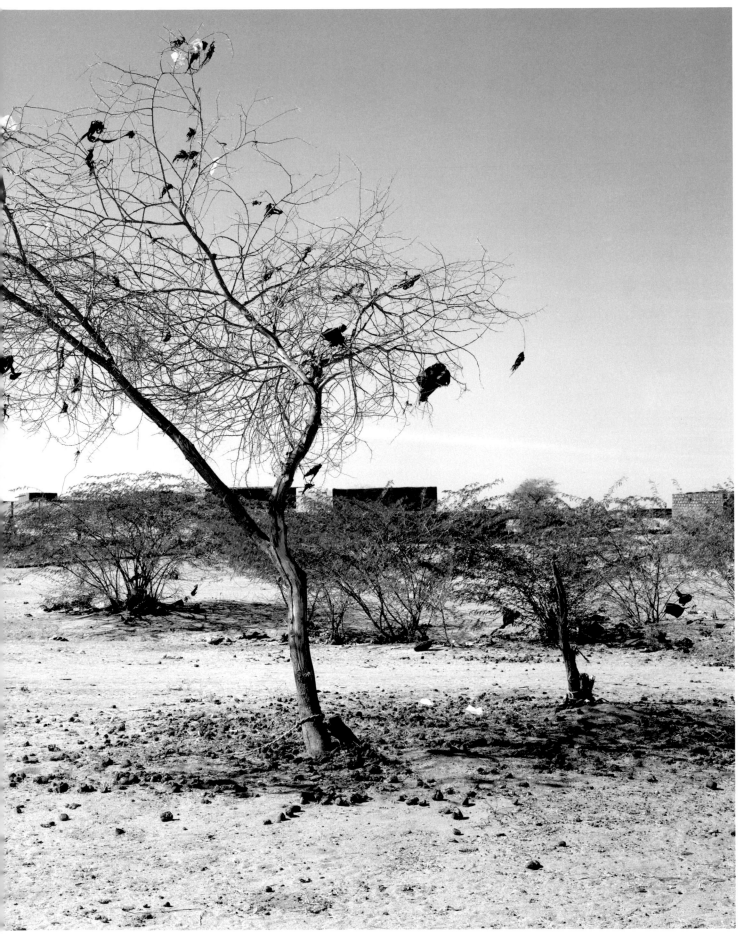

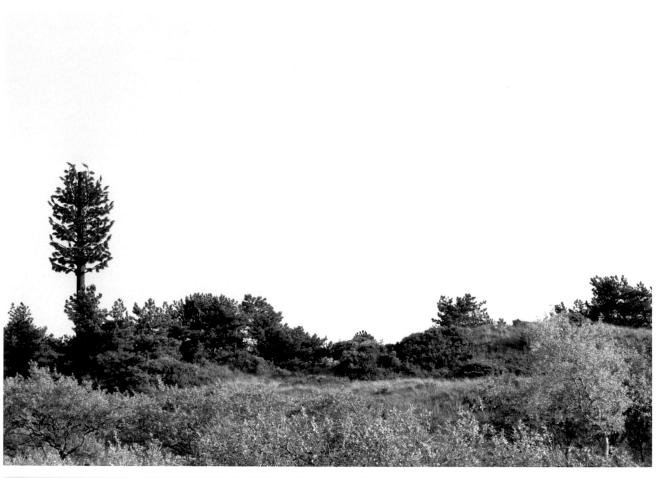

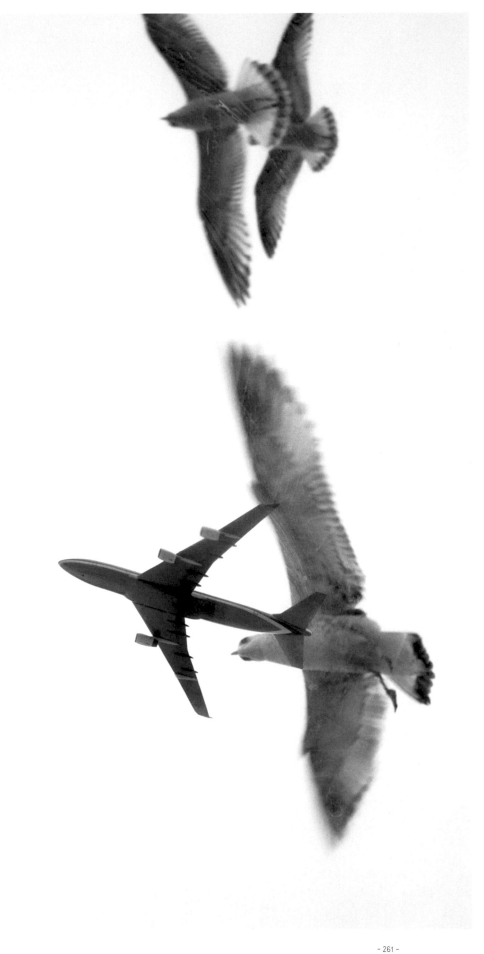

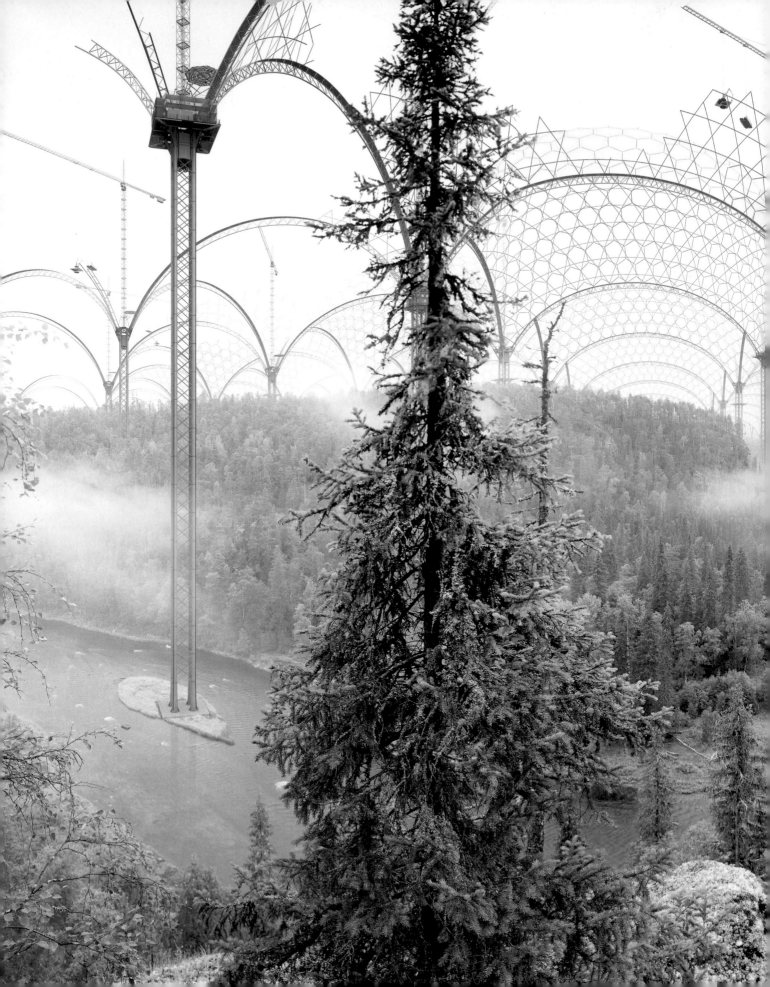

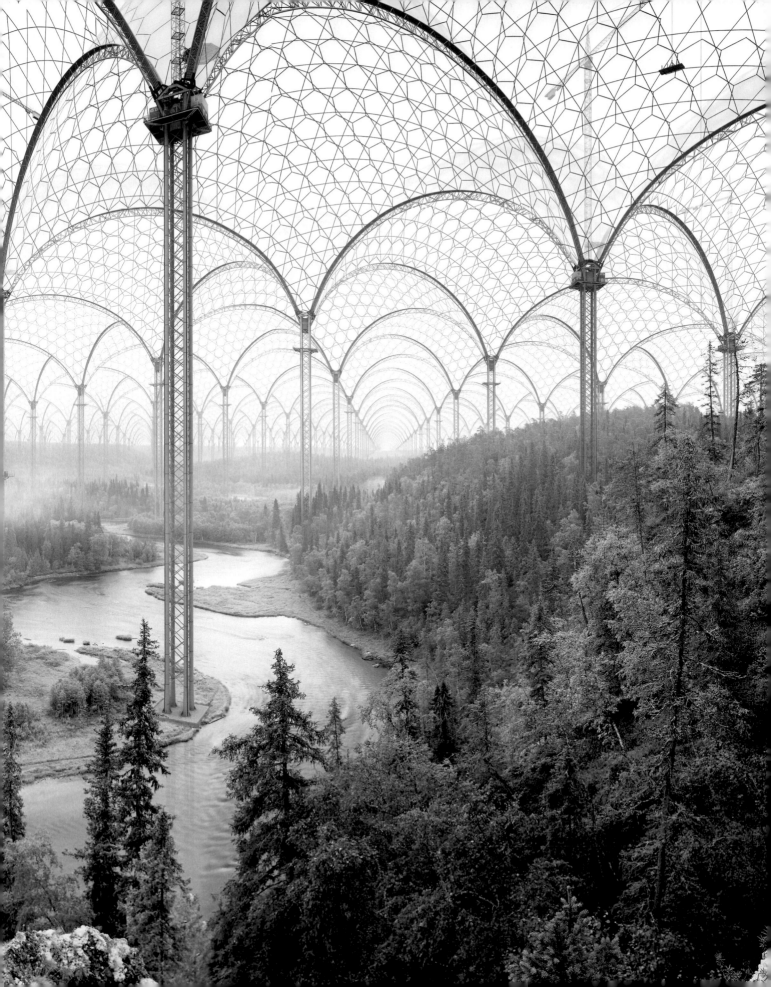

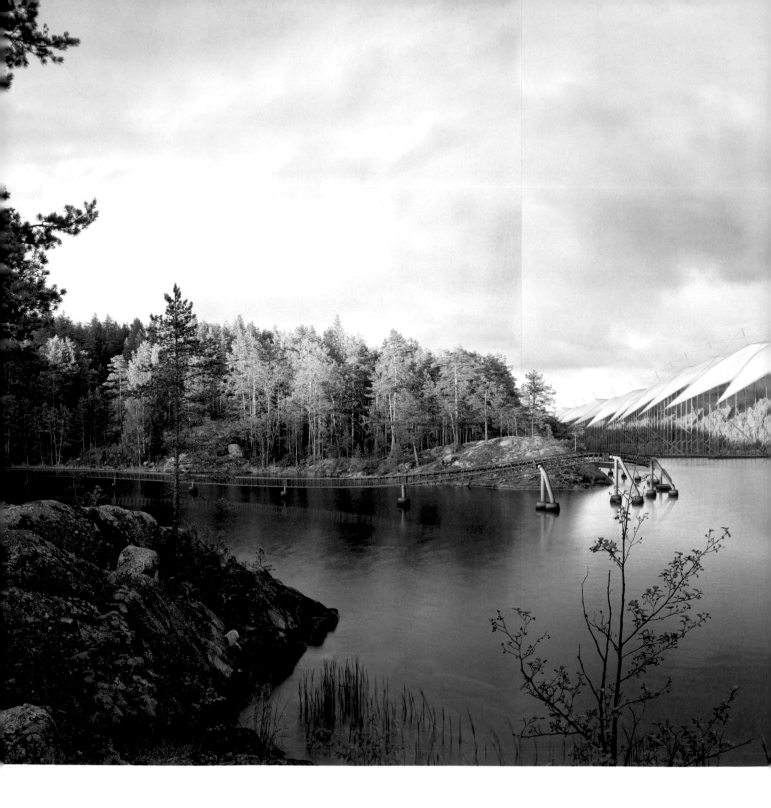

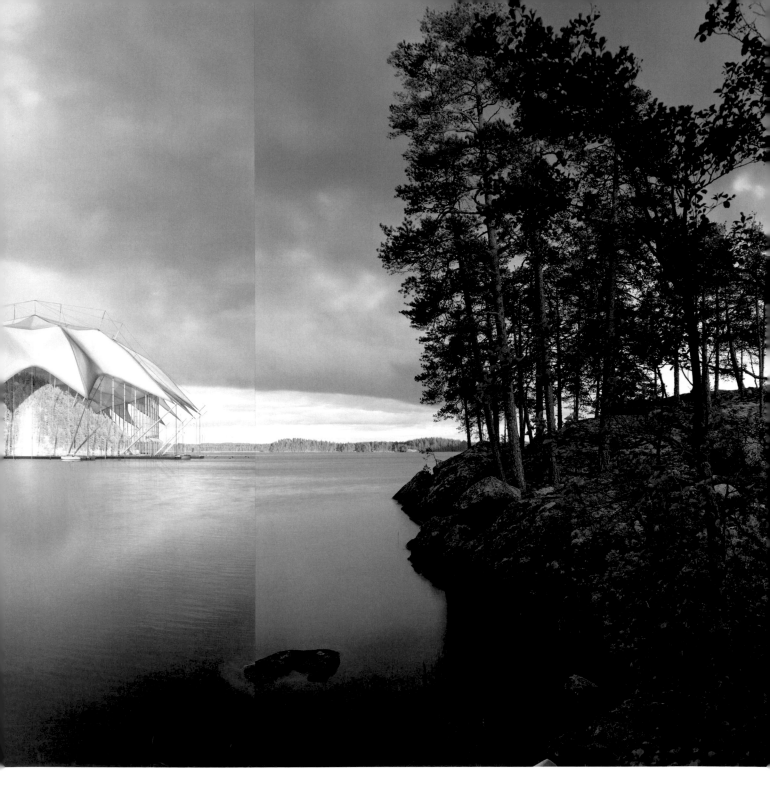

Into the nature of Creatures and Wilderness

Edited by Robert Klanten, Mika Mischler, Sven Ehmann
Layout and Design by Mika Mischler
Editorial support by Julian Sorge
Production Management by Martin Bretschneider

Cover Photo by Koen Hauser, www.unit.nl
Typeface: Naiv, type design by Timo Gaessner
Foundry: www.die-gestalten.de

Antiseptic (Preface) and Texts by Cathy Larqué with Robert Klanten
"The belling stag" Text by Katharina Klara Jung
Translation by Michael Robinson

Published by Die Gestalten Verlag, Berlin
Printed by fgb - Freiburger Graphische Betriebe, Freiburg
Made in Europe

Bibliographic information published by Die Deutsche Bibliothek
Die Deutsche Bibliothek lists this publication in the Deutsche
Nationalbibliografie; detailed bibliographic data is available on
the Internet at http://dnb.ddb.de.

ISBN-10: 3-89955-099-4
ISBN-13: 978-3-89955-099-3

For your local dgv distributor please check out:
www.die-gestalten.de